The Mosaics of St. Peter's

THE MOSAICS OF SAINT PETER'S
Decorating the New Basilica

FRANK DiFEDERICO

THE PENNSYLVANIA STATE UNIVERSITY PRESS
UNIVERSITY PARK AND LONDON

Publication of this book was assisted by a grant from the Samuel H. Kress Foundation.

Library of Congress Cataloging in Publication Data

DiFederico, Frank R,
 The mosaics of Saint Peter's.

 Includes bibliography and index.
 1. Mosaics, Italian—Vatican City. 2. Basilica
di San Pietro in Vaticano. 3. Studio del mosaico
(Vatican City) I. Title.
NA3820.D53 1983 726'.527 82-42777
ISBN 0-271-00344-8

Per Don Cipriano Cipriani—in omaggio e con gratitudine infinita

Contents

List of Illustrations

The following abbreviations are used throughout: AF, Arte Fotografico; ARFSP, Archivio della Reverenda Fabbrica di S. Pietro; GFN, Gabinetto Fotografico Nazionale, Instituto Centrale per il Catalogo e la Documentazione, Rome.

Plan of the Basilica (page 58)

Figures (pages 37–52)

Plates *(pages 81–148)*

Color Plates

Preface

This book is a study of the mosaic decorations in the Basilica of Saint Peter. Relying on the records of payments made to the painters and mosaicists and on other relevant documents in the Archivio della Reverenda Fabbrica di S. Pietro, I attempt to establish as accurately as possible a chronology for the decorative scheme of the basilica, to determine the many personalities involved, to suggest an iconographic program for the domes and chapels, and to outline the history of the Vatican Mosaic Studio, which was responsible for the execution of the entire ensemble.

My debt to previous studies of the mosaic decorations is immeasurable, but as informative as most of the earlier works are, too often the attributions or chronologies they propose are only partially correct. To acknowledge them in each instance—often either to correct or add to them—would have resulted in needless confusion. Consequently, earlier studies are specifically noted only when they are relevant to a particular argument. Those studies include Furietti's *De Musivis* and Gerspach's *La Mosaïque,* which contain short surveys of the mosaics within their comprehensive histories of the medium, as well as works specifically devoted to the decorations in the basilica and to the Vatican Mosaic Studio, such as Giannelli's "Studio del Musaico al Vaticano" (1845), Busiri-Vici's *Il celebre Studio del Mosaico* (1901), Hautecoeur's "I musaicisti Sampietrini del settecento" (1910), Strappati's "Lo Studio Vaticano del Mosaico" (1931), and the short volume *Studio Vaticano del Mosaico* published in Milan in 1934. Of these, Busiri-Vici's study is the most extensive.

Until the publication of my article "Documentation for Francesco Trevisani's Decorations for the Vestibule of the Baptismal Chapel in Saint Peter's" in 1970, little else on the subject had appeared in print, except for the documents of the decorations published by Oskar Pollak in 1915 and 1931 and by Johannes Orbann in 1919. A recent publication, *I mosaici minuiti romani* (1981), contains an interesting essay by Maria Grazia Branchetti, "Ambienti storico sociale dei mosaicisti del '700 e dell '800 dallo Studio Vaticano del Mosaico alla libera attività," and a bibliographical index of mosaicists active in Rome from 1727 to about 1870.

Among the most useful sources on the mosaics are the guidebooks to and descriptions of the basilica, particularly Tiberio Alpharano's *De Basilicae Vaticane*, Fontana's *Templum Vaticanum*, Bonanni's *Numismata Summorum Pontificum*, Gizzi's *Breve descrizione della Basilica Vaticana*, Vasi's *Descrizione della Basilica di S. Pietro*, Pistolesi's *Il Vaticano*, Mignanti's *Istoria della Sacrosanta Patriarcale Basilica Vaticana*, Sergiacomo's *Guide complet de la Basilique de St-Pierre à Rome*, Turcio's *La Basilica di S. Pietro*, and two books by Galassi Paluzzi, *San Pietro in Vaticano* and *La Basilica di S. Pietro*. In addition there are the highly informative eighteenth-century guides by Raffaele Sindone and Antonio Martinetti, *Della sacrosanta basilica di S. Pietro in Vaticano*, and Giovanni Pietro Chattard, *Nuova descrizione del Vaticano*.

In the descriptions of the chapels and the altarpieces, primary archival documentation is given in all instances where previously published information is either nonexistent, incorrect, contradictory, or confusing. Archival documentation has been omitted when previously published references for the cartoons, paintings, and/or mosaics, listed in the individual bibliographies, are correct.

The greatest debt I have incurred in preparing this book is to the Reverend Don Cipriano Maria Cipriani, O.S.B. Monteolivetano, archivist of the Reverenda Fabbrica di S. Pietro in Vaticano. Without his patience, interest, and assistance, the book simply would not have been possible. My research was completed in 1978 during a sabbatical leave from the University of Maryland and was supported by a Fulbright-Hays research grant. During my stay in Italy, Cipriana Scelba, executive director of the Commissione per gli scambi culturale fra l'Italia e gli Stati Uniti, and her staff were extremely gracious and helpful. A grant from the Samuel H. Kress Foundation enabled me to have all the mosaics in Saint Peter's photographed, most for the first time, and for that I am especially indebted to Mary E. Davis, formerly executive vice-president of the foundation, whose enthusiasm for my project is very much appreciated. The photographs were taken by Vito Rotondo of Arte Fotografica in Rome. The problems he faced were complex and often, I felt, unsurmountable. The pictures are a credit to his skill and talent.

I would also like to acknowledge the generosity and assistance of the administrations and staffs of the Catholic University of America Library and the Byzantine Library at Dumbarton Oaks in Washington, D.C., and the Bibliotheca Hertziana, the Biblioteca dell'Istituto Nazionale d'Archeologia e Storia dell'Arte, and the Vatican Library in Rome.

Among the individuals at the Vatican who were particularly generous with their time and knowledge were Mrs. Marjorie Weeke of the Pontificia Commissione per le Comunicazione Sociale; Dr. Pierluigi Silvan, assistant director of the Reverenda Fabbrica di S. Pietro; Commendatore Francesco Ricceri and Professor Virgilio Cassio, administrator and director, respectively, of the Vatican Mosaic Studio. Together with them I would like to thank my friends and colleagues who contributed in so many different ways to the successful completion of this work: Mrs. Jane Block; Dr. Diane DeGrazia, curator of Italian drawings at the National Gallery of Art; the late Anthony M. Clark; Professor Charles Dempsey, Johns Hopkins University; Professor Italo Faldi, University of Viterbo; Mr. William Kloss; Ms. Carolyn T. Lee, librarian, Catholic University of America; the late Professor Wolfgang Lotz; Professor Elizabeth Pemberton, Latrobe University, Bundorra, Victoria, Australia; Dr. Gianna Piantoni De Angelis, curator of painting, Galleria Nazionale d'Arte Moderna, Rome; and Professor Marie Spiro, University of Maryland.

Decorating the New Basilica of Saint Peter

1 The Michelangelo–Della Porta Domes

The construction of the new basilica of Saint Peter, begun under Pope Julius II in 1506, took more than a hundred years to complete and involved the leading architects of the time, among them Donato Bramante, Antonio Sangallo the Younger, Michelangelo, Giacomo della Porta, and Carlo Maderno.[1] Michelangelo's dome was finished in 1590, thirty-six years after his death, and the nave and façade by Maderno were completed in the early 1620s. The new basilica was consecrated by Pope Urban VIII on 18 November 1626, on the 1,300th anniversary of the consecration of the old basilica built by Constantine.

During the construction of the new church, the old basilica was entirely destroyed, and the mosaic decorations that covered the façade, the nave, the apse, and the walls of many of the chapels were destroyed with it (*Figs. 1–3*).[2] Among the fragments that survive are a portion of the figure of Saint Paul from a fourth-century mosaic, formerly in the apse, and the head of Pope Gregory IX from the mosaic on the façade. A number of pieces from the mosaic decorations that covered the walls of the Oratory of Pope John VII also survive.

Perhaps the most famous mosaic in the old basilica was the *Navicella* (*Fig. 4*), designed by Giotto in the first decade of the fourteenth century and probably executed under his direction.[3] Originally, the mosaic was located on the east wall, the entrance wall, of the atrium of the church. On entering the courtyard from the outside one would have had to turn around to see the image. But upon exiting from

the basilica, one was unavoidably confronted by the scene of Christ walking on the storm-tossed waters of the Sea of Galilee about to support Saint Peter, who had ventured out of the boat, which holds the other apostles, to join him. The image is a symbolic representation of Christ sustaining a foundering church in its never-ending battle against persecution.

The *Navicella* remained in place until 1610, when the courtyard was torn down to make room for the new building. In 1619 it was restored by Marcello Provenzale and placed over a fountain near a door that gave access to the Vatican Palace. But Pope Urban VIII, in 1628, concerned that the mosaic was being ruined by the elements, had it moved inside the basilica and placed over the main door. In 1649 Pope Innocent X again had the mosaic placed outside, in the courtyard that was demolished in 1660 to construct the Scala Regia. At that time, Giotto's mosaic was destroyed. Only two fragments of angels from the border survive, one preserved in the Vatican Grottoes, the other in S. Pietro, Boville Ernica (Frosinone).

In 1628, before the *Navicella* was moved and placed over the central portal in the basilica, the Congregazione della Reverenda Fabbrica di S. Pietro consulted with Carlo Maderno, Gian Lorenzo Bernini, and the mosaicist Giovanni Battista Calandra. All three men agreed that moving the mosaic could damage it. Consequently, before it was taken down, a cartoon of the same size, design, and color as the original mosaic was made so that it could be reconstructed if it were damaged. Apparently the move was made without difficulty, but the idea was providential. On the basis of the existence of the cartoon, Orazio Manenti reconstructed the *Navicella* in 1674–75 for its present location in the lunette over the central portal in the portico of the basilica. Its present position is analogous to its original site, and if one looks up on leaving the church, it is the last image one sees before going out into the piazza.

Giotto's *Navicella* is an outstanding example of mosaics as the traditional medium for the pictorial decorations in S. Pietro in Vaticano. Through its vicissitudes it represents the actual transition of mosaic decorations from the old to the new basilica, and it underscores the continuity of traditional mosaic church decoration that existed in Rome from the fourth century on.

In 1578 Girolamo Muziano was commissioned by Pope Gregory XIII to decorate the first of the four minor domes and chapels of the new basilica. The pendentives, lunettes, and vault of the Gregorian Chapel, as it was later to be called, were to be covered with mosaics. Muziano designed the cartoons, supervised the making of the

mosaics, and created several important mosaic passages himself. The original pendentive mosaic of Saint Jerome was signed and dated by him in 1579.

Originally, the main dome and the four minor domes of the Michelangelo plan for the new basilica had been conceived as pure architectural forms devoid of painted or applied figurative decoration. The domes as executed by della Porta preserved their architectonic character, so the decision to decorate them was made essentially in contradiction to the intent of the two architects. But times had changed, and the needs of the Counter-Reformation Church in the last quarter of the sixteenth century superseded those of formal architectural purity. The Council of Trent in its last session in 1563 decreed that religious imagery complemented religious teaching and was effective in the Church's battle against Protestantism.[4] In direct opposition to Protestant iconoclasm, the Council of Trent insisted upon the efficacy of invoking and venerating sacred images, which it saw as teaching, confirming, and giving inspiration and example for a Christian life. In conformity with that decree, the new basilica of Saint Peter was to become a resplendent image of the legitimacy, authority, mystery, power, and grandeur of the true Church.

The decision to use mosaics as the decorative medium for the Gregorian Chapel was significant and decisive for the future decorative scheme of the new building. One of the forces that dictated the choice was the emphasis placed on Early Christian traditions by the new Catholic historicism, which was fostered within the Church by Philip Neri and advanced by the future cardinal Caesar Baronius in his sermons and writings.[5] In the 1560s, on the suggestion of Neri, Baronius had begun work on a history that would establish beyond a doubt the orthodoxy and authority of the Roman Church. The first volume of *Annales Ecclesiastici,* finished in 1579 and published in 1588, brought attention to the man and his work in papal circles. In 1580 Baronius prepared for Pope Gregory XIII a biography of Saint Gregory Nazianzus to commemorate the transfer of the saint's remains from the church of S. Marta in Campo Marzo to the Gregorian Chapel in Saint Peter's. Baronius's method was grounded in a search for historical authenticity as manifest in the writings of Early Christian historians, whose authority he accepted on the level of revealed truth. His respect for Early Christian writers extended to all things Early Christian. The discoveries of Early Christian archaeology were considered revelatory of a true and original Christian state, and Early Christian art was thought to be an aesthetic embodiment of pure and direct religious expression.

Because mosaics were the traditional Early Christian medium for church decorations, they were the obvious medium for the decorations in the new basilica. The

medium was dictated by historical precedence, justified theologically by contemporary writers, and, most important, sanctified by the existing Early Christian mosaic decorations in the apse and on the façade of the old basilica, which were still mostly intact and in place at that time.

Since the early fourteenth century, when the mosaic of Giotto's *Navicella* was made, the art of mosaics had declined in Rome, having been supplanted in good part by large-scale frescoes. The situation was such that in 1516 Raphael had to call the Venetian Luigi da Pace to Rome to execute the mosaics in the dome of the Chigi Chapel in S. Maria del Popolo (*Fig. 5*).[6] In the sixteenth century Venice was the one place in Italy were the art was still being practiced with some intensity and creativity. Consequently, in May 1578 Pope Gregory XIII appealed to the Venetian Nuncio to send him four of the best and most experienced men in Venice to work on the mosaics in the Gregorian Chapel.[7] The Nuncio could spare only one man from the work on S. Marco, and he could be released only for a short time.

The Venetian mosaicist, assuming he actually was sent to Rome, worked under Muziano, who had been trained in the Veneto and may have had some acquaintance with the techniques of mosaics. Muziano's skill matured quickly, no doubt from the close association with the Venetian, and before long he was an expert mosaicist. While working in the Gregorian Chapel, he had even developed a new oil-based mastic as a setting ground for the *tesserae* to replace the traditional plaster ground. The advantage of the new material was that it remained soft for three or four days and thus allowed the mosaicist more leisure and flexibility in the execution of his piece. Muziano's mosaics must have been similar to those made in Venice at the end of the sixteenth century. He used vitreous *tesserae* and decorated his pendentives with jewels, which must have given the mosaics a brilliant sparkling effect.[8]

From the time they were finished, the decorations in the Gregorian Chapel were heralded as extraordinary and unique. Raffaelo Borghini in 1584 said the mosaics were so beautifully done that they seemed to have been painted with a brush and colors, and Giovanni Baglione, in his biography of Muziano, praised the mosaics in the chapel as the most beautiful that had been executed since ancient times.[9] The impact of the decorations was so strong that they were accepted as the model for the decorations for the three other minor domes in the new basilica.[10]

Muziano's approach to mosaics called for the artist who designed the cartoon to maintain firm control over the making of the mosaic, often executing principal passages himself. The method assumed that artist-designer and mosaicist-craftsman would, at the very least, work closely together; ideally, they would be the same

person. Cesare Nebbia, Paolo Rossetti, and Giacomo Stella, among others who learned the art of mosaics in Muziano's studio while working under him in the Gregorian Chapel, also tended to favor this method. The practice continued in the execution of the mosaics for the pendentives of the dome of the crossing in 1598–99.[11] The pendentives representing the apostles John and Luke (*Pls. 67, 69*) were designed and executed in mosaic by Giovanni de' Vecchi, another Muziano disciple; those representing the apostles Matthew and Mark (*Pls. 66, 68*) were designed by Cesare Nebbia and made into mosaic by Nebbia and Paolo Rossetti. But the practice did not last; by 1601–2, during the decoration of the Clementine Chapel, it had already been superseded by a working method that was first developed during the late medieval period. This method separated the artist-designer from the mosaicist. Although the earlier practice endured for a few more years, the new method became standard for all the mosaic work done in the new basilica of Saint Peter after 1629, the year that work was begun on the Chapel of the Madonna della Colonna.

The decorations of the Clementine Chapel were designed by Christofano Roncalli, called "Il Pomerancio." The mosaics were made by a fairly large group of emerging professional mosaicists. Paolo Rossetti, Lodovico Martinelli, Ranuccio Semprevivo, and Marcello Provenzale represent a school of Roman mosaicists that in twenty years had grown from about a half-dozen men working with Muziano in the Gregorian Chapel into a highly trained core of mosaicists capable of the most complicated and exacting work.

The decorations of the four minor domes were thought of as a whole, but after the completion of the Clementine Chapel the work on the remaining two domes was postponed. At first perhaps, energy and money were being diverted to decorate the dome of the crossing. When that was finished in 1612, construction of the nave undoubtedly became the first priority. In any case, the mosaics in the dome of the Chapel of the Madonna della Colonna were not begun until 1629, and the scheme was not completed until 1757; those in the Chapel of Saint Michael were begun in 1631 and finished only in 1729. Nevertheless, the decorations are unified in appearance as well as iconographically.

The similarity of the decorations of all four domes resulted from a respect for, or at least an acknowledgment of, the existent architectural division of the surfaces of the domes. The sixteen ribs, the eight resulting wedge-shaped compartments, and the quadrangles and roundels set into each furnished the basic design within which the various individual schemes were developed. In the Gregorian and Clementine

chapels (*Pls. 36, 77*), for instance, the mosaics in the roundels are set well into the frame of the architectural form. In the Chapel of the Madonna della Colonna (*Pl. 72*), the roundels are treated as raised areas filled in by mosaics, and in the Chapel of Saint Michael (*Pl. 45*) there are three-dimensional stucco figures rather than mosaics in the roundels. The strong architectonic quality of the decorations is further enhanced by grounds of gold *tesserae,* which define the spatial limits of the structures even as those same structures tend to dissolve into light. The coherence of the decorations of the four minor domes is emphasized by the similarity of their designs to the scheme employed in the main dome of the crossing. All five domes function together visually, formally, and iconographically. In contrast, the six domes that flank the nave of the basilica belong to another sphere.

The Gregorian Chapel, the Clementine Chapel, and the Chapel of the Madonna della Colonna are all dedicated to the Virgin Mary.[12] The fourth chapel is dedicated to both Saint Petronilla and Saint Michael the Archangel. In the old basilica at least four chapels and oratories had been dedicated to the Virgin, and a chapel dedicated to Saint Petronilla existed more or less in the same location as that of the present chapel. There was a deliberate attempt to accommodate aspects of the old basilica into the new building, but instead of the rather random arrangements that had previously existed, tradition was organized into a coherent and comprehensive scheme. The role of Mary as *Virgo Filia-Sponsa-Mater Dei,* Mary as a cornerstone of the faith, Mary as the Church, is explicit in the veneration afforded her in the chapels that bulwark the crossing, the tomb of Saint Peter, and the main dome.

Sharing this position with her—though to a lesser degree, since they literally share a chapel—are Saint Petronilla, the legendary daughter of Saint Peter and patroness of France, and Saint Michael, the archdefender of the Church. The veneration of Saint Petronilla carries over from the old basilica the privilege long extended to France of maintaining a major altar in the church. The symbolism—as Petronilla is to Peter, so is France to the Holy See—extends to all the national churches of the world. The remains of Saint Petronilla are enshrined in the chapel, and the altarpiece (*Pl. 130*) and the two lunettes over it represent scenes from her life and death.

Saint Michael enjoyed a surge of popularity in the late sixteenth century. His role as the champion of God who battles against rebellious angels was reinterpreted in terms of the fight of the Church against Protestant heresy. Because he takes precedence over Saint Petronilla as the principal saint honored in the chapel, the chapel is

named for him alone. The vault (*Pl. 45*), which is dedicated to him, depicts a host of angels symbolizing aspects of the Heavenly Army under his leadership in its external conflict against the forces of evil. Along with the Virgin Mary, Petronilla as a "princess" of the Universal Church and Michael as "prince" of the heavenly host help sustain and bolster the faith.

In the Gregorian Chapel the presence of the Virgin Mary is alluded to by her symbols, which have been placed in the eight sections of the vault (*Pl. 36*): the Sun, the Cypress, the Temple, the Ark of the Covenant, the Moon, the Well, the Tower of David, and the Palm. In one pair of lunettes are the Virgin and the Angel of the Annunciation (*Pls. 41, 42*); in the other two (*Pls. 43, 44*) are images of the Old Testament prophets Ezekiel and Isaiah, with inscriptions alluding to the virginity and maternity of Mary. The principal altar in the chapel displays the image of the Madonna del Soccorso, which had been painted under Pope Pascal II and formerly had been preserved in the old basilica in the Oratory of Leo I. Allusions to the Virgin Mary also appear in the Clementine Chapel. In the lunettes (*Pls. 82–85*) is a representation of the Visitation, and the presence of Daniel and Malachi acknowledge the prophets who most exactly predicted the coming of Christ.

The vault of the Chapel of the Madonna della Colonna (*Pl. 72*) contains symbols of the Virgin Mary in the roundels and in the quadrangles above them. Among the sixteen hieroglyphics are the Lily, the Well, the Fountain, the Closed Gate, the Flowering Almond, the Tower of David, and the Cypress. In the lunettes are scenes of the Nativity with the Virgin and Child and the Dream of Saint Joseph. Narratively, the episodes represented in this chapel follow those placed in the Gregorian and Clementine chapels. The two prophets in the lunettes, David and Solomon, establish the holy genealogy of the Savior. The altar under the scenes of the Nativity and the Dream of Saint Joseph houses the image of the Madonna della Colonna, so called because the picture had originally been painted on a column in the old basilica.

The pendentives of all four minor domes of the new basilica depict images of Doctors and Fathers of the Church, titles bestowed on certain ecclesiastical writers, theologians, and philosophers to honor them for their important exposition on matters of faith and doctrine. Two Greek and two Latin Doctors or Fathers were chosen to support each dome. The distinction between the two titles rests in the fact that all Doctors are canonized saints, whereas technically, Fathers need not be canonized (although most of them in fact are).[13] Before 1568 there were only four Doctors, the Latin saints Ambrose, Augustine, Jerome, and Gregory the Great,

recognized by Pope Benedict VIII in 1298. In 1568 Pope Pius V recognized four Greek Doctors—saints John Chrysostom, Basil the Great, Gregory of Nazianzus, and Athanasius—and he added Saint Thomas Aquinas to the college. Pope Sixtus V in 1588 added Saint Bonaventure to the list, bringing the number of Church Doctors to ten. Since then, twenty have been added, the last being Saint Lawrence of Brindisi, nominated by Pope John XXIII in 1959.

The pendentives in the Gregorian and Clementine chapels portray the eight Doctors who had been designated by 1568. Those in the Chapel of the Madonna della Colonna represent saints Bonaventure and Thomas Aquinas and the Greek Doctors saints Cyril of Alexandria and John Damascene, only officially recognized by Pope Leo XIII in 1882 and 1890, respectively. In the Chapel of Saint Michael are the images of Pope Leo the Great, belatedly recognized as a Church Doctor by Pope Benedict XIV in 1754, and Saint Bernard of Clairvaux, nominated by Pope Pius VIII in 1830. The other two personages, Saint Denys the Areopagite and Saint Gregory Thaumaturgus, were never recognized as Doctors. They are the only two remaining Church Fathers represented in this exalted company.

That portraits of the Doctors and Fathers of the Church are included in the minor domes of the new basilica is another manifestation of the influence of Cardinal Caesar Baronius and the new Catholic historicism in establishing the iconographic program of the new building. Special devotional or dogmatic interest in the Virgin Mary is not implicit in the choice of the writers for the three Marian chapels. Nor is an alliance with angels or with Saint Michael or Saint Petronilla implied by the selection of the Church Doctors and Fathers represented in the Chapel of Saint Michael. The primary iconographic intent of the images is to demonstrate how the Church rests on the writings and dogmas of these men—that is, on a firm revelatory and historical foundation. A correspondence with the main dome of the basilica, which is supported by the four Evangelists, is intentional.

Another theme in the iconographic program for the center of the new basilica appears on the altars set into the back of the four piers of the main dome. Paintings representing saints Jerome and Basil the Great, designed by Muziano, had earlier been placed on the two altars of the Gregorian Chapel. On that basis, it would appear that a scheme had been developed around 1580 for connecting the pier altars in subject to the other decorations of the corner chapels. However, in about 1599 a change occurred, and it was decided that the remaining six altars would be decorated with a series of paintings devoted to Saint Peter. The subjects chosen

were Saint Peter healing the cripple at the Porta Spetiosa, the death of Sapphira, the martyrdom of Saint Peter, the fall of Simon Magus, Christ walking on the water, and the raising of Tabitha.[14]

The influence of Cardinal Baronius is again unescapable. In the late 1560s he had begun to practice a special devotion to Saint Peter as the symbol of Church unity and authority, making daily visits to the basilica in order to demonstrate his dedication to the saint and the papacy.[15] In *Annales Ecclesiastici,* one of the principal themes is the historical foundation for the legitimacy, authority, and sovereignty of the papacy through the mission vested in Peter by Christ.

The altarpieces, painted mostly on slate from 1599 to 1606, have fared badly, and we know five of the eight paintings today only from engravings. They had to be restored often, and finally in the eighteenth century they were replaced by mosaics. Even the iconographic integrity of the cycle was violated when, in about 1759, the mosaic after Raphael's *Transfiguration* replaced *The Crucifixion of Saint Peter* by Domenico Passignano, and when, in 1925, the mosaic representing the appearance of Jesus of the Sacred Heart to Saint Margaret-Mary Alacoque replaced the *Fall of Simon Magus* by Francesco Vanni.

In assessing the iconographic program for the new basilica of Saint Peter as it stood around 1600, five principal themes, with minor deviations, can be distinguished. The Marian theme was introduced in the Gregorian Chapel, carrying over into the new basilica the veneration of the Virgin Mary practiced in the old basilica. The theme was elaborated upon in two other minor domes, in the Clementine Chapel and in the Chapel of the Madonna della Colonna. In the fourth the Marian theme was usurped by a traditional commitment to the French national altar dedicated to Saint Petronilla, a commitment that was moderated by the principal dedication of the chapel to Saint Michael in response to the newly popular Counter-Reformation cult of the Archangel.

The theme of Christian historicism and the authority and revelation invested in Early Christian writers was represented in the images of the Church Doctors and Fathers on the pendentives of all four minor domes. Early Christian heroes as well were celebrated by the enshrinement of early saints and martyrs of the Church under the new altars of the basilica. Saint Gregory Nazianzus, Pope Gregory the Great, Pope Leo the Great, and Saint Petronilla were reinterred in the corner chapels during this period, giving expression to the idea that the Church rests on the bones as well as the thoughts of its early believers. The theme of papal authority

and legitimacy, developed about 1599, was expounded in the altarpieces for the six pier altars that had remained undecorated. The fifth theme, the Passion of Christ and his ultimate sacrifice, was advanced in 1606, when the Lance of Saint Longinus and the Holy Face were temporarily installed, together with the Head of Saint Andrew, in the niches in the upper part of the piers of the main dome.[16] These five themes culminate in the mosaic decorations executed at the core of the new basilica, in the vault of Michelangelo's dome.

The cartoons for the decorations of the main dome were designed by the Cavaliere d'Arpino, and the mosaics were executed from 1603 to 1612 by a number of prominent mosaicists. Among them were Paolo Rossetti and Marcello Provenzale.[17] Rossetti had been a student of Muziano and had learned the art of mosaics while working in the Gregorian Chapel. After Muziano's death, Rossetti pursued a career as a mosaicist, working with Cesare Nebbia on the mosaics of the figures of saints Matthew and Mark (*Pls. 66, 68*) in the pendentives of the dome of the crossing and participating in the execution of the decorations in the Clementine Chapel. In the vault of the main dome, Rossetti was responsible for the figures of Christ, Saint Thomas, and Saint Matthew (*Pls. 52, 54, 58*). Rossetti was a member of the Accademia di San Luca and the Congregazione dei Virtuosi al Pantheon. Among the other mosaics that he executed in Rome are those in the vault of the Caetani Chapel in S. Pudenziana (*Figs. 6–8*), an impressive ensemble made from cartoons by Federico Zuccari.

Rossetti is said to have been Marcello Provenzale's teacher. Like Rossetti, Provenzale was born in Cento, and the men were undoubtedly closely associated because of that alone. Provenzale's first documented work in Saint Peter's was on the pendentives of the main dome, where, in 1600, with Rossetti and Lodovico Martinelli, he executed some of the *putti* and decorative elements around the roundels representing the Evangelists. It must have been on that project, and not on the decoration of the Clementine Chapel, that Provenzale learned from Rossetti the art of mosaics. In the Clementine Chapel, Provenzale emerged as an independent and wholly proficient mosaicist. Alone, he made the pendentive mosaic representing Saint Ambrose (*Pl. 78*) and the lunette mosaic with Daniel in the lions' den (*Pl. 85*); he also contributed to the decorations in the vault. In the vault of the main dome of the basilica, he executed the figures of saints Philip, Andrew, and John the Evangelist (*Pls. 59–61*), as well as portions of the frieze in the drum.

From 1619 to 1621 Provenzale is named as *munizioniere* of the Fabbrica, which connects him with the making and distribution of *smalti* and *tesserae* for mosaics.

Although he lived until 1639, this seems to have been his last association with Saint Peter's. Provenzale was renowned as a master of small mosaic panels. The members of the Borghese family were his principal patrons, and for them he executed a portrait of Paul V, which has yet to be rediscovered, and many small panels, such as the mosaic of an owl and other small birds in a landscape with the Acqua Paola and the façade of Saint Peter's, signed and dated 1616 (*Fig. 9*), which Scipione Borghese sent as a gift to Ferdinand II of Florence.

From 1605 to 1608 and from 1608 to 1613, respectively, Andrea Aretino and Pietro Paolo Bernascone were the supervisors of the mosaic work done in Saint Peter's. The position at that time, however, was mostly concerned with perfunctory matters, such as work schedules and job allocations, and had nothing to do with artistic supervision. That was firmly in the hands of the Cavaliere d'Arpino, who apparently monitored the execution of the mosaics in the vault of the main dome from beginning to end.

In line with the decorations of the minor domes, the Cavaliere d'Arpino accepted the architectural control imposed by the structure of the main dome (*Pl. 50*). His designs fit into sixteen wedge-shaped compartments and respect the quadrangles, roundels, and lunettes. The result is a rigidly architectonic arrangement of shapes that function both vertically and horizontally. The pattern, however, is dominated by the figures in the second register, which are placed against gold backgrounds and thus create a ring of large colorful shapes that establish a horizontal pattern for the whole design. In this way, some concession was made to modern sensibility and to contemporary illusionistic dome and ceiling decoration.

A reading of the iconography of the decorations of the dome of the crossing begins with the pendentives portraying the four Evangelists in the roundels that rest on the papal emblems, the keys and the triple tiara, and that are flanked by angels displaying symbols of martyrdom and victory (*Pls. 66–69*). The pendentives support the monumental Latin inscription running around the base of the dome, which states, "You are Peter and on this rock I will build my Church and I will give to you the keys of the Kingdom of Heaven." On the lowest level of the vault (*Pl. 50*), in lunettes, are portraits commemorating the popes and bishops buried in the basilica, all of whom remain anonymous. Above them is an open field with full-length seated representations of Saint Paul, Saint Peter, the Virgin Mary, Christ, Saint John the Baptist, and the other eleven apostles. The third tier contains images of naked adoring angels. The three over the Virgin Mary, Christ, and Saint John the Baptist carry symbols of the Passion, the Cross, the Crown of Thorns, and the

Column. The top two rows show seraphim in roundels and, in the quadrangles, clothed angels in adoration. From the vault of the lantern, God the Father surveys the whole.

The iconographic themes of papal supremacy and legitimacy, the authority of Early Church historians and writers, the example of Early Christian saints and martyrs, Marian intercession, and the Passion of Christ are recapitulated in a major key here in the inside of the dome. On the outside, the structure grandly and majestically rises above Rome as a symbol of Christian and Catholic triumph over the pagan past. In the course of the seventeenth century most of these ideas were thunderously reproclaimed when Gian Lorenzo Bernini erected the baldachin, decorated the piers of the dome with monumental statues, and enshrined the Chair of Saint Peter in gold and bronze at the end of the apse.

2 The Vestibules of the Nave Chapels

Work on the mosaic decorations in the new basilica of Saint Peter was suspended until the construction of the façade and the nave of the new building were completed. When the decorations were resumed in 1629, work was begun in the chapels of the Madonna della Colonna and Saint Michael. Cartoons for the pendentives of both chapels (*Figs. 10,11*), as well as for the lunettes of the Chapel of the Madonna della Colonna, were painted by Giovanni Lanfranco, Andrea Sacchi, Giovanni Francesco Romanelli, and Carlo Pellegrini. The mosaics were made by Giovanni Battista Calandra and by Guido Ubaldo Abbatini, who finished Calandra's work on the pendentive of Saint Denys the Areopagite in the Chapel of Saint Michael and the lunette of King Solomon in the Chapel of the Madonna della Colonna.

Calandra was the chief mosaicist of the Reverenda Fabbrica di S. Pietro from 1629, when he was named superintendent of mosaics, until his death in 1644.[1] The mosaic studio was probably small, given the amount of work that was produced, and Calandra probably executed most of it. Little is known of the composition of the studio, since the documents credit Calandra alone for the work executed during his tenure. Calandra's own career, however, is easy enough to outline. Born in Vercelli (Piedmont), he went to Rome in 1602 at the age of sixteen. He studied with Marcello Provenzale and probably assisted in making the mosaics in the main dome of Saint Peter's, even though his name does not appear in the records.

Calandra's first important undertaking for the new basilica was a mosaic altarpiece after the Cavaliere d'Arpino's *Saint Michael the Archangel*—the first made for the church—commissioned by Pope Urban VIII in 1627 for the Chapel of Saint Michael. Calandra was a member of the Accademia di San Luca from 1630, and in 1643 he was elected to serve as *Principe* of that body. Throughout his career he made many portraits in mosaic, and he also restored ancient works, such as the Nile mosaic at Palestrina.

The decorations in the chapels of the Madonna della Colonna and Saint Michael were not completed during Calandra's lifetime. And in fact, by 1652, when the Chapel of the Madonna della Colonna still lacked decorations in the vault and only the pendentives in the Chapel of Saint Michael had been finished, the Fabbrica's attention had shifted to the chapels of the nave. Pietro da Cortona, the leading decorative painter of the day, was asked to design cartoons for the vestibules of the chapels of the Sacrament, Saint Sebastian, and the Pietà. He began with the chapels of the Sacrament and Saint Sebastian, and from 1652 to 1662 he painted thirty-two cartoons for both vaults, eight cartoons for the pendentives, and two cartoons for lunettes in the Chapel of Saint Sebastian. The other cartoons for the lunettes in the Chapel of Saint Sebastian and all six of the lunette cartoons for the Chapel of the Sacrament were painted by Raffaele Vanni between 1659 and 1663. The mosaics in both chapels were completed in 1663. Cortona had some trouble settling accounts with the Fabbrica for his work in the two chapels, and he was hesitant to begin work on the designs for the decorations for the Chapel of the Pietà until he had received satisfaction. It was late in coming, and only in the second half of 1668 did he begin work on the decorations for the Chapel of the Pietà. When he died in May 1669, Cortona left behind three unfinished cartoons for the dome. The commission passed to his student and helper Ciro Ferri, who started anew and provided the Fabbrica, from 1669 to 1681, with all the cartoons needed for the mosaic decorations of the chapel.

At about the same time, Carlo Maratti had been appointed to paint the cartoons for the Presentation Chapel. The commission was awarded to Maratti in about 1675, but he did not actually start work on the project until 1683. During the next six years he painted the cartoons for the pendentives and lunettes (*Figs. 12, 13*). Before Maratti began the cartoons for the vault, however, the Fabbrica asked him to help in the Chapel of the Choir. The commission had been awarded to Ferri, but when he died in 1689, work came to a halt. Maratti made enlargements of Ferri's cartoons of David and Jonah for the pendentives, and he painted the pendentive

cartoons of Daniel and Habakkuk himself. But at that point he was excused from working on the Chapel of the Choir so that he could finish the vault of the Presentation Chapel. Between 1703 and 1713, and with the assistance of Giuseppe Chiari after 1708, Maratti completed the cartoons for that project.

The mosaicist who emerged as the strongest personality during the third quarter of the seventeenth century was Fabio Cristofari.[2] He was appointed by the Fabbrica to succeed Guido Ubaldo Abbatini, who died in 1656.[3] At the time, Cristofari was a fully trained painter and mosaicist, and by 1658 he had become a member of the Accademia di San Luca. His first documented work in the basilica was done in the early 1660s, in the chapels of Saint Sebastian and of the Sacrament. In the 1670s and 1680s Cristofari became the foremost mosaicist at work in the basilica. He made all the mosaics in the Chapel of the Pietà, after Ferri's cartoons, from 1669 to 1681; and he made the mosaics in the pendentives and lunettes of the Presentation Chapel, after Maratti, from 1683 to 1689. In addition, he executed the mosaic altarpiece in the Chapel of the Crucifixion representing Saint Nicholas of Bari and the four altarpieces in the Grotto after Andrea Sacchi's pictures (*Pls. 122, 139–142*).

At this time, the mosaic studio was located in the basilica in the octagonal hall near the dome of the Clementine Chapel. The room is fairly small and could not have accommodated a large number of artists or a great deal of activity. Hence, the workshop that supported Cristofari's creative activities and provided all the help and services necessary for the execution of the mosaics must have been modest in scale, with Cristofari himself at its head and with a small number of artisans and artists as his assistants. This must have been more or less the type of arrangement that had been in force in the studio since 1629, when the decorations were resumed after the completion of the building. Leadership passed from Calandra to Abbatini and, after a short interlude from about 1656 to 1669—when a more communal arrangement allowed for Matteo Piccioni, Orazio Manenti, and Bartolomeo Colombo to share the creative work—to Cristofari.

Cristofari was succeeded by Giuseppe Conti.[4] In 1697 Conti asked the Congregazione della Reverenda Fabbrica to grant him some work as a mosaicist in the basilica. In response to his petition he was named to complete the mosaic decorations for the Presentation Chapel, a job that had been Cristofari's. Maratti's cartoons for the vault, however, were not begun until 1704, and in the meantime Conti made the mosaics for the four pendentives of the Chapel of the Choir. From 1704 to 1716 he made the bulk of the mosaics in the vault of the Presentation Chapel.

Up to this point in Conti's career, the organization of the mosaic studio remained stable. But after 1717 several mosaicists began to emerge from the anonymity of the studio, and recognition and payments for their work were accorded them as independent, professional artists working under the supervision of Giuseppe Conti. Ironically, it may have been for reasons of health or age that Conti admitted other mosaicists as near-equals during the last stages of the decorations in the vault of the Presentation Chapel. One by one, Leopoldo del Pozzo, Domenico Gossoni, Giuseppe Ottaviani, Matthia Moretti, Matthia de' Rossi, and Prospero Clori assumed their places among the artists employed by the mosaic studio of the Fabbrica. This new arrangement suffered a slight reversal in 1720, when Conti retired and was replaced by the painter Giuseppe Chiari, who oversaw the Presentation Chapel to its completion in 1725. But by that time the mosaicists had become accustomed to the system of independence and personal recognition, both artistic and financial, that had developed under Conti. They must have objected to not being able to supervise and be responsible for their own work and to having a painter rather than a mosaicist making final judgments and evaluations of their work.

From 1717 to 1723 Filippo Cocchi, Giuseppe Ottaviani, and Prospero Clori executed the mosaics in the vault and lunettes of the Chapel of the Choir. The cartoons for the vault and for four lunettes had been painted by Marcantonio Franceschini; the remaining two lunette cartoons were done by Niccolò Ricciolini. From about 1722 to 1726, Giuseppe Ottaviani made the mosaics in the lunettes of the Chapel of Saint Michael from cartoons by Bonaventura Lamberti, Lorenzo Gramiccia, and Marco Benefial; and from 1724 to 1726 Giuseppe Ottaviani, Liborio Fattori, and Giovan Battista Brughi executed Francesco Trevisani's cartoons for the pendentives of the dome of the Baptismal Chapel. On all of these projects the painters who had provided the cartoons were to evaluate the completed mosaics in conformity with a procedure established by the Cavaliere d'Arpino at the beginning of the seventeenth century. But the pattern had been broken under Giuseppe Conti and a new precedent was initiated whereby the mosaicists themselves, or at least the mosaic studio, were to be responsible for the final critical evaluation of the work.

In 1727 the new procedure was formalized with the appointment of Pietro Paolo Cristofari, Fabio's son and a mosaicist, as the director of the mosaic studio of the Reverenda Fabbrica di S. Pietro. He was followed in that position by Pier Leone Ghezzi, and under their supervision in the next thirty years most of the mosaic decorations yet to be done in the chapels of the basilica were completed. The

decorations in the vault of the Chapel of Saint Michael were made from 1726 to 1729 on the basis of cartoons by Ricciolini. From 1732 to 1746 Trevisani's designs for the lunettes and the vault of the Baptismal Chapel were executed; and from 1751 to 1757 the mosaics for the vault of the Chapel of the Madonna della Colonna, after the designs of Giacomo Zoboli, were completed.

The decorations of all six of the nave chapels in the new basilica were based on the designs that Pietro da Cortona had provided for the chapels of Saint Sebastian and the Sacrament (*Pls. 14, 15, 24, 25*). With its full baroque illusionism stemming from Giovanni Lanfranco's decorations in the dome of S. Andrea della Valle in Rome, the scheme is identical to the one Cortona employed for the fresco decorations in the dome of the Chiesa Nuova from 1647 to 1651 (*Fig. 14*). The principal figures in Cortona's domes, large in scale, are ringed around the base of the vault, creating a definite foreground plane of focus and narrative interest. The designs recall Correggio's decorations in S. Giovanni Evangelista in Parma, and they adapt the innovations Cortona introduced in his painted ceiling decorations in the Palazzo Pitti in Florence in the late 1630s and early 1640s. In the Chapel of Saint Sebastian (*Pls. 14, 15*), for instance, the composition in the vault centers on the figures of God the Father and the Mystical Lamb placed high on the central axis and foreground plane of the design. A large crowd of adoring martyrs is placed against a blue sky around the base of the vault. Behind the foreground ring, forms and figures gradually dissolve in the golden atmospheric haze of infinity. The domes designed by Ferri (*Pls. 1–3*), Maratti (*Pls. 99, 100*), Franceschini (*Pls. 86–88*), and Trevisani (*Pls. 109, 110*) for the other chapels of the nave adopt this model with only minor, personal variations in style. There is a span of about one hundred years from the time Cortona began the domes in the chapels of Saint Sebastian and the Sacrament to the time Trevisani completed the cartoons for the dome of the Baptismal Chapel, yet the decorations have a notable stylistic integrity, which is further enhanced by the uniformity of the textures and colors of the mosaics themselves.

The designs for all the pendentives were also established by Cortona's decorations. In the pendentives of the Chapel of the Sacrament (*Pls. 26–29*) he repeated along the edges of the triangles a garland motive that he had used in the pendentives in the Chiesa Nuova (*Fig. 15*). The motive reappears in the pendentives in the Chapel of the Choir (*Pls. 89–92*), and a variation of it appears in those of the Chapel of the Pietà and the Baptismal Chapel (*Pls. 4–7, 112–115*). In the Chapel of

Saint Sebastian (*Pls. 16–19*), Cortona employed an architectural molding, again adopted from the pendentives in the Chiesa Nuova, along the edge of the triangles. The same device is used in the pendentives in the Presentation Chapel across the nave (*Pls. 101–104*).

The baroque style of the mosaics in the domes of the six nave chapels, with its concern for realism, narration and illusionism, is quite distinct from the decorative, emblematic, and hierarchical style of those in the dome of the crossing and the four minor domes at the west end of the basilica. Moreover, this contrast in manner and appearance is underscored by a profound contextual shift. Whereas the earlier decorations were Counter-Reformational in spirit and expressed the concerns of the Church Militant, the decorations in the nave chapels herald and celebrate the Church Triumphant.

Five of the six domes illustrate quotations and episodes from the Revelation of Saint John the Divine. Interest in this book of the Bible had revived at the end of the sixteenth century, and new interpretations of the text were proposed, particularly by Jesuit scholars, in reaction against the exegesis of Protestant reformers.[5] Francisco de Ribera and Luís de Alcazar advocated a more literal reading of the text, in contrast to the allegorical and mystical interpretations that had dominated criticism in the fourteenth and fifteenth centuries. Consequently, they were responsible for recovering a method of exegesis that had been prevalent among Early Christian writers on the Apocalypse but subsequently had been ignored and then forgotten under the influence of more abstract, esoteric readings. The confessor and first biographer of Saint Theresa of Avila, Ribera published his commentary on the Revelation of Saint John in Salamanca in 1591; it was reissued in 1592, 1603, and 1623. Alcazar's book, first published in Antwerp in 1611, was dedicated to Pope Paul V; new editions followed in 1619 and in 1631.[6]

The method of interpretation that Ribera and Alcazar employed in their commentaries was derived from the historical approach Cardinal Baronius was taking in *Annales Ecclesiastici*. Like Baronius, the Spanish Jesuits sought precedence and consequently revelation and truth among Early Christian writers and in contemporary sources. Ribera and Alcazar attempted to understand the Revelation of Saint John from the point of view of the author and to relate episodes in the book to contemporary events. They identified Babylon as heathen Rome and saw Christian Rome as a fulfillment of divine prophecy. Alcazar contended that the Millenium, the thousand-year reign of Christ, had begun with the conversion of Constantine,

thereby associating Christ's reign on earth directly with the Church of Rome and the papacy.

The Revelation of Saint John is generally understood to contain a message of consolation and encouragement.[7] Followers of Jesus must go through a period of great tribulation, many will suffer martyrdom, and the Church itself will be subject to vicious attacks—all this has been foreseen and preordained. But in the end the Church, with Christ at its head, will be victorious, and the forces of evil will be vanquished. For the sixteenth- and seventeenth-century theologian the war against the Antichrist in his contemporary guise as Protestant was one of a number of battles the Church must wage before its ultimate glorious victory against Satan. And just as the final victory is assured, so is the outcome of the present engagement beyond doubt. The Church was, is, and will be triumphant.

In the mid-seventeenth century the triumph of the contemporary Church was manifest, and for the decorations of five of the nave chapels reference to the Apocalypse was made to reveal to all who entered the new basilica that Jesus the Lamb, the Son of God, is the Savior and the Redeemer and that his Church will endure all tribulation in triumph to the end of time. The specific theme for each of the chapels appears in an inscription around the base of the lantern. In the Chapel of the Pietà the Latin inscription reads: "Do not harm the servants of our Lord till we have sealed them upon their foreheads." Four angels at the corners of the world hold back the winds, while other angels mark those who have been chosen (*Pls. 1–3*). The theme is further elaborated in the pendentives (*Pls. 4–7*), where the concept of redemption is related to the four covenants God had made with man. The covenants with Noah, Abraham, and Moses suggest stages in the dispensing of grace upon the people of Israel, while the presence of Jeremiah alludes to the New Covenant that he prophesized and which came to fulfillment with the coming of Christ.

The New Covenant theologically is the covenant "of the fulness of time, of the consummation of the ages, and for this reason the everlasting covenant."[8] It is apocalyptic in nature and thus unequivocally links the personages represented in the pendentives to the scene in the vault. The two lunettes set over the entrance to the chapel proper, containing the images of the Cumaean and Phrygian sibyls (*Pls. 10, 11*), invoke the reign of Christ. The sibyls prophesized, respectively, his birth and his resurrection. The four Old Testament prophets in the other lunettes (*Pls. 8, 9, 12, 13*) refer to other instances of the covenant either having been broken (Zechariah and Amos) or reestablished (Hosea and Isaiah) by God with his chosen people.

The Chapel of Saint Sebastian is dedicated to the martyrs: "These are they who have come out of the great tribulation; they have washed their robes and made them white in the blood of the Lamb" (Rev. 7:14). In the vault (*Pls. 14, 15*), God the Father sits enthroned, with the Mystical Lamb on his right, in the presence of a great multitude in prayer and adoration crying out, "Salvation belongs to our God who sits upon the throne, and to the Lamb" (Rev. 7:10). The pendentives (*Pls. 16–19*) depict Old Testament martyrs: Abel, the first martyr, killed by his brother Cain because of the preference God showed him; Zechariah, son of the high priest Jehoiada, who was stoned in the atrium of the Temple of Jerusalem for his evangelical zeal; and the prophets Isaiah and either Jeremiah or Ezekiel, who were martyred for their passionate dedication to God. The lunettes (*Pls. 20–23*) contain episodes of martyrdom from the Old Testament, four from the Book of Maccabees and two from the Book of Daniel—Daniel in the lions' den and the miracle of the fiery furnace, wherein men are delivered from death because of their faith. On the altar in the chapel, *The Martyrdom of Saint Sebastian* (*Pl. 124*) focuses the theme of all the decoration upon the Roman soldier who died for a Christian Rome.

The Chapel of the Sacrament holds the Holy Eucharist. The inscription around the base of the lantern is adapted from the verse that alludes to the mysteries of the Mass: "The smoke of the incense rose with the prayers of the saints from the hand of the angels, before God" (Rev. 8:4). In the presence of a multitude of saints and martyrs, an angel fills a golden censer with incense and, with the prayers of all the saints, offers the smoke at the altar before the throne of God (*Pls. 24, 25*). The prayers and incense mingle and rise as an offering to the Eternal God. In the pendentives (*Pls. 26–29*), the elements of the Eucharist are embodied in depictions of King Melchizedek, who made an offering of bread and wine to God in thanksgiving for Abram's victory over Chedonlaomet; Elijah provided with bread by an angel; a priest dispensing the ceremonial bread from the Golden Table; and Aaron collecting manna for sacrifice.

The scenes in the lunettes (*Pls. 30–35*), also episodes from the Old Testament, contain direct references to the bread and wine of the Holy Eucharist—the offering of the first fruits of the grain harvest to God and the large bunch of grapes brought back after the reconnaissance into Canaan. The purging, purifying, and restorative nature of the Holy Eucharist is implied by the angel about to touch Isaiah's mouth with a live coal, and by Jonathan eating the honey, which made him see clearly. The terrible consequence for those who dare to defile the Holy Eucharist is made vivid by recalling how Uzzah, the son of Abinadab, was struck dead by God for touching

the ark, even though he merely meant to prevent it from tipping. The power of the presence of God in the Holy Eucharist is manifest in the shattered image of Dagon, the principal deity of the Philistines, who could not withstand the emanation of the one true God.

The episode illustrated in the dome of the Chapel of the Sacrament is similar to that in the dome of the Chapel of the Choir (*Pls. 86–88*), directly across the nave:

> And between the throne and the four living creatures and among the elders, I saw a Lamb standing, as though it had been slain, with seven horns and with seven eyes, which are the seven spirits of God sent out into all the earth; and he went and took the scroll from the right hand of him who was seated on the throne. And when he had taken the scroll, the four living creatures and the twenty-four elders fell down before the Lamb, each holding a harp, and with golden bowls full of incense, which are the prayers of the saints (Rev. 5:6–10).

The theme of giving thanks to God in songs and hymns is stated in the inscription: "They fell down and worshipped the One who lives." The four prophets represented in the pendentives, Habakkuk, Daniel, David, and Jonah (*Pls. 89–92*), are remembered here for the songs of praise and thanksgiving offered to the Lord for their salvation. In the lunettes, scenes with Deborah and Barak, Judith, and Jeremiah (*Pls. 93, 94, 97, 98*), further illustrate that theme.

Two lunettes, *Moses Praying to God Supported by Aaron and Hur* and *Azariah Rebuking King Uzziah* (*Pls. 95, 96*), seem less concerned with giving expression to the theme of praising the Lord through song than with depicting the rights and privileges of the priesthood and the Church, the exclusiveness of ecclesiastical functions. Since the Chapel of the Choir belongs to the Canons of Saint Peter's, the ecclesiastical theme of the two scenes is appropriate. Originally, however, *Miriam Singing and Dancing in Thanksgiving for the Safe Passage through the Red Sea* and *Hannah Dedicating Samuel to God* (*Figs. 16, 17*), episodes directly related to the theme of singing praises to the Lord, were intended for those two lunettes. The alteration, which occurred in 1720, is a deviation from the consistency and integrity of the original program.

"He has respected the low estate [of his handmaid] and He has scattered the proud" reads the inscription around the base of the lantern in the Presentation Chapel. The phrase is adapted from the canticle Mary sings to the Lord on her visit to Elizabeth (Luke 1:48, 51). However, the scene in the vault (*Pls. 99, 100*), which shows "a woman clothed with the sun, with the moon under her feet, and on her

head a crown of twelve stars" together with "a great red dragon, with seven heads and ten horns, and seven diadems upon his heads," illustrates the episode in the Revelation of Saint John (12:1–9) wherein the woman is rescued by God from the dragon and the monster is cast out of heaven by the avenging angel. A connection between the Virgin Mary and the Woman of the Apocalypse is rarely encouraged in the exegesis of this passage. Rather, the Woman is understood as a symbol of the Church. But since the Virgin Mary as well is seen as a symbol of the Church, the distinction becomes dim in the casual perception of most believers.

In the Chapel of the Presentation the distinction is further obscured by the subject of the altarpiece, which depicts the presentation of the Virgin as a child to the temple (*Pl. 149*), and by the name of the chapel itself. That the chapel is not dedicated to the Virgin Mary is made clear by the references contained in the pendentives and lunettes. The main theme of the chapel is God's deliverance of the Church from persecution; the scenes that decorate it depict Aaron forestalling the plague with incense, Noah surviving the flood, Gideon's victory over the Midianites, and Balaam prophesying to Balak, King of Moab, that a "star from Jacob" will assume the leadership of Israel and overcome (*Pls. 101–104*). The episodes in the lunettes (*Pls. 105–108*) show how God will destroy the enemies of the Church as he, through Judith, Jael, Moses, and Joshua, destroyed the enemies of Israel. It also shows how the Church will be delivered and righteousness triumph, as it was proclaimed to Moses in the burning bush and through the prophet Isaiah (45:8), who writes:

> Send victory like a dew, you heavens,
> and let the clouds rain it down.
> Let the earth open
> for salvation to spring up.
> Let deliverance, too, bud forth
> which I, Yahweh, shall create.[9]

The Baptismal Chapel is the only nave chapel in which the decorative program is not connected to the Revelation of Saint John. The inscription, "He who believes and is baptized will be saved," is from the Gospel According to Saint Mark (16:16). Depicted in the vault (*Pls. 109–111*) are the three modes of baptism—by water, by blood, and by desire. In the pendentives, the four parts of the world—Europe, Asia, Africa, and America (*Pls. 112–115*)—show how salvation through Christ has spread to all the people of the earth. The lunettes represent various aspects of baptismal

doctrine and scenes of early baptism (*Pls. 116–121*): the baptisms of Saint Peter, Constantine, and the Centurion Cornelius, the eunuch of Queen Candace; Noah praying before the rainbow of the covenant; and Moses striking water from the rocks. The scenes of the baptisms of Saint Peter and Constantine, placed over the entrance to the chapel proper, serve to remind the worshipper anew of the authority and legitimacy of papal Rome. One reason the program for the decorations of the Baptismal Chapel had to be treated separately from that of the other nave chapels was because baptism, specifically, does not appear in the Revelation of Saint John. However, the decorations are still intimately connected to those of the five other nave chapels through the dominant themes of salvation and triumph.

Along the nave, from the entrance of the basilica to the altar, additional associations link the chapels laterally as stages in a pilgrim's progress, from initiation to ultimate, everlasting triumph in Christ. The reading is supported by a decorative scheme that in its details—the framing elements of the pendentives and the stucco designs around the bases of the lanterns—reinforce the lateral connections of the chapels. The Chapel of the Pietà and the Baptismal Chapel depict Old and New Testament covenants that secure the redemption of the faithful. The sealing and baptism serve the same purpose: to mark the faithful as God's property, to protect them against demons, and to ensure their salvation.[10] The Chapel of Saint Sebastian and the Presentation Chapel are testimony to the persecutions and tribulations that the Church and its martyrs must suffer in time. The Chapel of the Sacrament and the Chapel of the Choir manifest the heavenly rewards, the glories and mysteries of the Lamb and the External God, which are accessible only through sacrifice. The journey leads to and culminates at the high altar, the sacramental core of the basilica, where the greatest of all sacrifices, Christ's supreme sacrifice in the form of the Mass, is performed by his vicar on earth, the pope.

By the fall of 1757 the mosaic decorations in all the domes of the new basilica of Saint Peter were completed. From the beginning they had entailed a great deal of maintenance and restoration, and the mosaicists were constantly occupied with patching and redoing sections that had crumbled or calcified. A complete restoration was begun in the mid-1760s in the Gregorian Chapel to repair the mosaics in the vault, the lunettes, and the pendentives. New cartoons were painted after Muziano's original designs by Nicola LaPiccola and Salvatore Monosilio, director of the mosaic studio from 1755 to 1776. By the time the decorations in the Gregorian Chapel were unveiled in August 1779, two hundred and one years had passed since

Muziano had begun the original mosaics in the same chapel. The mosaic studio of the Reverenda Fabbrica di S. Pietro had become the foremost mosaic school in Europe, and examples of its work were prized throughout the world. The mosaics executed in the domes of the new basilica, however, were to be unique. The studio had been created by the specific demands of time and place, and it had had its finest hour in fulfilling those demands.

3 The Evolution of the Altarpieces

The first mosaic altarpiece in the new basilica of Saint Peter, *Saint Michael the Archangel,* was made by Giovanni Battista Calandra in 1627–28 after a cartoon by the Cavaliere d'Arpino. The work was commissioned by Pope Urban VIII as an experiment. The humidity in the old building apparently had wrecked havoc on pictures executed on canvas and wood, and it was imperative to find an enduring medium for the altarpieces in the new basilica. Slate was tried for some of the pieces for the pier altars, all of which were finished by 1606, but it proved to be disastrous; in less than twenty years the pictures were in sad decay and either had to be restored or replaced. Since mosaics were considered durable and especially resistant to the elements, the medium provided the ideal solution. Mosaics had proven to be effective decoratively and technically in the main dome and in the domes of the Gregorian and Clementine chapels. In addition, mosaics were sanctioned by Early Christian usage.

Calandra's altarpiece was received with a great deal of applause by the pope, the Cavaliere d'Arpino, and the many people who came to view it. But when the suggestion was made by the Congregazione della Reverenda Fabbrica that all the altarpieces in the new basilica be made in the same medium, enough objection was raised that Pope Urban VIII finally rejected the idea.[1] Mosaics the size of altarpieces were expensive to make, and there were complaints both by Calandra, who thought he had been underpaid for his work, and by some cardinals, who thought a

medium other than mosaic would be cheaper and perhaps better. Some preferred marble reliefs, and others suggested that as pictures deteriorated they should be replaced with new ones by new artists so that there would always be something modern and original on the altars. Some cardinals objected to the shiny surface of the mosaic panel and complained that the picture was difficult to view because of the glare. Others warned that the single advantage of mosaic altarpieces derived from their rarity; too many throughout the basilica would reduce their effect. Nothing was resolved, and altarpieces on canvas continued to be commissioned.

In the remainder of the seventeenth century, only five more mosaic altarpieces were made, all of them by Fabio Cristofari in the 1680s: the four pieces on the altars in the Grotto under the piers to the dome (*Pls. 139–142*), after canvases painted by Andrea Sacchi from 1633 to 1650, and an altarpiece representing Saint Nicholas of Bari for the Chapel of the Crucifixion (*Pl. 122*). This activity signals a less hostile attitude toward the use of mosaic altarpieces in the basilica, but it was short-lived. In 1711, while Filippo Cocchi was working on the mosaic after Valentin's *Martyrdom of Saints Processus and Martinianus* (*Pl. 127*), the Congregazione della Reverenda Fabbrica remarked, in a resolution on the price and the time schedule for Cocchi's piece, that at that time there were only two other mosaic altarpieces in the basilica proper—*Saint Michael the Archangel* by Calandra (*Pl. 129*) and *Saint Nicholas of Bari* by Fabio Cristofari (*Pl. 122*).

The turning point occurred in the 1720s with Pietro Paolo Cristofari's commission for a mosaic altarpiece after Lanfranco's *Navicella* (*Pl. 133*). The work was a great success, and as a result, in July 1727, Pietro Paolo was appointed director of the Vatican Mosaic Studio and put in charge of all the mosaic work for the domes and altars in the basilica.[2] The decision to proceed with the plan of having all the altarpieces for the basilica done in mosaic apparently had been made by the Fabbrica quietly, perhaps even casually, in the mid-1720s. The deciding factor must have been the emergence of Pietro Paolo as an extremely talented and skilled mosaicist capable of organizing, directing, and executing large-scale works.

In addition, there were other pressures. The mosaic decorations in the domes were nearing completion at a time when the mosaic studio was still vital and creative. The mosaicists were seeking other professional outlets for both expressive and financial reasons, and they saw the altarpieces as a natural, almost inevitable direction for their art to take. The Congregazione della Reverenda Fabbrica recognized the unique and valuable resource it possessed in the mosaic studio, and it was anxious to continue to take advantage of the mosaicists' talents. A good deal of

work had yet to be done in the basilica, and the Congregazione must have felt that much of it could be done extremely well by the mosaic studio. Behind these immediate aesthetic and political factors, however, there were also the traditional ideas about the permanence of mosaics and their association with Christian antiquity. And finally, mosaics were considered a "new" and "modern" medium. Expensive, elitist, elegant, and fashionable, they expressed the corresponding qualities in an eighteenth-century aesthetic sensibility.

Pietro Paolo Cristofari was officially the first director of the mosaic studio. His appointment formalized the structure, organization, and working methods that had been followed for about fifty years, since the time his father, Fabio, had been head of the shop. When Pietro Paolo assumed control in 1727, the members of the mosaic studio were fairly independent artists who had begun to achieve individual recognition and reward for their work. During Pietro Paolo's tenure, this trend continued, at least with regard to the decorations being done in the domes of the basilica. However, he seems to have taken literally the diction in his letter of appointment, which made him *sopraintendente e capo* of all the mosaic artists who were working in the basilica, and he kept tight, and at times tyrannical, control of their work. From 1726 until his death in 1743, Pietro Paolo made for the new basilica of Saint Peter seven mosaic altarpieces, and he completed another three that had been begun by Giovan Battista Brughi.

Pietro Paolo worked exclusively on altarpieces and restricted to a supervisory role his involvement with the decorations that were being executed in the domes of the Baptismal Chapel and the Chapel of Saint Michael. Among the mosaics he made are *The Presentation of the Virgin* (*Pl. 149*) after Giovanni Francesco Romanelli, *The Burial of Saint Petronilla* (*Pl. 130*) after "Il Guercino," *The Martyrdom of Saint Sebastian* and *The Last Communion of Saint Jerome* (*Pls. 124, 131*) after Domenichino, and *The Martyrdom of Saint Erasmus* after Nicolas Poussin (*Pl. 128*). He also executed in 1742, on the basis of a painting by Ignazio Stern, the mosaic portrait of Maria Clementina Sobieska, the wife of James III of England, for the monument located in the aisle between the Baptismal and the Presentation chapels (*Fig. 18*).[3] At one point late in his career, Pietro Paolo was accused of never doing his own work, of charging large fees, and of sharing neither fame nor money with those who deserved them.[4] The accusation may be somewhat unjust, but it has some credibility, since Pietro Paolo's name alone appears in the records of payments he received for his altarpieces, even though he must have had professional assistance.

Although the idea for mosaic altarpieces for the new basilica goes back to the

early seventeenth century, the mosaics themselves are almost entirely an eighteenth-century artistic and decorative phenomenon. Work continued after Pietro Paolo Cristofari's death, and by the end of the century most of the altarpieces for the church were finished. The mosaics executed during the third quarter of the century include *The Mass of Saint Basil* (Pl. 132), finished in 1751, *Saint Peter Healing the Cripple at the Porta Spetiosa* (Pl. 135), finished in 1758, *Saint Michael the Archangel* after Guido Reni (Pl. 129), finished in 1758, *The Raising of Tabitha* (Pl. 134), finished in 1760, *The Transfiguration* after Raphael (Pl. 138), finished in 1767, and *Saint Gregory and the Miracle of the Corporal* (Pl. 147), finished in 1772. In contrast, in the last quarter of the century only two mosaic altarpieces were made, *The Crucifixion of Saint Peter* (Pl. 145) after Reni for the sacristy, from 1779 to 1784, and *The Ecstasy of Saint Francis* (Pl. 125) after Domenichino, from 1775 to 1801.

Since 1767, the mosaic studio had been located in the Court of the Belvedere in a place called the "fonderia" because Bernini had cast the *Cathedra* there. During the French occupation at the end of the century, it was moved to the Palazzo del Santo Uffizio. In 1814, after his return to Rome, Pope Pius VII moved the studio into the Palazzo Giraud, presently the Palazzo Torlonia, and in 1825 Pope Leo XII finally reestablished it in the Vatican in a gallery adjacent to the Court of Saint Damasus, where it remained until 1931. These disruptions, occasioned and compounded by the Italian political situation, contributed to delays in the completion of two mosaic altarpieces for the basilica—one after Vincenzo Camuccini's *Incredulity of Saint Thomas* (Pl. 143) and the other after Caravaggio's *Entombment of Christ* (Pl. 146), each of which took more than ten years to make. Since 1825, only four new mosaic altarpieces have been executed for the basilica. The last, *Saint Joseph Patron of the Universal Church* (Pl. 144), commissioned by Pope John XXIII, was completed in 1963.

4 The Art of Post-Renaissance Mosaics

From the late sixteenth century on, the method of creating the mosaics in Saint Peter's remained essentially unchanged. The first step was the making of the preparatory paintings, or cartoons. Most often these were commissioned from well-known artists outside the mosaic studio, but in some instances, such as Muziano's decorations in the Gregorian Chapel, mosaicists were called upon to create their own designs. In working up the designs for a dome and its lunettes and pendentives, an artist would sketch his ideas and submit them to the Congregazione della Reverenda Fabbrica di S. Pietro for approval. Then he would paint the full-sized cartoons, which would serve as working models for the mosaicists. The cartoons for the vaults were painted in sixteen pieces; each lunette and pendentive was painted in one piece. The cartoons painted by the Cavaliere d'Arpino for the vault of the main dome were done in tempera on canvas, but in the course of the seventeenth century the standard medium for cartoons became gouache on canvas.

At the beginning of the eighteenth century the Congregazione recognized that the cartoons could be used to decorate churches, palaces, and other buildings that belonged to the Holy See after the mosaicists were finished with them. It found, however, that the cartoons painted in gouache were unstable and needed constant restoration, so it decreed that all cartoons made for mosaics be painted in oil.[1] At the same time, the Congregazione prescribed that each cartoon be painted in sections, so that two or three pieces comprised a whole picture that could then be used

as a decoration in another location. Francesco Trevisani's cartoons for the Baptismal Chapel, now hanging in the church of S. Maria degli Angeli in Rome, were the first to conform to this new format. After 1727 the church of S. Maria degli Angeli also received a number of altarpieces from the basilica after they were executed in mosaics. The cartoons for the altarpieces were of various types. Some were paintings executed specifically for the mosaicists, such as Pierre Subleyras's *Mass of Saint Basil* (*Fig. 19*). Others were copies painted after pictures on various altars in the basilica, such as Giovanni Lanfranco's *Navicella* or Romanelli's *Presentation of the Virgin,* or of pictures in other locations, such as Raphael's *Transfiguration* or Domenichino's *Martyrdom of Saint Sebastian* (*Fig. 20*). Often in the later case it was necessary to scale the cartoon copy of the picture to its new site. In some cases, particularly for the altars in the transepts, no cartoons as such were made, and the mosaicists worked directly from the paintings.

In the mosaic studio a tracing of the cartoon design was made and subsequently divided into a number of sections according to the size of the work. Whether a piece was executed entirely by one mosaicist or by several, the following method was employed for each section of the work. The bottom of a wooden frame of the appropriate size was spread with a layer of mastic and the tracing was placed upon it; the corresponding section of the cartoon was attached to a stand behind it. Using the tracing as a guide for forms and shapes and the cartoon as a guide for color and shading, little pieces of enamel, the *tesserae,* were applied to create the image. When the section was finished, a piece of gauze was glued on top of it to hold the *tesserae* firmly in place. The mosaic was then detached from the frame and turned upside down so that all the mastic on the back could be removed. After it had been cleaned, the mosaic was ready to be set in place either as a section of an altarpiece or as a portion of a dome or wall decoration.

The foundation of the mosaic altarpiece and the dome decorations was a slab of peperino or travertine. It was covered with a layer of plaster on which the design was traced to serve as a guide for the placement of the mosaic sections. The plaster was scored and an oil-based mastic, often tinted with an encaustic mixture to match the *tesserae,* was applied to a small area at a time as the mosaics, gauze side up, were set onto the surface of the stone. When the mastic was dry, the gauze was removed and the surface was retouched, cleaned, and polished.

The uniqueness of the mosaic style developed by the Vatican Mosaic Studio results from the use of an opaque enamel *tessera* in virtually an unlimited range of colors. Alessio Mattioli, who was in charge of the production of the *tesserae* for the

mosaic studio from about 1730 to 1750, is often credited with invention of this medium in 1731.[2] However, opaque enamel *tesserae* had been used as early as 1600 in the decorations of the main dome, and Mattioli's contribution must be seen more modestly, in terms of improvement and refinement rather than invention. He created a *tessera* in a new color, *porporino,* a rich and unique shade of red, which was prized by the mosaicists; and under his direction the studio could boast of having more than 15,000 tints at the disposal of its artists. Since the mid-eighteenth century the number has increased to more than 28,000.[3] In addition to flat rectangular *tesserae,* the studio also developed a type of enamel, called *smalti filati,* produced in thin strips that allowed the mosaicist great freedom and versatility in composition.

Since the early Renaissance, mosaics and painting became increasingly concerned with volume, space, and three-dimensionality. Symbolism and stylization were replaced by a narrative, didactic emphasis that was realistic and empirical in its imitation of nature. In the case of mosaics, the new development received strong support from the example of realistic ancient Roman mosaics, which were concerned with naturalism and illusionism. Successive phases in the development of the Renaissance style in mosaics can be seen in the series on the life of the Virgin by Pietro Cavallini in S. Maria in Trastevere in Rome, and in the series by Jacopo Torriti in S. Maria Maggiore from the late thirteenth century (*Figs. 21, 22*); in the mosaics executed in the basilica of Saint Mark's in Venice in the first half of the sixteenth century, particularly those after the cartoons by Titian, Tintoretto, and their followers (*Figs. 23, 24*), and in the mosaics in the vault of the Chigi Chapel in S. Maria del Popolo in Rome (*Fig. 5*), executed by the Venetian Luigi da Pace in 1516 after Raphael's designs[4]; and in the mosaics after cartoons by the Cavaliere d'Arpino in the vault of the main dome of the new basilica of Saint Peter (*Pl. 50*). As the style matured, it turned more and more to painting for guidance, since painting had so successfully solved the problems of illusionism and realism, which the contemporary aesthetic demanded. Painting became the ideal toward which mosaics aspired, but that aspiration would not have been possible without the thousands of different colored *tesserae,* which permitted an exact imitation of the tonal range found in painting.

The mosaics executed in the nave chapels of the new basilica of Saint Peter were meant to be mistaken as paintings, but they were not to be seen merely as slavish copies *after* paintings. The decorations had been conceived as mosaics. The cartoons

by Pietro da Cortona or Carlo Maratti were made exclusively as cartoons for mosaics following a practice in vogue since the late Middle Ages, when the functions of designer and mosaicist were separate. Although the designs are modern and reflect contemporary aesthetic standards and taste, the intention in all cases was not to reproduce paintings but to create mosaics. What makes the mosaics so distinctive, and makes them appear to be different from all earlier mosaics, is that they embody almost ideally the contemporary baroque conceit of illusionism.

From a distance, the viewer accepts the mosaics as paintings, admiring them for their pictorial qualities and responding to them aesthetically and emotionally. As the viewer comes closer, though, he realizes that the pictures are not paintings, that the boundaries of reality and illusion are even more tenuous than they first appeared. What was originally seen as a fresco or oil painting, in which the activities and actions portrayed belong as easily to fiction or reality, becomes upon closer inspection something more amazing—a mosaic. As the viewer perceives the conceit, he understands, to his delight, that what he is looking at is a mosaic giving the illusion of a painting giving an illusion of the real.

Altarpieces are a somewhat different matter. The first mosaic altarpiece for the new basilica was conceived and executed as a mosaic. The Cavaliere d'Arpino's cartoon served as a model for Calandra's mosaic of Saint Michael commissioned by Pope Urban VIII. But by the end of the seventeenth century there had been a decided shift in emphasis. Mosaic altarpieces were specifically being copied from paintings. Fabio Cristofari's mosaics were copied from Sacchi's altarpieces in the Grotto. The distinction between the two types of mosaics—those conceived as mosaics and those that reproduce a work in another medium, even though both start with a cartoon as the model—is that the second type is based on a "cartoon" of an existing work, a work that is autonomous. The mosaic is simply a translation of that work into a different medium. All of the mosaic altarpieces in the basilica are of the second type. In the eighteenth century decaying altarpieces in the basilica and other masterpieces of Italian art were reproduced in mosaic for the altars. Even in cases where new pictures were painted—such as Subleyras's *Mass of Saint Basil* (Fig. 19) or Vincenzo Camuccini's *Incredulity of Saint Thomas* (Fig. 25)—the cartoons were thought of as autonomous works, and the altarpieces were considered transcriptions of them into mosaic.

In January 1770, as the decorations in Saint Peter's were being completed, the Congregazione della Reverenda Fabbrica proposed that unemployed mosaicists be

put to work on the mosaic altarpieces for the Sanctuary of the Holy House of Loreto.[5] This project extended well into the nineteenth century, and it firmly established for the Vatican Mosaic Studio the practice of executing paintings in mosaics. The first phase of the project dated from shortly after 1770 to 1788 and included mosaics after Federico Barocci's *Annunciation*, originally in Loreto and now in the Vatican Picture Gallery, his *Visitation* in the Chiesa Nuova, Rome, and Annibale Carracci's *Birth of the Virgin*, once in Loreto and now in the Louvre.[6] In 1788 and 1789 new contracts were made for, among other pieces, mosaics after Carlo Maratti's *Immaculate Conception* in S. Isidoro Agricola, Rome, and Domenichino's *Ecstasy of Saint Francis* (*Pl. 125*) and Guido Reni's *Saint Michael the Archangel,* both in S. Maria della Concezione in Rome, all of which were finished by the end of 1790.[7] Among the altarpieces made from 1790 to 1845 were mosaics after Maratti's *Wedding of the Virgin,* formerly in the Chapel of Saint Joseph in S. Isidoro Agricola, Simon Vouet's *Last Supper* in the Apostolic Palace in Loreto, and Christoph Unterberger's *Saints Philip Neri and Ignatius of Loyola.*[8]

The other large project that occupied the Vatican Mosaic Studio in the nineteenth century was the redecoration of the basilica of S. Paolo fuori le Mura in Rome.[9] The church was rebuilt immediately after it had been almost completely destroyed by fire in 1823, and the new basilica was consecrated by Pope Pius IX in 1854. The studio was responsible for the reconstruction of the mosaics on the triumphal arch and the apsidal, some of which dated back to the fifth century; others had been executed by Cavallini in the late thirteenth century. The papal portraits that had lined the nave of the old basilica—presently there are 265 representing all the popes from Saint Peter to John Paul II—were remade in mosaic. On the façade, Filippo Agricola and Nicola Consoni executed in the third quarter of the nineteenth century the mosaic of Christ between saints Peter and Paul. During the same period, in 1871, the mosaic portrait of Pope Pius IX by Giovanni Ubizi, made after the painting by Francesco Grandi, was placed over the statue of Saint Peter (*Fig. 26*) in the crossing in Saint Peter's to commemorate him for his reign of more than twenty-five years, the longest reign of any pope. He had been elected in 1846.[10]

Gradually, the baroque aesthetic that sustained the mosaic work in Saint Peter's changed, and inevitably the medium was modified and reinterpreted to meet new aesthetic demands. The nineteenth-century decorations in S. Paolo fuori le Mura, for instance, reflect a stylistic return to pre-Renaissance art. And works such as *Saint Joseph Patron of the Universal Church* (*Pl. 144*) recently made by the studio can

be seen in a twentieth-century neo-impressionistic context. However, in the history of mosaics since the Renaissance, no more important and impressive manifestation of the art can be found than the mosaics created in the new basilica of Saint Peter in the seventeenth and eighteenth centuries. They were, and they remain, one of the most complete and dramatic expressions of their age.

Figures

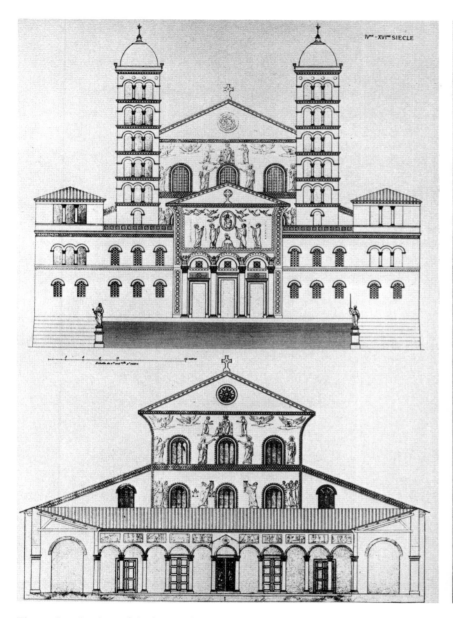

Figure 1. Section of Atrium and Façade of Old Basilica of Saint Peter (Letarouilly, Pl. 12).

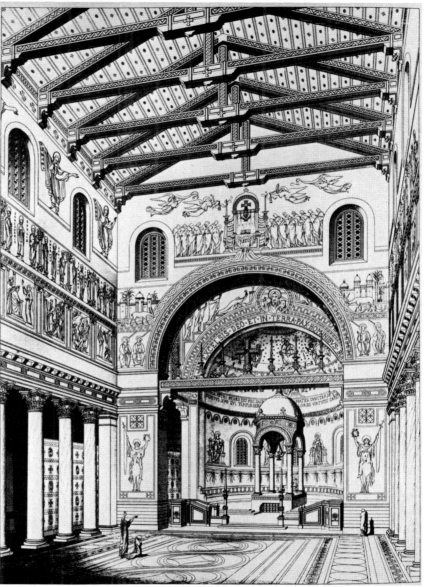

Figure 2. Interior of Old Basilica of Saint Peter (Letarouilly, Pl. 10).

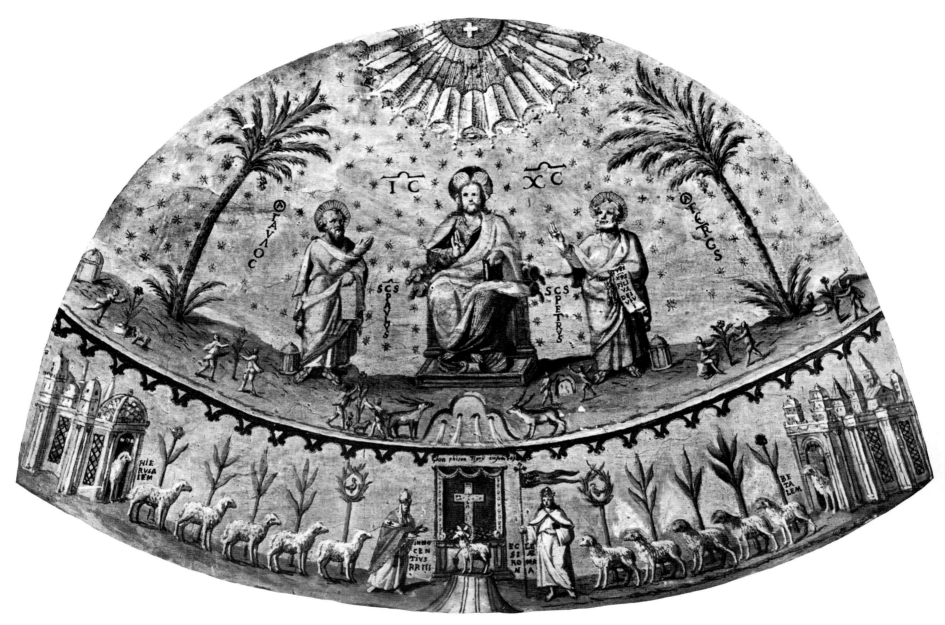

Figure 3. Fresco copy of apse mosaic from Old Basilica of Saint Peter, Rome, Vatican Grottoes (Anderson).

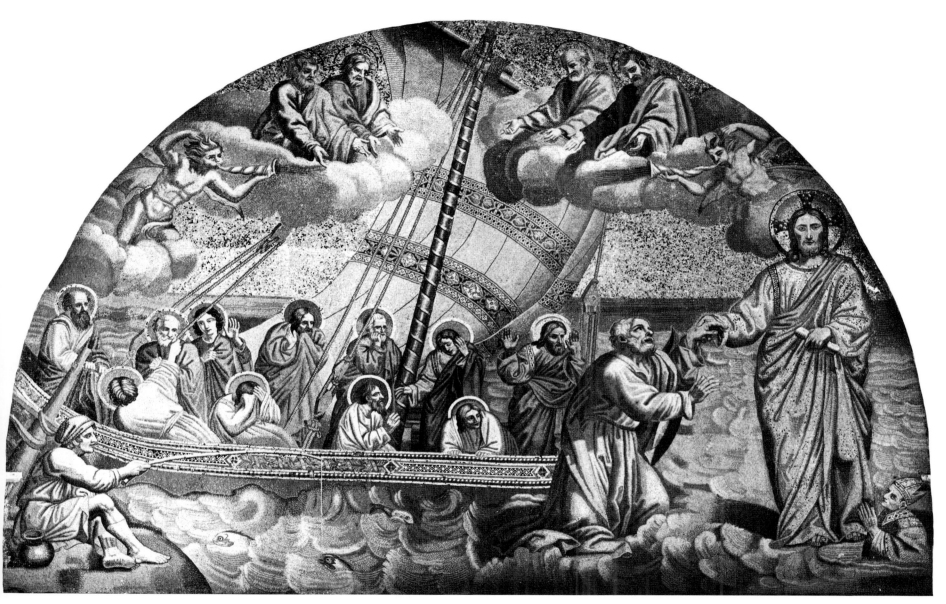

Figure 4. *Navicella,* after Giotto, Rome, S. Pietro in Vaticano (Anderson).

Figure 5. Raphael and Luigi da Pace, Dome, Chigi Chapel, Rome, S. Maria del Popolo (GFN).

Figure 6. Federico Zuccari and Paolo Rossetti, Vault, Caetani Chapel, Rome, S. Pudenziana (GFN).

Figure 7. Federico Zuccari and Paolo Rossetti, Vault (detail),
Caetani Chapel, Rome, S. Pudenziana (GFN).

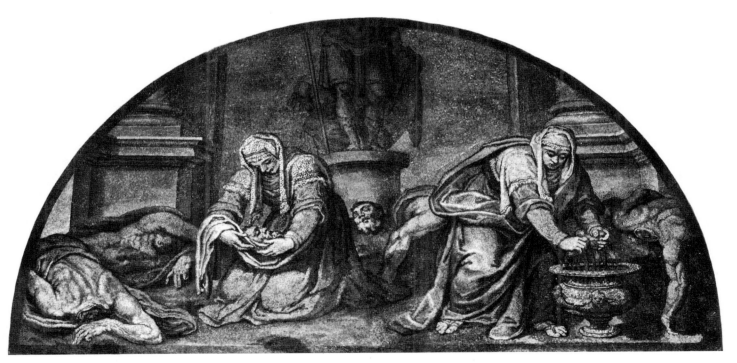

Figure 8. Federico Zuccari and Paolo Rossetti, *Saints Pudenziana and Prassede Burying the Remains of the Martyrs,* Caetani Chapel,
Rome, S. Pudenziana (GFN).

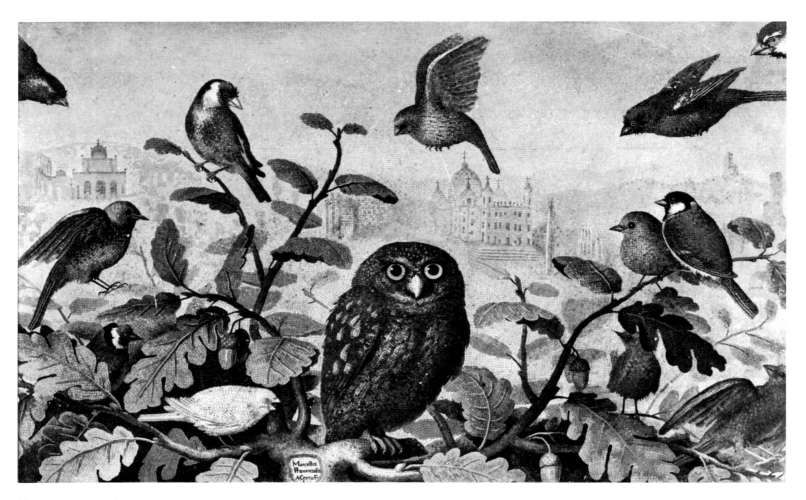

Figure 9. Marcello Provenzale, *Landscape with Birds,* Florence, Palazzo Pitti, Museo degli Argenti (Gabinetto Fotografico, Soprintendenza alle Gallerie, Firenze).

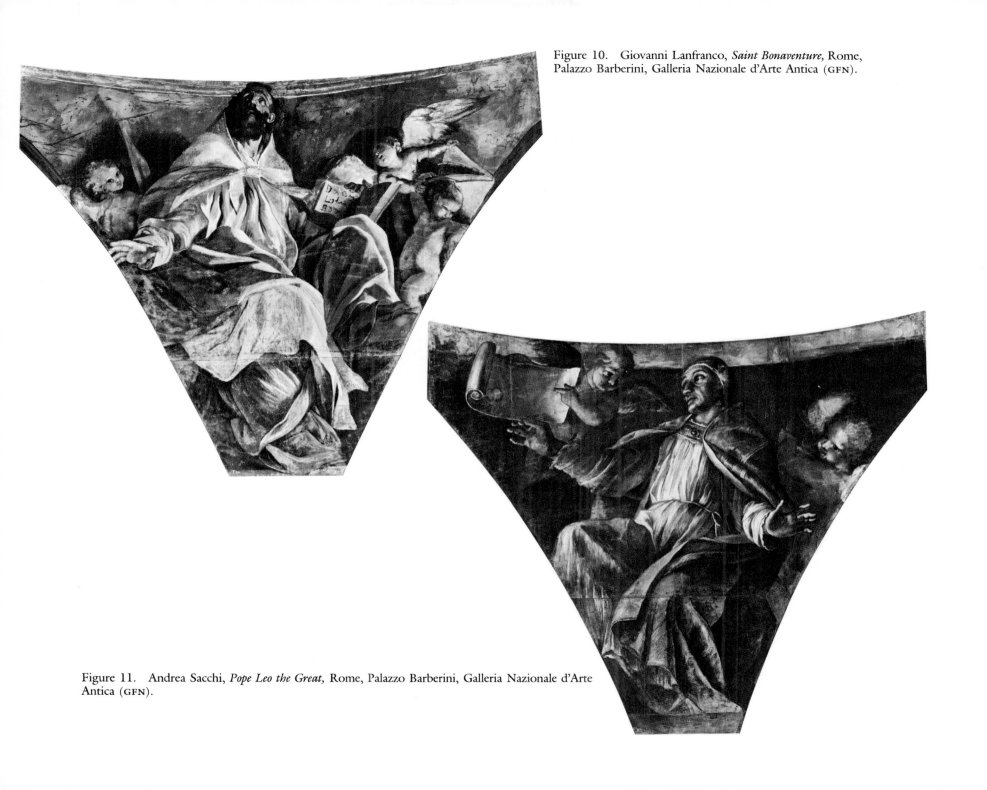

Figure 10. Giovanni Lanfranco, *Saint Bonaventure,* Rome, Palazzo Barberini, Galleria Nazionale d'Arte Antica (GFN).

Figure 11. Andrea Sacchi, *Pope Leo the Great,* Rome, Palazzo Barberini, Galleria Nazionale d'Arte Antica (GFN).

Figure 12. Carlo Maratti, *Judith with the Head of Holofernes,* Rome, S. Pietro in Vaticano, Bendiction Loggia (Archivio Fotografico Vaticano).

Figure 13. Carlo Maratti, *Jael Killing Sisera,* Rome, S. Pietro in Vaticano, Benediction Loggia (Archivio Fotografico Vaticano).

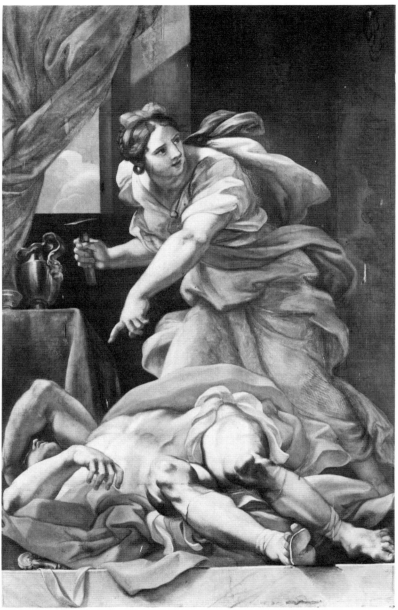

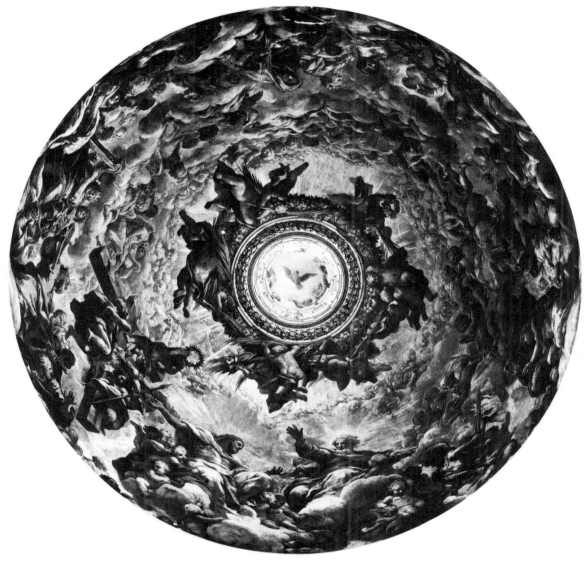

Figure 14. Pietro da Cortona, *Holy Trinity in Glory,* Rome, S. Maria in Valicella (Alinari).

Figure 15. Pietro da Cortona, *Isaiah,* Rome, S. Maria in Valicella (Alinari).

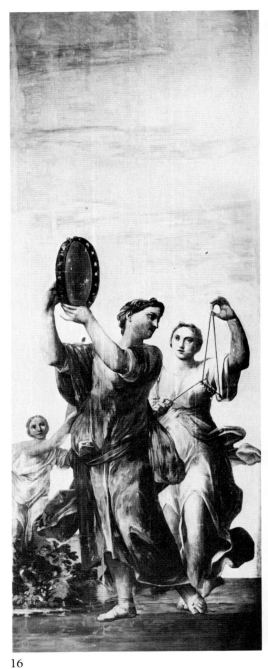

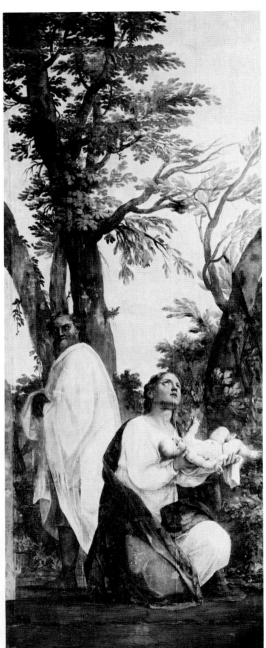

Figure 16. Marcantonio Franceschini, *Miriam Singing and Dancing in Thanksgiving for the Safe Passage through the Red Sea,* Rome, Palazzo della Cancelleria (Archivio Fotografico Vaticano).

Figure 17. Marcantonio Franceschini, *Hannah Dedicating Samuel to God,* Rome, Palazzo della Cancelleria (Archivio Fotografico Vaticano).

16 17

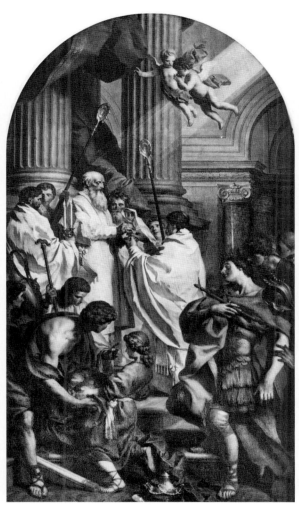

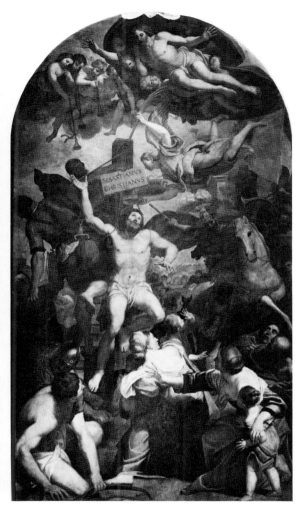

Figure 19. Pierre Subleyras, *Mass of Saint Basil,* Rome, S. Maria degli Angeli (Alinari).

Figure 20. Domenichino, *Martyrdom of Saint Sebastian,* Rome, S. Maria degli Angeli (Anderson).

Figure 18. Tomb of Maria Clementina Sobieska, Rome, S. Pietro in Vaticano (Anderson).

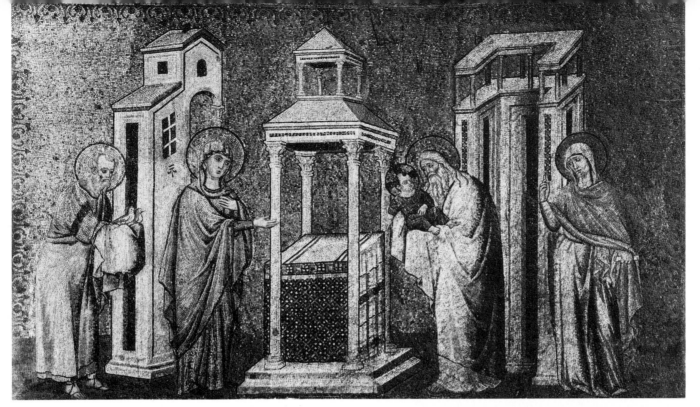

Figure 21. Pietro Cavallini, *Presentation to the Temple,* Rome, S. Maria in Trastevere (GFN).

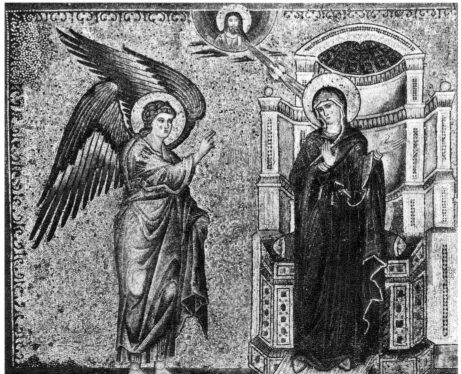

Figure 22. Jacopo Torriti, *Annunciation,* Rome, S. Maria Maggiore (Anderson).

Figure 23. Titian (attributed), *Saint Mark in Ecstasy,* Venice, S. Marco (Anderson).

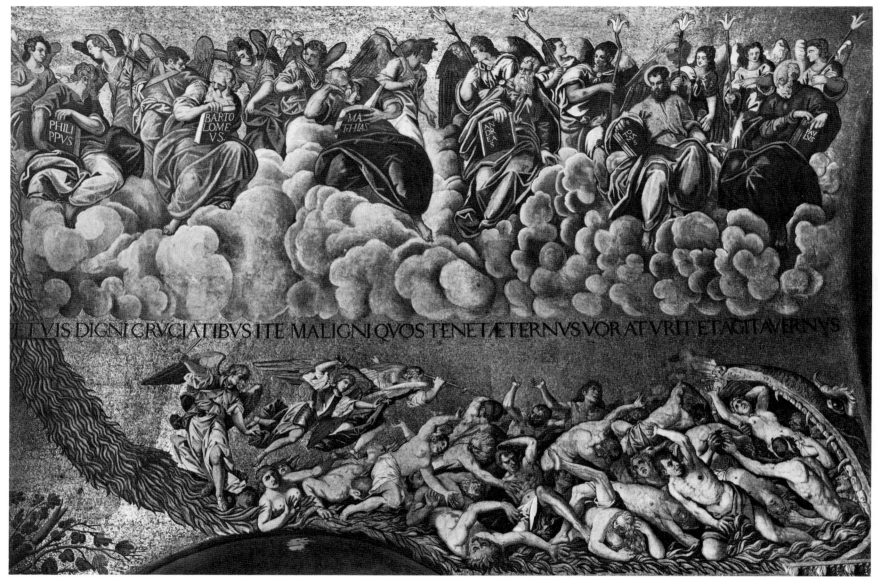

Figure 24. Tintoretto and others, *Triumph of the Elect and Damnation of the Sinners* (detail), Venice, S. Marco (Anderson).

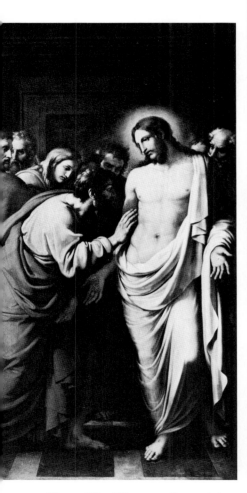

Figure 26. Portrait of Pius IX and the statue of Saint Peter, Rome, S. Pietro in Vaticano (Giordani).

Figure 27. *Saint Peter,* Rome, S. Pietro in Vaticano (Archivio Fotografico Vaticano).

Figure 25. Vincenzo Camuccini, *Incredulity of Saint Thomas,* Rome, formerly Museo Petriano (Anderson).

Figure 28. Giovanni Lanfranco, *Navicella* (fragment), Rome, S. Pietro in Vaticano, Benediction Loggia (Archivio Fotografico Vaticano).

Notes

1 THE MICHELANGELO–DELLA PORTA DOMES

1. For the history of the building of the new basilica of Saint Peter, see James S. Ackerman, *The Architecture of Michelangelo*, rev. ed., 2 vols. (London, 1964, 1966); Howard Hibbard, *Carlo Maderno* (University Park, Pa., 1971); and Ennio Francia, *1506–1606. Storia della construzione del nuovo San Pietro* (Rome, 1977).

2. For the old basilica of Saint Peter in general, see Richard Krautheimer, *Corpus Basilicarum Christianarum Romae*, Vol. 5 (Città del Vaticano, 1977), pp. 165–279; and *Rome: Profile of a City, 312–1308* (Princeton, 1980), passim. For the mosaic decorations in the old basilica, see G. B. De Rossi, *Musaici cristiani e saggi di pavimenti* (Rome, 1873–99); Joseph Wilpert, *Die römischen Mosaiken und Malereien des kirchlichen Bauten von IV. bis XIII. Jahrhundert*, 4 vols. (Freiberg, 1917); Antonio Muñoz, "Musaici della vecchia basilica Vaticana nel Museo di Roma," *Bollettino dei musei comunali di Roma* 6 (1959): 8–13; Hans Belting, "Das Fassadenmosaik des Atriums von Alt. St. Peter in Rom," *Wallraf-Richartz Jahrbuch* 23 (1961): 37–54; Per Jonas Nordhagen, "The Mosaics of John VII," *Acta Institutum Romanum Novegiae* 2 (1965): 121–66; H. P. L'Orange and P. J. Nordhagen, *Mosaics*, Ann E. Keep, trans. (London, 1966); Walter Oakshott, *The Mosaics of Rome* (London, 1967); and Guglielmo Matthiae, *Mosaici medioevali delle chiese di Roma* (Rome, 1967), pp. 215–24, 327–36.

For illustrations of the old mosaics, see Stephan Waetzoldt, *Die Kopien des 17. Jahrhunderts nach Mosaiken und Wandmalereien in Rom* (Vienna/Munich, 1964), and Giacomo Grimaldi, *Descrizione della basilica antica di S. Pietro in Vaticano*, Reto Niggl, ed. (Città del Vaticano, 1972).

3. For the summary of the fate of Giotto's *Navicella*, I am indebted to Giuseppe Cascioli, "La Navicella di Giotto a S. Pietro in Vaticano," *Bessarione* 33 (1916): 118–38. See also Lionello Venturi, "La 'Navicella' di Giotto," *L'Arte* 25 (1922): 49–69; Werner Körte, "Die Navicella des Giotto," *Festschrift Wilhelm Pinder* (Leipzig, 1938), pp. 223–63; and Matthiae, *Mosaici medioevali*, pp. 391–95.

4. *Canons and Decrees of the Council of Trent*, H. J. Schroeder, trans., 4th printing (Saint Louis, Mo., 1960), pp. 215–17.

5. See Cyriac K. Pullapilly, *Caesar Baronius* (Notre Dame, Ind., 1975), for a comprehensive bibliography. For an excellent discussion of the influence of Baronius on the decorations of Saint Peter's, see Miles L. Chappell and W. Chandler Kirwin, "A Petrine Triumph: The Decorations of the Navi Piccole in San Pietro under Clement VIII," *Storia dell'arte* 21 (1974): 119–70. See also Richard Krautheimer, "A Christian Triumph in 1597," *Essays Presented to Rudolf Wittkower*, Douglas Fraser, Howard Hibbard, and Milton J. Lewine, eds., vol. 2 (London, 1967), pp. 174–78.

6. "Mosaics," *Encyclopedia of World Art*, vol. 10 (London, 1965), cols. 353–54. Augusto Agazzi, *Il mosaico in Italia* (Milan, 1926), p. 49, gives the name as Aloisio Pace.

7. Pierre Saccardo, *Les Mosaïque de Saint-Marc à Venise* (Venice, 1896),

pp. 102–3. The correspondence is also noted in Luwig Pastor, *The History of the Popes*, vol. 20 (London, 1952), p. 568.

8. Rosamond E. Mack, *Girolamo Muziano* (Ph.D. diss., Harvard University, 1973), pp. 196, 331, cat. 21, doc. VI.

9. *Il Riposo* (Florence, 1584), pp. 576–77; Giovanni Baglione, *Le vite de' pittori, scultori, et architetti* (Rome, 1642), pp. 49–52.

10. Pastor, *The History of the Popes*, vol. 20, p. 573. In the mid–eighteenth century, when the mosaics in the dome of the Gregorian Chapel were redone, this attitude was again expressed.

11. Baglione, *Le vite de' pittori*, pp. 116–17, 169–70, 336.

12. For discussions of the iconography of the decorations in the new basilica, see principally Hans Sedlmayr, "Der Bilderkreis von Neu- St. Peter in Rom," *Epochen und Werke*, vol. 2 (Vienna, 1960), pp. 7–44; Herbert Siebenhüner, "Umrisse zur Geschichte der Ausstatung von St. Peter in Rom von Paul III bis Paul V (1547–1606)," *Festschrift für Hans Sedlmayr* (Munich, 1962), pp. 229–320; and Carlo Galassi Paluzzi, *San Pietro in Vaticano*, vol. 1 (Rome, 1963), and *La Basilica di S. Pietro* (Bologna, 1974), pp. 168–76.

13. "Doctor of the Church," *New Catholic Encyclopedia*, vol. 4 (Washington, D.C., 1967), pp. 938–39; "Fathers of the Church," *New Catholic Encyclopedia*, vol. 5 (Washington, D.C., 1967), pp. 853–55.

14. This series of altarpieces is discussed at length in Chappell and Kirwin, "A Petrine Triumph."

15. Pullapilly, *Caesar Baronius*, p. 29.

16. Irving Lavin, *Bernini and the Crossing of Saint Peter's* (New York, 1968), pp. 3–4. In Bernini's baldachin and in the decorations of the piers, Lavin also recognizes iconographic allusions to the Holy Sacrament, the Trinity, the Temple of Solomon, and the city of Jerusalem, pp. 18, 35 passim.

17. For Rossetti, see Baglione, *Le vite de' pittori*, pp. 169–70; Lione Pascoli, *Vite de' pittori, scultori, ed architetti moderni*, vol. 2 (Rome, 1736), p. 24; and *Allgemeines Lexikon der Bildenden Künstler*, Ulrich Thieme and Felix Becker, eds., vol. 29 (Leipzig, 1935), pp. 50–51. For Provenzale, see Baglione, *Le vite de' pittori*, pp. 349–50; *Die Künstlerbiographien von Giovanni Battista Passeri*, Jacob Hess, ed. (Leipzig, 1934), pp. 164–65; Pascoli, vol. 2, pp. 24–25; Girolamo Baruffaldi, *Vite de' pittori e scultori ferraresi*, vol. 2 (Ferrara, 1846), pp. 412–24; *Allgemeines Lexikon*, vol. 27 (Leipzig, 1933), pp. 428–29; Alvar González-Palacios, "Il quadro di pietra," *Bolaffiarte* 6 (October 1975): 42–43, 108, and "Provenzale e Moretti: indagine su due mosaici," *Antichità viva* 15 (1976): 26–33; and Jennifer Montagu, "Alessandro Algardi and the 'Borghese Table,'" *Antologia di Belle Arti* 4 (1977): 212, 322.

2 THE VESTIBULES OF THE NAVE CHAPELS

1. For Calandra, see Lione Pascoli, *Vite de' pittori, scultori, et architetti moderni*, vol. 2, pp. 23–34; *Die Künstlerbiographien . . . Passeri*, pp. 164–66; *Allgemeines Lexikon*, vol. 5 (Leipzig, 1911), p. 372; Alvar González-Palacios, "Giovanni Battista Calandra un mosaicista alla corte dei Barberini," *Ricerche di storia dell'arte*, nos. 1–2 (1976): 211–40; and Luigo Avonto, "Giovanni Battista Calandra: mosaicista vercellese del XVII secolo," *Bollettino storico vercellese* 9 (1977): 99–102.

2. For Fabio Cristofari, see Pascoli, *Vite de' pittori*, vol. 2, pp. 33–34; and *Allgemeines Lexikon*, vol. 8 (Leipzig, 1913): 116.

3. For Abbatini, see *Die Künstlerbiographien . . . Passeri*, pp. 234–40; *Allgemeines Lexikon*, vol. 1 (Leipzig, 1907), p. 11; Luigi Grassi, *Bernini pittore* (Rome, 1945), pp. 44–47; and Bruno Toscano, "Il pittore del Cardinal Poli: Guidubaldo Abbatini," *Paragone*, no. 177 (1964): 36–42.

4. See *Allgemeines Lexikon*, vol. 7 (Leipzig, 1912), p. 336; and *I mosaici minuiti romani* Domenico Petochi, ed. (Rome, 1981), p. 54.

5. I am indebted to R. H. Charles, *Studies in the Apocalypse* (Edinburgh, 1913), pp. 33–36 and passim, for the discussion on the Revelation of Saint John the Divine. Citations in the discussion, unless otherwise noted, are from *The New Oxford Annotated Bible* (New York, 1973).

6. See *Bibliothèque de la Compagnie de Jésus*, Carlos Sommervogel, ed., vol. 1 (Brussels, 1890), vol. 6 (1895), *sub voce*. The title of Ribera's book is *In sacram beati Ioannis apostoli et evangelistae Apocalypsim commentarij*; the title of Alcazar's is *Vestigatio arcani sensus in Apocalypsi*.

7. André Feuillet, *The Apocalypse*, Thomas E. Crane, trans. (Staten Island, N.Y., 1965), pp. 74 ff.; and "Apocalypse, Book of," *New Catholic Encyclopedia*, vol. 1 (Washington, D.C., 1967), pp. 654 ff.

8. "Covenant," *The New Bible Dictionary*, J. D. Douglas, ed. (Grand Rapids, Mich., 1962).

9. *The Jerusalem Bible* (New York, 1966).

10. Charles, *Studies in the Apocalypse*, p. 126.

3 THE EVOLUTION OF THE ALTARPIECES

1. The arguments against the use of mosaic altarpieces in the Basilica of Saint Peter are based on Lione Pascoli, *Vite de' pittori, scultori, et architetti moderni*, vol. 2, pp. 26–27.

2. See *Allgemeines Lexikon*, vol. 8 (Leipzig, 1913), p. 116; and *I mosaici minuiti romani*, Domenico Petochi, ed. (Rome, 1981), p. 55. The following is a transcription of the letter dated 9 July 1727 appointing Pietro

Paolo Cristofari as director of the Vatican Mosaic Studio (ARFSP, *Studio de' mosaici,* vol. 3/14, p. 856).

> Il Colleggio degli Eminentissime, e R.mi Sig.e Cardinali della S. Congregazione della Rev. Fabrica di S. Pietro di Roma.
>
> Al diletto nostro in Cristo Pietro Paolo Cristofari pittore di mosaico salute.
>
> Avendo voi con somma nostra sodisfazione, e commune applauso terminato e posto al pubblico nella Sagrosanta Basilica Vaticana il quadro rappresentante S. Pietro in atto de naufragare, chiamato volgarmente della Navicella dipinto dal Cav.e Lanfranco, e da voi ridotto a mosaico, e considerando noi quanto conferisca alla manutenzione, ad aumento di quest'arte il deputare una persona, che sopraintenda non solo ai pittori che operano li mosaici tanto nei lavori incominciati quanto in quelli che in qualsivoglia tempo siano per farsi si nelli quadri e cuppole, ma anche assiste alla construzione de smalti per ordinare al fonditore di essi a suo luogo, e tempo la qualità delle tinte e colori per disporli poi, ed adattarli nelle monizioni. Quindi è che col tenore del presente dichiariamo e nominiamo voi Pietro Paolo Cristofari in sopraintendente, e capo di tutti i pittori di mosaico, che operaranno nelle cuppole e quadri della Basilica Vaticana ed in ogni altra opera, che occorrera farsi, con tutti li onori, facolta, prerogative . . . coll'emolumento di scudi dieci il mese.

3. ARFSP, *Liste 1742,* vol. 4/83, Lista 23 March–31 July. Stern's painting was exhibited in the late 1920s at the Museo Petriano. See Giuseppe Cascioli, *Guida illustrata al nuovo museo di San Pietro (Petriano)* (Rome, [1925]), p. 51.

4. ARFSP, *Studio de' mosaico,* vol. 3/14, pp. 396ff.

4 THE ART OF POST-RENAISSANCE MOSAICS

1. See Frank R. DiFederico, "Documentation for Francesco Trevisani's Decorations for the Vestibule of the Baptismal Chapel in Saint Peter's," *Storia dell'arte* 6 (1970): 161–62 and docs. 44, 45.

2. ARFSP, *Studio de' mosaico,* vol. 3/14A, p. 426.

3. Vincenzo Strappati, "Lo Studio Vaticano del Mosaico," *L'Illustrazione Vaticana,* no. 22 (30 November 1931).

There exists in the archives an interesting, if undecipherable, manuscript written in the Saxon dialect from 1744 to 1749 by Federico Stribal, the manufacturer of *smalti* for the Vatican Mosaic Studio at that time, which describes the composition of the various *tesserae,* including Mattioli's *porporino* (ARFSP, *Fabbricazione degli smalti,* vol. 3/154).

4. See Pierre Saccardo, *Les Mosaïque de Saint-Mark à Venise* (Venice, 1896), for the mosaics in the Basilica of Saint Mark after 1500; and Giovanni Musolino, *La Basilica di San Marco in Venezia* (Venice, 1955), pp. 60–64.

5. ARFSP, *Decreta,* vol. 3/170, p. 80v.

6. ARFSP, *Liste 1778,* vol. 4/117, pp. 380, 380v, 888, 888v, 911, 911v.

7. ARFSP, *Liste 1790,* vol. 5/16, nos. 293, 395, 396.

8. ARFSP, *Studio de' mosaici,* vol. 3/14B, "Regolamento per lo Studio del Mosaico."

9. For S. Paolo fuori le Mura, see Krautheimer, *Corpus Basilicarum,* vol. 5, pp. 93–364; and for a brief summary of the history of the mosaics, see Oakshott, *The Mosaics of Rome* (1967), pp. 295–97, 383.

10. Genesio Turcio, *La Basilica di S. Pietro* (Florence, 1946), p. 131. Grandi's portrait was exhibited at the Museo Petriano in the late 1920s according to Giuseppe Cascioli, *Guida illustrata al nuovo museo di San Pietro (Petriano)* (Rome, [1925]), p. 51.

The Mosaics

Plan of the Basilica

KEY

THE CHAPELS

A Chapel of the Pietà
B Chapel of Saint Sebastian
C Chapel of the Sacrament
D Gregorian Chapel
E Chapel of Saint Michael
F Dome of the Crossing
G Chapel of the Madonna della Colonna
H Clementine Chapel
I Chapel of the Choir
J Presentation Chapel
K Baptismal Chapel

18 Christ Carrying the Cross, and Saint Veronica
19 Saint Andrew Adoring the Cross of His Martyrdom
20 Martyrdom of Saint Longinus
21 Saint Helen and the Miracle of the True Cross
22 Incredulity of Saint Thomas
23 Saint Joseph Patron of the Universal Church

THE ALTARPIECES

1 Saint Nicholas of Bari
2 Saint Joseph and the Child Jesus
3 Martyrdom of Saint Sebastian
4 Ecstasy of Saint Francis
5 Saint Wenceslas of Bohemia
6 Martyrdom of Saints Processus and Martinianus
7 Martyrdom of Saint Erasmus
8 Saint Michael the Archangel
9 Burial of Saint Petronilla
10 Last Communion of Saint Jerome
11 Mass of Saint Basil
12 Navicella
13 Raising of Tabitha
14 Saint Peter Healing the Cripple at the Porta Spetiosa
15 Christ of the Sacred Heart Appearing to Saint Margaret Mary Alacoque
16 Death of Sapphira
17 Transfiguration

24 Crucifixion of Saint Peter
25 Entombment of Christ
26 Saint Gregory and the Miracle of the Corporal
27 Immaculate Conception
28 Presentation of the Virgin
29 Saint Peter Baptizing the Centurion Cornelius
30 Baptism of Christ
31 Baptism of Saints Processus and Martinianus

The Chapels

A. Chapel of the Pietà Plates 1–13

NOLITE NOCERE & QVO ADVSQVE SIGNEMVS
SERVOS DEI NOSTRI IN FRONTIBVS EORVM
(Rev. 7:3)

PENDENTIVES
Noah and the Ark
Abraham and the Sacrifice of Isaac
Moses with the Tables of the Law
The Prophet Jeremiah

LUNETTES
The Prophet Amos
 VENDIDERVNT IVSTVM PRO ARGENTO (Amos
 2:6)
The Prophet Zechariah
The Phrygian Sibyl
 SCINDETVR TEMPLI VELVM
The Cumaean Sibyl
 IMPIGET ILLI COLAPHOS
The Prophet Hosea

EGO REDEMI EOS. OSEA CAP. VII (Hos. 7:13)
The Prophet Isaiah

Originally, the chapel was known as the Chapel of the Crucifixion. It was renamed after Michelangelo's *Pietà* was moved from the Chapel of the Choir on 7 November 1749 (ARFSP, *Diario dei Cerimonieri*, busta 36, ff. 436–37). At that time, a crucifix attributed to Pietro Cavallini was moved next door to the small Chapel of Saint Nicholas of Bari, which is now called the Chapel of the Crucifixion. The commission for the decorations had been awarded to Giovanni Lanfranco in 1629; the mosaics were to have been executed by Giovanni Battista Calandra (ARFSP, *Decreta*, vol. 3/159, pp. 166, 169v). However, Lanfranco actually decorated only the interior of the chapel proper, and that in fresco. His decorations are the sole frescoes in the basilica.

Around the middle of 1668, after he had received satisfaction for an adjustment in price he was asking for his work on the cartoons for the chapels of the Sacrament and Saint Sebastian, Pietro da Cortona began to paint the cartoons for the Chapel of the Pietà (ARFSP, *Decreta*, vol. 3/165, pp. 17–18; see the discussion on the Chapel of the Sacrament). At the time of his death, on 16 May 1669, Cortona left three unfinished cartoons, his only

work for the project. His estate was to be paid 400 *scudi* for them.

Ciro Ferri was commissioned by Pope Clement IX to finish Cortona's three cartoons and to paint the rest of the pictures (ARFSP, *Artisti, diverse munizione*, vol. 1/2, no. 10). It is impossible to know which cartoons Cortona began, but most likely they were for sections of the vault. The final payment to Ferri in 1681 noted that he painted sixteen cartoons for the vault, four for the pendentives, and six for the lunettes; that is, *all* the cartoons for the decorations of the chapel (ARFSP, *Liste 1681*, vol. 4/22, Lista 26 November). It was further noted that he was responsible for paying Cortona's heirs. In October 1728 Ferri's cartoons, after they were restored by Niccolò Ricciolini, were sent to decorate the dome of the church of S. Chiara in Urbino, where they are still preserved (ARFSP, *Spese diverse*, vol. 425, pp. 8–8v; *Liste 1728*, vol. 4/69, Lista 11 November). The church presently serves as a vestibule to the city hospital.

The mosaics in the chapel were all done by Fabio Cristofari. He received payment for his work in the vault from November 1669 to April 1677 (ARFSP, *Liste 1669*, vol. 4/10, p. 60; *Liste 1677*, vol. 4/18, Lista 7 July); for the pendentives from 1 December 1677 to 17 May 1679 (ARFSP, *Liste 1677*, vol. 4/18; *Liste 1679*, vol. 4/20); and for the lunettes from 21 February 1680 to 26 November 1681 (ARFSP, *Liste 1680,* vol. 4/21; *Liste 1681,* vol. 4/22). The payments are explicit in recording that Cristofari had done all the work himself.

The mosaic over the Porta Santa, representing Saint Peter (*Fig. 27*), was placed there in 1675 for the Holy Year celebrations. The mosaic was originally executed by Giovanni Battista Calandra on the basis of a cartoon by the Cavaliere d'Arpino. Later, Ciro Ferri made new designs for a restoration carried out by Fabio Cristofari. The one payment relative to this work that has been uncovered was made to Cristofari on 19 November 1674 for restoring a piece of the drapery, the book, and the cloud (ARFSP, *Liste 1674*, vol. 4/15, pp. 77, 336).

References: Pollak, 1913, p. 14; Briganti, 1962, pp. 252–53; Giannatiempo, 1977, pp. 28–33.

B. Chapel of Saint Sebastian Plates 14–23

HI SVNT QVI VENERVNT EX MAGNA TRIBVLATIONE ET SEQVNTVR AGNVN (Rev. 7:14)

PENDENTIVES
Abel Offering a Lamb as a Sacrifice (Gen. 4:4)
The Prophet Isaiah
Zechariah, Son of Jehoiada, Stoned in the Atrium of the Temple (2 Chron. 24:20–21)
The Prophet Jeremiah (or Ezekiel)

LUNETTES
Martyrdom of Two Hebrew Women Thrown from the Walls of the City for Having Circumcised Their Sons (2 Macc. 6:10)
Eleazar Refusing to Eat Forbidden Meat (2 Macc. 6:18–31)
Martyrdom of the Seven Maccabees Brothers and Their Mother (2 Macc. 7)
Mattathias Killing an Idolatrous Jew (1 Macc. 2:23–24)
Daniel in the Lions' Den (Dan. 6:16–23)
Shadrach, Meshach, and Abed-nego in the Fiery Furnace (Dan. 3:13–30)

The cartoons for the decorations of the vault, pendentives, and two unspecified lunettes in the chapel, most probably those over the entrance to the chapel proper representing the seven Maccabees and Mattathias, were painted by Pietro da Cortona from 1652 to 1662. The four remaining lunette cartoons were done by Raffaele Vanni from 1659 to 1663 (see the payments to Cortona and Vanni in the discussion of the Chapel of the Sacrament).

The mosaics in the vault were begun in late 1654 by Guido Ubaldo Abbatini and Matteo Piccioni (ARFSP, *Spese*, vol. 304, Lista 26 November 1654). When Abbatini died in 1656, he was replaced by Fabio Cristofari (ARFSP, *Spese*, vol. 304, Lista 3 March 1657); and in June 1657, for a short time, the two men were joined by Orazio Manenti (ARFSP, *Spese*, vol. 304, Lista 22 June 1657). Final payment for the mosaics in the vault was made to

Cristofari and Piccioni in September 1660 (*Liste 1660*, vol. 4/1, pp. 38, 305, 307). From 1723 to 1725 Pietro Adami redid some of the mosaics in the vault on the basis of Cortona's original cartoons (ARFSP, *Liste 1725*, vol. 4/66, Lista 24 August).

Posthumous payments were made to Abbatini in September 1660 for the pendentive mosaics representing Abel and Isaiah (ARFSP, *Liste 1660*, vol. 4/1, p. 305). Payments for the other two pendentive mosaics have not been uncovered, but a date of about 1660 for them as well is quite probable. The mosaics in the lunettes were executed from 1661 to 1663. Piccioni worked the lunette to the left of the window over the altar with the representation of the seven Maccabees (ARFSP, *Liste 1661*, vol. 4/2, p. 292); Fabio Cristofari did the one on the right with the "zealous Mattathias" (ARFSP, *Liste 1663*, vol. 4/4, p. 46). The other four were done by Orazio Manenti in 1662 and 1663 (ARFSP, *Liste 1662*, vol. 4/3, p. 278; *Liste 1663*, vol. 4/4, p. 157).

References: Briganti, 1962, pp. 146, 252–53.

C. Chapel of the Sacrament

Plates 24–35

ASCENDIT FVMVS AROMATVM CORAM DEO
(Rev. 8:4)

PENDENTIVES
King Melchizedek Making an Offering of Bread (Gen. 14:18)
Elijah Restored by an Angel (1 Kings 19:4–8)
A Priest Dispensing Ceremonial Bread (Lev. 24:5–9)
Aaron Filling a Vase with Manna (Exod. 16:33–34)

LUNETTES
Uzzah Struck Dead While Attempting to Steady the Ark of the Covenant (2 Sam. 6:6–7)
An Angel About to Touch Isaiah's Lips with a Live Coal (Isa. 6:6–7)
High Priest Offering to God the Fruits of the First Grain Harvest (Lev. 23:9–14)
Return from Canaan with the Large Bunch of Grapes (Num. 13:21–24)

Jonathan Tasting the Honey (1 Sam. 14:24–30)
The Idol Dagon Destroyed by the Presence of the Ark (1 Sam. 5:1–4)

In the 1640s the decorations in the vestibule of the Chapel of the Sacrament were entrusted to Nicolò Tornioli, but after a faint beginning, work was suspended until the early 1650s, when Pietro da Cortona undertook the project. The cartoons for the vault and for all four pendentives were painted by him. In 1652 Cortona mentions in a letter to the Grand Duke of Florence that he has begun to work in Saint Peter's. The payments for his work in the chapels of the Sacrament and Saint Sebastian date from 1653 to 1662 (ARFSP, *Libro della liste*, vol. 292, pp. 162, 249). As of September 1667 Cortona had received only 5,200 *scudi* for his cartoons, the last prior payment having been made in 1662. He requested a total recompense of 7,900 *scudi* and asked for the difference in a letter, explaining that he had painted thirty-two cartoons for two vaults, eight cartoons for pendentives, and two cartoons for lunettes for the Chapel of Saint Sebastian (ARFSP, *Decreta*, vol. 3/164, p. 554; *Documenti diversi*, vol. 1/6, no. 59, p. 215). The cartoons for the lunettes in the Chapel of the Sacrament, were painted by Raffaeli Vanni from the spring of 1659 to late summer 1663 (ARFSP, *Documenti diversi*, vol. 1/6, no. 60, p. 226; *Libro delle liste*, vol. 292, p. 239; *Liste 1663*, vol. 4/4, p. 18).

The mosaics in the vault were begun by Guido Ubaldo Abbatini in early September 1653 (ARFSP, *Libro dei manuali*, vol. 261, p. 163). In February 1654 he was joined by Matteo Piccioni (ARFSP, *Libro dei manuali*, vol. 261, p. 166). Both mosaicists were paid in full for their work on 23 September 1656 (ARFSP, *Spese diverse*, vol. 4/27, p. 442). Abbatini, before his death in 1656, also began the pendentive mosaic with King Melchizedek; it was finished later, in 1663, by Fabio Cristofari (ARFSP, *Spese*, vol. 304, Lista 7 April 1657; *Liste 1663*, vol. 4/4, pp. 2, 46). The mosaics in the other three pendentives were executed by Orazio Manenti from about 1656 to 1660. The final payment to Manenti is dated 16 December 1660 (ARFSP, *Libro dei manuali*, vol. 261, p. 186; *Liste 1660*, vol. 4/1, p. 370). Manenti also made the mosaics for the lunettes in the same period. He most likely began to work on the mosaics in late 1659 as Vanni provided the cartoons. Manenti was

paid for four of the lunettes at the end of December 1660 (ARFSP, *Liste 1660*, vol. 4/1, p. 370); the last two, with the representations of Jonathan and the idol Dagon, however, were not finished until mid-1662 (ARFSP, *Liste 1662*, vol. 4/3, pp. 19, 199).

References: Briganti, 1962, pp. 146, 252–53, Heimbürger Ravalli, 1977, p. 202 passim.

D. Gregorian Chapel Plates 36–44

GREGORIVS XIII BONCOMPAGNVS BONON
P O M AN MDLXXVII

PENDENTIVES
Pope Gregory the Great
Saint Jerome
Saint Gregory Nazianzus
 ΕΞΑΗΜΕΡΟΝ ΚΑΙ ΕΙΔΕΝ Ο ΘΕΟΣ ΟΤΙ ΚΑΛΑ
Saint Basil the Great

LUNETTES
The Annunciation, Virgin Mary
The Annunciation, Angel
The Prophet Ezekiel
 PORTA HAES CLAVSA ERIT ET NON APERI-
 ETVR ET VIR NON TRASIBIT PER EAM. EZE-
 CHIELIS XLIIII (Ezek. 44:2)
The Prophet Isaiah
 ECCE VIRGO CONCIPIET ET PARIET FILIVM
 ET VOCABIT NOME EIVS EMANVEL (Isa. 7:14)

Ugo Procacci's biography of Girolamo Muziano notes that Muziano was responsible for both the paintings and the mosaics in the Gregorian Chapel and that the work took him two years to finish. The chapel had been consecrated in February 1578, and by August of that year Muziano had begun work on his designs for the decorations, according to a letter he wrote to the Opera del Duomo of Orvieto. The decorations were finished by 11 June 1580 for the ceremony installing the remains of Saint Gregory Nazianzus under the high altar of the chapel. An *avviso* sent to the Marchese Filippo d'Este at that time called the decorations in the chapel the most beautiful in the world, surpassing even those of the ancients. The praise was repeated in several other contemporary accounts of the chapel. An inscription on the original pendentive of Saint Jerome was signed and dated 1579. The mosaics were executed under Muziano's supervision, and he personally made sections of them himself. His studio consisted of Cesare Nebbia, Paolo Rossetti, and Giacomo Stella, among others. The only mosaicist on record as having received payments for work in the chapel is Giovanni Caprei, from May to October 1578.

By 1758 the mosaics had calcified and were falling off the walls, and the Congregazione della Reverenda Fabbrica decided to redo them all (ARFSP, *Decreta*, vol. 3/170, pp. 36v–37). However, since Muziano's original cartoons were lost, the Congregazione decreed that either Stefano or Giuseppe Pozzi be asked to make new ones for the mosaicists. The decree mentions that the new cartoons could probably be improved over those Muziano had originally designed. Giuseppe Pozzi, who accepted the commission for the new cartoons, never did any work on the project. However, in 1768 the records show that the commission had been assumed by Nicola LaPiccola, and from 1768 to 1772 he was paid for the four cartoons for the pendentives (ARFSP, *Liste 1770*, vol. 4/111, pp. 97, 241; *Liste 1771*, vol. 4/112, p. 213; *Liste 1772*, vol. 4/113, pp. 184v, 227). The mosaics were executed by Liborio Fattori, Giovanni Battista Fiani, and Bartolomeo Tomberli in the order in which the Fabbrica received the cartoons from LaPiccola. *Saint Gregory Nazianzus* was finished by 31 October 1770; *Pope Gregory the Great* by 20 April 1771; *Saint Basil the Great* by 25 April 1772; and *Saint Jerome* by 24 October 1772 (ARFSP, *Liste 1770*, vol. 4/111, p. 427; *Liste 1771*, vol. 4/112, p. 121; *Liste 1772*, vol. 4/113, pp. 184v, 633v).

The vault was redone next. The cartoons were painted by Salvatore Monosilio from early 1772 to the end of 1775 (ARFSP, *Liste 1772*, vol. 4/113, p. 39v; *Liste 1775*, vol. 4/116, Lista 16 December). The first record of mosaic work in the vault dates from the spring of 1773: Giovanni Battista Fiani and Lorenzo Roccheggiani were paid for some decorative work in a band under the lantern (ARFSP, *Liste 1773*, vol. 4/114, Lista 13 April). By fall, the upper area of the vault, which contains panels with stars in chiaroscuro against a gold ground, was completed. The mosaics had been done

by Giovanni Battista Fiani, Giovanni Francesco Fiani, Domenico Cerasoli, Antonio Castellini, Filippo Carlini, Giuseppe Regoli, Andrea Volpini, Lorenzo Roccheggiani, and Vincenzo Cocchi (ARFSP, *Liste 1773*, vol. 4/114, Lista 17 August to 30 October).

Between February and June 1774 the hieroglyphs in the lower sections of the vault were finished. The Palm was executed by Giovanni Battista and Giovanni Francesco Fiani, Andrea Volpini, Domenico Cerasoli, and Lorenzo Roccheggiani; The Ark by Vincenzo Cocchi; The Temple by Antonio Castellini; The Sun, The Tower, and The Well by Giovanni Battista and Giovanni Francesco Fiani; and The Moon and The Cypress by Andrea Volpini, Domenico Cerasoli, and Lorenzo Roccheggiani (ARFSP, *Liste 1774*, vol. 4/115, Liste 18 February, 19 April, and 11 June).

Finally, in the spring of 1776 LaPiccola began to paint the cartoons for the lunettes. He was paid for the Angel of the Annunciation in October 1777, the Virgin in April 1778, Isaiah in December 1778, and Ezekiel in October 1779 (ARFSP, *Liste 1777*, vol. 4/118, p. 761; *Liste 1778*, vol. 4/119, p. 228v; *Liste 1778*, vol. 4/120, p. 364v; *Liste 1779*, vol. 4/122, p. 77). Although the notices on the making of the mosaics for the lunettes have not been located, it is known that all the mosaics were completed by 7 August 1779, at which time, according to the *Diario dei Cerimonieri*, which records all services and ceremonies in the basilica, the new decorations in the Gregorian Chapel were officially unveiled (ARFSP, busta 38, f. 185).

References: Rastelli, [n.d.], p. 32; Borghini, 1584, pp. 576–77; Baglione, 1642, pp. 49–52, 116–17, 169–70, 336; Sindone and Martinetti, 1750, p. 141; Saccardo, 1896, pp. 102–3; Procacci, 1954, pp. 252, 262; Vinella, 1971–72, p. 114 passim; Mack, 1973, cat. 21, doc. II, VII, and cat. 26, doc. VII, passim.

E. Chapel of Saint Michael

Plates 45–49

CLEMENS XII PONT MAX AN SAL MDCCXXXI PONT II

PENDENTIVES
Pope Leo the Great
 LEO EPISCOP.VS DILECTISSIMO FRATI FLAVIANO CONSTANTINPONO EPISCOPO

Saint Bernard of Clairvaux
Saint Denys the Areopagite
Saint Gregory Thaumaturgus
 ΕΙΣ ΘΕΟΣ ΕΙΣ ΘΕΟΣ
 ΕΚ ΘΕΟΥ ΣΟΦΙΑ ΕΝ

LUNETTES
Elijah and the Angel
Tobias and the Archangel Raphael
Saint Peter Baptizing Saint Petronilla
Saint Nicodemus Giving Communion to Saint Petronilla

The pendentive cartoon of Saint Gregory Thaumaturgus was painted by Giovanni Francesco Romanelli, who received payment for it from 15 October 1636 to 26 September 1637 (ARFSP, *Libro dei manuali*, vol. 261, p. 61). The one representing Saint Bernard was done by Carlo Pellegrini, payments to whom date from 21 August 1636 to 23 July 1637. The mosaics of both pendentives were executed by Giovanni Battista Calandra, who received final payment for his work on 30 October 1638 (ARFSP, *Spese*, vol. 272, p. 120v). The other two pendentive cartoons, those of Pope Leo the Great (*Fig. 11*) and Saint Denys, were painted by Andrea Sacchi. The first payment to Sacchi was made in 1631. Other payments were made in 1639, 1640, and 1642, but Sacchi did not receive final recompense for the two pictures until 1647. *Pope Leo* was the first of the two cartoons Sacchi finished. The mosaic was made by Calandra between November 1638 and May 1639. *Saint Denys* must have been delivered to the Fabbrica in 1644, since the mosaic was begun by Calandra before his death in October of that year. It was finished by Guido Ubaldo Abbatini, who received payments for his work on 13 April 1647 and on 3 January 1648 (ARFSP, *Libro dei manuali*, vol. 261, p. 94). Sacchi's *Pope Leo the Great* and Romanelli's *Saint Gregory Thaumaturgus* are presently in the Galleria Nazionale d'Arte Antica, Palazzo Barberini, Rome. The other two pendentive cartoons are unlocated.

The lunettes in the chapel were not decorated until early in the eigtheenth century. Bonaventura Lamberti was commissioned, perhaps in 1713, to provide the cartoons for the lunettes and the vault; however, the first payment he received from the Fabbrica, dated 23 December 1719, indicates that he did not start work on

the commission until that time (ARFSP, *Liste 1720*, vol. 4/61, p. 50). During 1720 and 1721 Lamberti received three additional payments for the lunette cartoons, but when he died on 19 September 1721, he had only completed two of the four, *Elijah and the Angel* and *Tobias and the Archangel Raphael,* and had barely started on a third (ARFSP, *Liste 1720*, vol. 4/61, p. 260v; *Liste 1721*, vol. 4/62, pp. 42, 164v). His heirs received the final payment for his work in March 1722 (ARFSP, *Liste 1722*, vol. 4/63, pp. 6–6v).

The unfinished cartoon representing Saint Peter baptizing Saint Petronilla was completed by Lorenzo Gramiccia, and the fourth and last lunette cartoon, *Saint Nicodemus Giving Communion to Saint Petronilla,* was painted by Marco Benefial, who received payment for it in one lump sum on 30 October 1722 (ARFSP, *Liste 1722*, vol. 4/63, pp. 3v, 5v, 50v–51, 327, 379v). The mosaics of all four lunettes were executed by Giuseppe Ottaviani, who received a final payment for the first three on 18 February 1723 and a final payment for the last, Benefial's, on 12 August 1726 (ARFSP, *Liste 1723*, vol. 4/64; *Liste 1726*, vol. 4/67).

After Lamberti's death the commission for the cartoons for the vault decorations passed to Niccolò Ricciolini. The payments to him date from 20 December 1721 to 3 October 1726 (ARFSP, *Liste 1721*, vol. 4/62, p. 415; *Liste 1726*, vol. 4/67, Lista 10 December). The vault in this chapel is unique in that the decorations consist of both mosaics and three-dimensional stucco figures. The mosaics are essentially decorative and support the iconographic program presented through the stucco figures in the roundels in the body of the vault. The mosaics in each of the eight sections consist of two heads of cherubs with intertwined wings, two sets of small angels, and two sets of large angels placed to the sides of the roundels. They were executed from 1726 to 1729 by Prospero Clori, Liborio Fattori, Domenico Gossoni, Alessandro Cocchi, Giovanni Francesco Fiani, and Enrico Enuò (ARFSP, *Liste 1726*, vol. 4/67, Lista 25 September; *Liste 1728*, vol. 4/69, Giustificazioni 8 January and 11 November; *Liste 1729*, vol. 4/70, Giustificazioni 28 July 1727–1 March 1728, 9 April 1729, 13 September 1729, 14 September 1729, and 4 October 1729). The stucco figures were executed by Lorenzo Ottone, who received final payment for them on 12 July 1725 (ARFSP, *Liste 1725*, vol. 4/66, Lista 4 August). The justification for the payment describes the figures in the roundels, who personify aspects of the Heavenly Army: Victory Against the Devil, Love for God, Universal Science, Command, Omnipotence, Obedience, Providence, and Absolute Authority.

References: Pollak, 1931, 2:579, nos. 2334–37; Patella, 1971–72, p. 77 passim; Harris, 1977, pp. 60–61.

F. Dome of the Crossing Plates 50–71

S. PETRI GLORIAE SIXTVS PP V A MDXC PONTIF V
TV ES PETRVS ET SVPER HANC PETRAM AEDIFICABO ECCLESIAM MEAM ET TIBI DABO CLAVES REGNI CAELORVM

PENDENTIVES
Saint Matthew
Saint John the Evangelist
Saint Mark
Saint Luke

Giovanni de' Vecchi executed both the cartoons and the mosaics of the Evangelists John and Luke in two of the roundels on the pendentives of the main dome of the basilica. He was paid for *Saint John* from 12 June 1598 to 17 February 1599, and for *Saint Luke* from 26 February to 5 November 1599 (ARFSP, *Spese*, vol. 162, pp. 10–10v, 43–43v). The cartoons for the other two Evangelists were painted by Cesare Nebbia, and the mosaics were executed by him and Paolo Rossetti. The payments for *Saint Matthew* date from 12 June 1598 to 5 March 1599, and those for *Saint Mark* from 12 March to 19 November 1599 (ARFSP, *Spese*, vol. 162, pp. 11–11v, 45–45v). In a letter dated 1621 Nebbia confirms that he had made the mosaics on the basis of his own cartoons (ARFSP, *Artisti diversi*, vol. 1/5, no. 73). Both he and de' Vecchi in this instance followed a procedure established by Girolamo Muziano in the Gregorian Chapel, where Muziano both painted the cartoons and made some of the mosaics. The cartoons for the *putti* and the other decorative elements of the pendentives were painted by Christofano Roncalli, who received payments for

them on 5 May, 23 June, and 8 September 1600 (ARFSP, *Spese*, vol. 162, p. 72). Work on the mosaics had begun by 26 November 1599 though, judging from payments made to mosaicists Paolo Rossetti and Lodovico Martinelli (ARFSP, *Spese*, vol. 162, pp. 63, 73–73v). These decorations were also worked on by Marcello Provenzale; they were finished by November 1600 (ARFSP, *Spese*, vol. 162, pp. 82–82v).

The cartoons for the vault were painted by the Cavaliere d'Arpino, who received payments from July 1603 to January 1612. The mosaics were worked concurrently. Ranuccio Semprevivo was paid from July 1603 to March 1604 for his mosaic in the lantern (ARFSP, *Spese*, vol. 171, pp. 75–75v). From 28 November 1603 to September 1605, Ranuccio Semprevivo, Donato Parigi, and Rosato Parasole were paid for unspecified mosaics in the vault; these could have been the first level of cherubs closest to the lantern (ARFSP, *Spese*, vol. 171, pp. 79–79v, 80–80v; *Entrata e uscita*, vol. 178, passim). In 1605–6, except for the frieze with the inscription "TU ES PETRUS . . . ," no mosaic work in the vault seems to have been initiated, but by the late summer of 1607 work had resumed. On 7 September, Lodovico Martinelli, Donato Parigi, Marcello Provenzale, and Rosato Parasole were paid for the mosaic figures they were making (ARFSP, *Libro mastro*, vol. 180, passim; *Entrata e uscita*, vol. 183, p. 67). Martinelli received the money for the group, so it could be assumed that he was in charge of this phase of the project. The payments to Martinelli and the people working with him continue to 30 May 1608 (ARFSP, *Entrata e uscita*, vol. 183, p. 114v). In the summer of the same year, new contracts were made with Martinelli, Parigi, and Provenzale, and later with Francesco Zucchi and Parasole, to continue work on the figures in the vault (ARFSP, *Entrata e uscita*, vol. 183, pp. 125v, 127, 138v, 142v, 148v). The works on hand likely were the representations of the adoring angels and of the angels with the instruments of the Passion. The payments continue through 1608 and early 1609.

By 30 January 1609, Ranuccio Semprevivo, Rosato Parasole, Cesare Rossetti, Francesco Zucchi, Marcello Provenzale, Cesare Torelli, and Donato Parigi had also started to work the frieze in the drum with figures of nude angels, masks, and garlands (ARFSP, *Registro dei mandati*, vol. 185, pp. 91–91v, 98v, 99). They were joined in late winter and early spring by Paolo Rossetti, Lodovico

Martinelli, and Orazio Gentileschi (ARFSP, *Registro dei mandati*, vol. 185, pp. 101v, 148v). After Martinelli's death in the summer of 1609, his heirs received a final payment for his work on the frieze (ARFSP, *Registro dei mandati*, vol. 185, p. 159). A final payment to Marcello Provenzale on 18 September 1609 seems to indicate that the frieze was finished by that date (ARFSP, *Registro dei mandati*, vol. 185, p. 168v).

The payments are particularly precise for the sections of the mosaics at the bottom level of the vault that contain the large figures of Christ, the Virgin Mary, Saint Paul, and the twelve apostles. The bishops portrayed in the lunettes under those figures are not identified in the records, but in most cases the mosaicists and the date of execution are known. Paolo Rossetti was paid for the mosaic of the figure of Christ from March to December 1610 (ARFSP, *Spese*, vol. 195, pp. 28v, 121v); he also did the figure of the "Patriarch" in the lunette in the same period (ARFSP, *Spese*, vol. 195, p. 113v). Final placement of the figure and some of the touch-up work continued into the spring of 1611 (ARFSP, *Liste dell'anno*, vol. 198, p. 69).

Going clockwise around the dome, Cesare Rossetti and Ranuccio Semprevivo were paid for *Saint John the Baptist* from June 1610 to May 1611 (ARFSP, *Spese*, vol. 195, p. 53; *Liste dell'anno* vol. 198, p. 69), and Rosato Parasole was paid for the bishop from 7 January to 6 May 1611 (ARFSP, *Spese*, vol. 195, p. 126v; *Liste dell'anno*, vol. 198, p. 69); Rosato Parasole for *Saint James the Great* from June 1610 to May 1611 (ARFSP, *Spese*, vol. 195, p. 53v; *Liste dell'anno*, vol. 198, p. 69), and Giovanni Ercolano for the bishop from December 1610 through February 1611 (ARFSP, *Spese* vol. 195, pp. 122, 140v); Donato Parigi and Cesare Torelli for *Saint Bartholomew* and for the bishop from June 1610 to January 1611 (ARFSP, *Spese*, vol. 195, pp. 60v, 126, 132); Paolo Rossetti for *Saint Thomas* and perhaps for the bishop as well from 26 November 1611 to 7 January 1612 (ARFSP, *Liste dell'anno*, vol. 198, p. 184v; *Spese*, vol. 204, p. 2); Cesare Rossetti and Ranuccio Semprevivo for *Saint Simon*, in seven payments from 9 September to 18 November 1611 (ARFSP, *Liste dell'anno*, vol. 198, pp. 140, 179), and Cesare Torelli for the bishop in early 1612 (ARFSP, *Spese*, vol. 204, p. 3v); Paolo Rossetti and Donato Parigi for *Saint Thaddaeus*, in three installments from 2 March to 30 March 1612

(ARFSP, *Spese*, vol. 204, pp. 31v, 47v), and Giovanni Ercolano for the bishop in the spring of 1611 (ARFSP, *Spese*, vol. 195, p. 145v); Ranuccio Semprevivo and Rosato Parasole for *Saint James the Less* from 10 February to 30 March 1610 (ARFSP, *Spese*, vol. 204, pp. 20, 47), and Donato Parigi for the bishop in the early spring of 1611 (ARFSP, *Spese*, vol. 195, p. 145v); Donato Parigi and Francesco Zucchi for *Saint Matthias* from 7 January to 3 February 1612 (ARFSP, *Spese*, vol. 204, pp. 2, 16v), and Zucchi for the bishop in the spring of 1611 (ARFSP, *Liste dell'anno*, vol. 198, p. 84); Paolo Rossetti for *Saint Matthew* and for the bishop from February 1611 to March 1612 (ARFSP, *Spese*, vol. 204, p. 35; *Spese*, vol. 195, pp. 141v, 145v; *Liste dell'anno*, vol. 198, p. 69); Marcello Provenzale for *Saint Philip*, in three payments from 3 February to 24 February 1612 (ARFSP, *Spese*, vol. 204, pp. 16v, 28) and for the bishop in February and March 1611 (ARFSP, *Spese*, vol. 195, pp. 141v, 144v); Provenzale for *Saint Andrew* and probably also for the bishop from 11 November to 23 December 1611 (ARFSP, *Liste dell'anno*, vol. 198, pp. 176, 194); Provenzale for *Saint John the Evangelist* and the "Patriarch," which was set in place in the spring of 1611, from July to December 1610 (ARFSP, *Spese*, vol. 195, pp. 75, 113v, 120v, 121v; *Liste dell'anno*, vol. 198, p. 69); Cesare Rossetti and Ranuccio Semprevivo for *Saint Paul* from September 1610 to February 1611 (ARFSP, *Spese*, vol. 195, pp. 95v, 140v) and the bishop from January to March 1611 (ARFSP, *Spese*, vol. 195, pp. 132, 144v); Cesare Rossetti and Semprevivo for *Saint Peter* and the bishop from July 1610 to February 1611 (ARFSP, *Spese*, vol. 195, pp. 70, 140v); Orazio Gentileschi for the *Virgin Mary* from 28 May to 6 August 1610 (ARFSP, *Spese*, vol. 195, pp. 51, 78), and Francesco Zucchi for the bishop, set in place in the spring of 1611, from December 1610 to February 1611 (ARFSP, *Spese*, vol. 195, pp. 122, 140v; *Liste dell'anno*, vol. 198, p. 69). The decorations had been completed by the spring of 1612, and the scaffolding was removed from the dome in the early summer of that year.

The sixteen cartoons by the Cavaliere d'Arpino for the large figures of the vault were preserved at Montecassino, but they were destroyed in 1944. Among the known extant cartoons for other sections of the vault are the angel with the column (private collection, Rome); the angels over the figures of Christ, the Virgin Mary, Saint Peter, Saint James the Great, and Saint James the Less (Palazzo Chigi, Ariccia); the angels over Saint Andrew and Saint Philip (Palazzo Colonna, Rome); two angels from the third level (Palazzo Chigi, Ariccia); and a cartoon for an angel straddling a garland for the frieze of the drum (Corsham Court, Wiltshire).

References: Pollak, 1915, pp. 76–78, no. 39; Kirwin, 1972, pp. 157–58; Röttgen, 1973, pp. 119–22; Chapell and Kirwin, 1974, pp. 125–26.

G. Chapel of the Madonna della Colonna Plates 72–76

BENEDICTVS XIV PONT MAX AN SAL
MDCCLVII PONT XVII

PENDENTIVES
Saint Bonaventure
 VERE DOMINI MATER ET REGINA ES MISER-
 ICO
Saint Thomas Aquinas
Saint Cyril of Alexandria
Saint John Damascene

LUNETTES
Nativity with the Virgin and Child
Dream of Saint Joseph
King David
King Solomon
 OSCVLETVR ME OSCOLO ORIS SVI (Song of Sol.
 1:1)

The pendentive cartoons representing saints Bonaventure (*Fig. 10*) and Cyril were painted by Giovanni Lanfranco; the other two with saints Thomas Aquinas and John Damascene were painted by Andrea Sacchi. The mosaics of all four were made by Giovanni Battista Calandra. Payments to Lanfranco for *Saint Bonaventure* date from January 1629 to December 1630, and to Calandra for the mosaic from December 1630 to July 1631. For *Saint Cyril*, Lan-

franco's payments date from June to October 1632; Calandra's for the mosaic from September 1633 to May 1634. Sacchi was paid for *Saint Thomas Aquinas* from 15 July 1628 to 11 October 1631 (ARFSP, *Libro dei manuali*, vol. 246, p. 29), and Calandra for the mosaic from January to October 1632. For *Saint John Damascene*, Sacchi was paid from December 1632 to May 1635, and Calandra for the mosaic from March 1634 to December 1635. The subjects for the pendentives were selected by Pope Urban VIII himself (ARFSP, *Decreta*, vol. 3/160, p. 18). Presently, Sacchi's *Saint Thomas Aquinas* and Lanfranco's *Saint Bonaventure* are in the Galleria Nazionale d'Arte Antica, Palazzo Barberini, Rome. The other two cartoons are unlocated.

Payments were made to Giovanni Francesco Romanelli for the cartoons for the lunettes in two blocks. From April 1643 to January 1644 he was paid for the cartoons of the Virgin Mary and of Saint Joseph, and from June to November 1644 he was paid for the other two. The mosaics were begun by Calandra. From May 1643 to May 1644 he received payments for his execution of Romanelli's first two cartoons. Before he died in October 1644, Calandra finished *King David* and had begun *King Solomon*. *King Solomon* was finished by Guido Ubaldo Abbatini, who received two payments, one in 1645 and the other on 6 February 1647 (ARFSP, *Libro dei manuali*, vol. 292, p. 70).

About a hundred years later, Giacomo Zoboli was commissioned to paint the cartoons for the vault of the chapel, which had remained bare for so long. According to a contract dated 4 May 1742, Zoboli was to receive a total of 3,000 *scudi* for the entire commission (ARFSP, *Liste 1746*, vol. 4/87, Lista 22 December). The first payment to him is dated 31 July 1742 and the final payment 30 December 1748 (ARFSP, *Liste 1742*, vol. 4/83; *Liste 1748*, vol. 4/89). The mosaics do not seem to have been started until 1751 (ARFSP, *Liste 1751*, vol. 4/92, Lista 14 August). The mosaicists were Liborio Fattori, Domenico Gossoni, Giovanni Francesco Fiani, Bernardino Regoli, Guglielmo Paleat, Giuseppe Ottaviani, Pietro Polverelli, and Andrea Volpini (ARFSP, *Liste 1751*, vol. 4/92, Lista 14 August; *Liste 1753*, vol. 4/94, Lista 14 April; *Liste 1757*, vol. 4/98, Lista 9 August). In the late 1920s several of Zoboli's cartoons for the dome were exhibited at the Museo Petriano.

References: Cascioli, [1925], p. 32; Pollak, 1931, 2:550–51, nos. 2198, 2201, 2202, 2207; pp. 554–58, nos. 2223–44; pp. 560–63, nos. 2253–70; Waterhouse, 1937, p. 77; Kerber, 1973, pp. 148, 167, n. 54; Harris, 1977, pp. 60–61.

H. Clementine Chapel Plates 77–85

CLEMENS VIII PONT MAX AN SAL MDCI PONT X

PENDENTIVES
Saint Ambrose
Saint Augustine
 TOLLE LEGE LVIII CONFESS C XII
Saint John Chrysostom
 ΠΑΛΙΝ ΗΡΩΔΙΑΕ ΜΑΙΝΕΤΑΙ
Saint Athanasius

LUNETTES
The Visitation, Saint Elizabeth
The Visitation, Virgin Mary
Malachi Assisted by an Angel
Daniel in the Lions' Den

The cartoons for all the decorations in the chapel were painted by Christofano Roncalli. He received an initial payment for them on 23 February 1601 (ARFSP, *Spese*, vol. 171, p. 6). A payment dated 13 December 1602 indicates that all the cartoons were finished at that time; consequently, they can be dated from about February 1601 to December 1602 (ARFSP, *Spese*, vol. 171, p. 6). However, a final payment to Roncalli for his work in the Clementine Chapel was not made until 4 June 1604 (ARFSP, *Liber mandatorum*, vol. 174, p. 76v). An inscription under the figure of Saint John Chrysostom notes Roncalli's endeavors. The mosaics were executed at about the same time. The pendentives were begun in the spring of 1601 and finished before midsummer of the same year. *Saint John Chrysostom* was done by Lodovico Martinelli and Paolo Rossetti; *Saint Ambrose* by Marcello Provenzale; *Saint Augustine* by Fran-

cesco Zucchi and Vincenzo Stella; and *Saint Athanasius* by Ranuccio Semprevivo and Rosato Parasole (ARFSP, *Spese*, vol. 171, pp. 10, 10v, 11, 11v, 12, 12v).

From midsummer to early fall of 1601, Lodovico Martinelli executed the lunette with Saint Elizabeth and Ranuccio Semprevivo, with Rosato Parasole, the lunette with the Virgin Mary (ARFSP, *Spese*, vol. 171, pp. 26v, 32, 32v). *Daniel* was made by Marcello Provenzale in the spring of 1602 (ARFSP, *Spese*, vol. 171, pp. 58, 58v). The payments for *Malachi* have not been recovered, but it is reasonable to assume that the mosaic was also made in this same period.

Payments for the mosaics of the decorative motives in the vault date from 19 April 1601 to 20 May 1602. Specific portions of the mosaics are not attributable to individual artists, but the men involved in the project were Francesco Zucchi, Vincenzo Stella, Ranuccio Semprevivo, Rosato Parasole, Marcello Provenzale, Lodovico Martinelli, Giacomo Bresciano, Cristoforo Casalano, Andrea Aretino, and Donato Parigi (ARFSP, *Spese*, vol. 171, pp. 15, 15v, 16, 16v, 26, 26v, 28, 30, 30v, 31, 31v, 35, 35v, 36, 36v, 41, 42, 42v, 47, 47v, 48, 48v).

References: Kirwin, 1972, p. 159 passim; Chappell and Kirwin, 1974, pp. 128–29).

I. Chapel of the Choir Plates 86–98

PROCIDEBANT ET ADORABANT VIVENTEM (Rev. 5:14)

PENDENTIVES
Habakkuk and the Angel (Dan. 14:31–42)
Daniel in the Lions' Den
King David
Jonah and the Whale (Jon. 2)

LUNETTES
Deborah Sending for Barak in order to Make Him the Leader of the People of Israel (Judg. 4:6)

Judith with the Head of Holofernes (Jth. 13:17–18)
Moses Praying to God Supported by Aaron and Hur (Exod. 17:11–13)
Azariah Rebuking King Uzziah for Attempting to Burn Incense on the Altar in the Sanctuary (2 Chron. 26:17–19)
Jeremiah Lamenting the Destruction of Jerusalem (Lam. 5:19–21)
Deborah and Barak Giving Thanks to the Lord for Their Victory (Judg. 5:1)

Ciro Ferri was the first artist who was asked to provide designs for the mosaic decorations for the vestibule of the chapel. Presumably, he undertook this new commission soon after he had finished the cartoons for the Chapel of the Pietà in 1681. However, when he died on 13 November 1689, he had only completed cartoons for two pendentives, for which his heirs were paid 300 *scudi* in August 1691. Although many artists were interested in continuing Ferri's work in the chapel, the Congregazione della Reverenda Fabbrica resolved in September 1691 that nothing would be decided until Carlo Maratti's work in the Presentation Chapel was completed. On 20 May 1699, however, the Congregazione reversed itself and ordered that Maratti supervise the execution in mosaic of Ferri's two cartoons, and that he then paint the rest of the cartoons for the decoration of the chapel himself. There were two conditions: that Ferri's cartoons be executed first, and that Maratti finish the work in the Chapel of the Choir before turning again to the Presentation Chapel.

From 1699 to 1702 Maratti painted the cartoon representing Daniel and the one of Habakkuk and the Angel. He also made an enlargement for the mosaicists of Ferri's *King David*; Ferri's pendentive cartoons were for *King David* and *Jonah and the Whale*. The mosaics for the four pendentives were executed by Giuseppe Conti. From June 1699 to March 1700, he made the mosaic of *Jonah and the Whale* on the basis of an enlargement of the Ferri cartoon that he himself had painted. Why enlargements of the Ferri cartoons were necessary is not clear from the records. From June 1700 to December 1701, he worked on *King David*; by the

end of November 1702 he had finished *Daniel,* and by the end of November 1703 *Habakkuk.*

Maratti again turned his attention to the Presentation Chapel, and work on the decorations in the Chapel of the Choir lay fallow until 1711, when Marcantonio Franceschini was called from Bologna by Pope Clement XI to assume the project. Franceschini's cartoons for the vault date from the summer of 1711 to the spring of 1712. The mosaics were made by Filippo Cocchi from the fall of that year to the end of 1716.

Franceschini returned to Bologna after he had painted the cartoons for the vault, and from there at the end of 1713 he sent four cartoons for the lunettes to Rome. In 1719 he delivered the last two. Giuseppe Ottaviani began the mosaics for the lunettes in that same year, and by July 1721 he had finished four lunette mosaics based on Franceschini cartoons. Two of Franceschini's cartoons for the lunettes, *Miriam Singing and Dancing in Thanksgiving for the Safe Passage Through the Red Sea* and *Hannah Dedicating Samuel to God (Figs. 16, 17),* were rejected at some point, and two new paintings commissioned from Niccolò Ricciolini were substituted. The lunette representing Moses and that of Azariah rebuking King Uzziah were painted from the spring of 1720 to the summer of 1721. The mosaics were executed by Prospero Clori from the fall of 1721 to the summer of 1723.

All of Franceschini's cartoons for the vault and four of his cartoons for the lunettes are preserved in the Aula Magna in the Palazzo della Cancelleria. They were badly restored in the late 1930s. The cartoons for the vault were all taken to the Cancelleria early in 1718. Allegedly, the four lunette cartoons were also in place by July 1719, but there is some doubt about that, since Ottaviani did not finish the mosaics based on the cartoons until July 1721. The matter is complicated because the four lunette cartoons that were sent to the Cancelleria do not correspond to the Franceschini designs used for the mosaics. Only two of the lunette cartoons in the Aula Magna, *Judith* and *Deborah and Barak Giving Thanks,* were so employed. The other two, *Miriam* and *Hannah,* are the cartoons that were replaced by Ricciolini's designs. The remaining two lunette cartoons by Franceschini, *Jeremiah Lamenting the Destruction of Jerusalem* and *Deborah Sending for Barak,* and

the two by Ricciolini are unlocated. Zannotti noted that some cartoons painted by Franceschini for the Chapel of the Choir were given to the cathedral of Urbino. But the pictures by Franceschini known to have been there over the baptismal font and destroyed when the dome of the cathedral fell in January 1789 do not correspond to the unlocated cartoons. They were described as representing Deborah, Judith, King David, and Jephthah.

References: Zanotti, 1739, 1:233, 239; Lazzari, 1801, p. 8; Mezzetti, 1955, pp. 343–44; DiFederico, 1978, pp. 71–81; Rudolph, 1978, pp. 593–601.

J. Presentation Chapel Plates 99–108

RESPEXIT HVMILITATEM: DISPERSIT SVPERBOS (Luke 1:48, 51)

PENDENTIVES
Aaron with the Censer (Num. 16:46–50)
Noah with the Ark and the Dove (Gen. 8:6–12)
Gideon with the Fleece (Judg. 6:36–40)
Balaam with the Star of Jacob (Num. 24:17)

LUNETTES
Moses Removing His Sandals as He Approaches the Burning Bush (Exod. 3:5)
Miriam Singing and Dancing in Thanksgiving for the Safe Passage Through the Red Sea (Exod. 20:21)
Judith with the Head of Holofernes (Jth. 13:15)
Jael Killing Sisera (Judg. 4:21)
Joshua Stopping the Sun (Josh. 10:12–13)
Isaiah with the Cloud (Isa. 45:8)

Carlo Maratti was given the commission for the decorations of the Presentation Chapel in about 1675, according to a reference in the Fabbrica archives dated 28 August 1697 (ARFSP, *Decreta,* vol. 3/167, p. 179). However, he did not start work on the project until 1683. In the fall of that year the mosaicist Fabio

Cristofari was paid for his work on the pendentives for the chapel (ARFSP, *Liste 1683*, vol. 4/24, Lista 22 September). The first payment to Maratti for two pendentive cartoons was made on 1 March 1684 (ARFSP, *Liste 1684*, vol. 4/25); all four were finished by early 1685 (ARFSP, *Liste 1685*, vol. 4/26, Lista 21 February). By the summer of 1686 Maratti had also finished four lunette cartoons (ARFSP, *Liste 1686*, vol. 4/27, Lista 16 July). The last two were done by the fall of 1688 (*Pls. 105–108; Figs. 12, 13*), (ARFSP, *Liste 1688*, vol. 4/29, Lista 24 November). The final payment to Maratti for the cartoons for the pendentives and the lunettes, though, was not made until 25 January 1690 (ARFSP, *Liste 1690*, vol. 4/31). The mosaics for the pendentives had been begun by Fabio Cristofari by September 1683. Payments continue regularly through November 1688. The mosaics in the pendentives and the lunettes were finished before Cristofari died in January 1689. His heirs were paid the balance due for his work in the chapel in the summer of that year (ARFSP, *Liste 1689*, vol. 4/30, Giustificazioni 27 July).

In 1704 Maratti returned to the project. He presented the Fabbrica with five cartoons for the vault, for which he was paid on 3 September (ARFSP, *Liste 1704*, vol. 4/45). The second payment was made several years later, in 1710 (ARFSP, *Liste 1710*, vol. 4/51, Lista 5 February). By that time, however, the execution of the cartoons had been turned over to Giuseppe Chiari. According to a decree dated 5 February 1708, Chiari, under Maratti's direction, was ordered to continue and to finish the cartoons that had been begun by Maratti for the Presentation Chapel (ARFSP, *Decreta*, vol. 3/168, p. 60v). This meant that Chiari was to paint the cartoons on the basis of designs and sketches already established by Maratti. Maratti himself continued to receive payments for the project (ARFSP, *Liste 1711*, vol. 4/52, Lista 18 March). The final payment, made to him on 15 February 1713, acknowledges Chiari's involvement, and in the fall of that year Chiari himself was granted a bonus in recognition of his work (ARFSP, *Liste 1713*, vol. 4/54, pp. 19–19v, 287, 330).

In 1697 Giuseppe Conti had requested from the Congregazione that he be assigned some mosaic work in the basilica, and it was granted to him that he succeed the late Fabio Cristofari in executing Maratti's cartoons for the Presentation Chapel (ARFSP, *Decreta*, vol. 3/167, p. 179). Maratti, though, did not turn his attention to the cartoons for the vault of the Presentation Chapel until 1704, and Conti in the meantime was put to work on other projects, including the mosaics for the Chapel of the Choir. Once the cartoons for the vault of the Presentation Chapel were ready, it was Giuseppe Conti who undertook the execution of the mosaics.

On 12 December 1714 Conti received a large payment for mosaics he had executed in the vault from 1 February 1704 to the end of November 1714 (ARFSP, *Liste 1714*, vol. 4/55, pp. 261v, 303). He had finished the four principal sections of the vault with the representations of God the Father and the Virgin Mary with groups of angels around them, as well as the garland around the base of the lantern. Conti continued to work the mosaics through 1716, but in 1717 he was replaced by Leopoldo del Pozzo, Domenico Gossoni, and Giuseppe Ottaviani (ARFSP, *Liste 1717*, vol. 4/58, pp. 58, 198v, 201v). In 1720 Conti received payments from the Fabbrica in recognition of his assistance in the Presentation Chapel, but that is the last time his name is mentioned in connection with the project (ARFSP, *Liste 1720*, vol. 4/61, pp. 53v, 55).

At this point Giuseppe Chiari became involved in the project again, now as supervisor of the mosaicists working in the chapel, obviously replacing Conti (ARFSP, *Liste 1721*, vol. 4/62, p. 165v). He followed the work through to its completion in 1725. A justification for the final payment for the mosaics in the vault, dated 12 July 1725, noted that the work had been executed by the late Giuseppe Conti, Leopoldo del Pozzo, Domenico Gossoni, Matthia Moretti, Giuseppe Ottaviani, Matthia de'Rossi, and Prospero Clori. In 1727 Chiari accompanied the cartoons that had served for the decorations for the vault to Urbino, where they were installed in the cathedral (ARFSP, *Liste 1727*, vol. 4/68, Lista 5 April 1726). They were destroyed when the dome fell in January 1789. Maratti's six cartoons for the lunettes presently hang in the Benediction Loggia in Saint Peter's. Those for the pendentives are lost.

References: Serie distinta degli avvenimenti nella caduta della cupola della chiesa . . . d'Urbino, 1789, p. 5; Mezzetti, 1955, p. 344, nos. 148, 150; Kerber, 1968, p. 80; Westin and Westin, 1975, pp. 59–67.

K. Baptismal Chapel

Plates 109–121

QVI CREDIDERIT ET BAPTIZATVS FVERIT SALUVS ERIT (Mark 16:16)

PENDENTIVES
Europe
Asia
Africa
America

LUNETTES
Saint Peter Baptizing the Centurion Cornelius (Acts 10:48)
Saint Philip Baptizing the Eunuch of Queen Candace (Acts 8:38)
Christ Baptizing Saint Peter
Saint Sylvester Baptizing Constantine
Moses Striking Water from the Rocks (Exod. 17:6)
Noah Praying Before the Rainbow of the Covenant (Gen. 9:16)

When Giovan Battista Gaulli died on 2 April 1709, he left unfinished the decorations in the dome of the vestibule of the Baptismal Chapel. The commission had been awarded to him by Pope Clement X in the 1670s, but only in the first decade of the eighteenth century, on the insistence of Pope Clement XI, did Gaulli actively begin to work on the project. In July 1708 he delivered designs for the mosaics to the Fabbrica and was told to proceed with the paintings. Several months later, in February 1709, the Congregazione approved some of the cartoons and ordered that the scaffolding for the project be erected. However, returning on 26 March from the Vatican, where he had been studying the relationship of his designs to the site, Gaulli fell ill. He died within a month. His heirs immediately asked the Congregazione that one of Gaulli's students be allowed to finish the decorations, but it voted instead to pay Gaulli's heirs 1,200 *scudi* for the work done, to return the designs to them, and to look elsewhere for an artist to execute the entire commission from the beginning.

The Congregazione turned to Francesco Trevisani, whose involvement in the project began slowly and progressed in stages. Sometime between the summers of 1710 and 1711, Trevisani painted a cartoon for the decorative frieze that runs around the bottom of the drum of the dome above the pendentives, but only about April 1713 did he begin to work on the pendentive cartoons themselves. They were not delivered to the Fabbrica, however, until the late fall of 1723. The cartoons for the lunettes date from shortly before September 1732 to the summer of 1737, and those for the vault from the spring of 1738 to the spring of 1745. The first cartoon for the vault, *God the Father*, dates from before May 1738, and the second, going clockwise, for *Baptism by Desire*, from the winter of 1738–39. The third cartoon, *Baptism by Blood*, dates from the spring of 1740. The fourth, fifth, and sixth cartoons, representing another section of *Baptism by Blood*, *Baptism by Water*, and *Christ Seated at the Right Hand of God*, respectively, can be dated only as a group from July 1740 to the spring of 1743. The cartoons for the glory of angels were painted from January 1744 to the spring of 1745. Final payment for the commission was made to Trevisani on 22 April 1745.

The mosaics for the pendentives were executed from 1724 to 1726. Giuseppe Ottaviani did *Europe* and *America*, Liborio Fattori did *Africa*, and Giovan Battista Brughi did *Asia*. The lunette mosaics were executed from 1737 to 1739. Nicolo Onofri and Domenico Gossoni worked on *Saint Peter Baptizing the Centurion Cornelius;* Liborio Fattori and Pietro Cardoni on *Saint Philip Baptizing the Eunuch of Queen Candace;* Enrico Enuò and Silverio de Lelii on *Saint Sylvester Baptizing Constantine;* Alessandro Cocchi and Giovanni Francesco Fiani on *Christ Baptizing Saint Peter;* Alessandro Cocchi and Bernardino Regoli on *Moses Striking Water from the Rocks;* and Nicolo Onofri and Bernardino Regoli on *Noah Praying Before the Ark of the Covenant.* The work was done under the direction of Pietro Paolo Cristofari. The mosaics in the vault were executed from 1739 to 1746 by Enrico Enuò, Domenico Gossoni, Giovanni Francesco Fiani, Liborio Fattori, Pietro Cardoni, Prospero Clori, Nicolo Onofri, and Alessandro Cocchi. They were made under the direction of Pietro Paolo Cristofari until his death in 1743, when Pier Leone Ghezzi succeeded him as supervisor of the mosaic studio.

The cartoons for the pendentives are now lost. Soon after the mosaics were made, the cartoons were sent to decorate the dome in the cathedral at Urbino. They were destroyed when the dome fell in January 1789. However, all six of the cartoons for the lunettes survive. *Christ Baptizing Saint Peter* and *Saint Sylvester Baptizing Constantine* are installed beside the throne in the Benediction Loggia in Saint Peter's, having been placed there after 1925. The other four were exhibited in the 1920s at the Museo Petriano and are currently in storage. Only one cartoon for the vault, that depicting Christ at the right hand of God, is lost. The others decorate the transept of S. Maria deligi Angeli in Rome.

References: DiFederico, 1970, pp. 155–74; 1972, pp. 321–24; 1977, pp. 65–69.

The Altarpieces

1. Saint Nicholas of Bari
Plate 122

According to information recorded by the Congregazione della Reverenda Fabbrica on 30 September 1711, there were only two mosaic altarpieces at that time in the basilica. One was *Saint Michael* by Giovanni Battista Calandra, the other *Saint Nicholas of Bari* by Fabio Cristofari (ARFSP, *Decreta,* vol. 3/168, 91v passim). However, no payments to Cristofari have been uncovered. The mosaic is based on a painting of Saint Nicholas on the right transept altar in the Basilica di San Nicola in Bari.

2. Saint Joseph and the Child Jesus
Plate 123

According to documents and payments, the mosaic altarpiece was executed from May 1888 to February 1893 by Giovanni Ubizi, Pietro Bornia, Federico Campanili, and Licinio Campanili on the basis of an 1888 painting by Francesco Grandi. However, the mosaic is signed and dated "F e L Campanili, 1892." Originally, there were two options for the locations of the piece: the altar in the Chapel of the Sacrament, which held the mosaic after Caravaggio's *Entombment of Christ,* later moved to the altar in the sacristy and replaced by the *Ecstasy of Saint Francis* after Domenichino, or the Chapel of Saint Nicholas of Bari. The latter site was chosen, and in 1888 the chapel was renovated to accommodate the new work (ARFSP, *Studio del musaico,* Sezione II, Titolo I, no. 96). Grandi's painting was exhibited at the Museo Petriano in the 1920s.

References: Cascioli, [1925], p. 51.

3. Martyrdom of Saint Sebastian
Plate 124

Domenichino's original picture for this altar (*Fig. 20*) was painted in oil on a stucco ground. He was paid for it from 1625 to 1635. In 1736 the picture was transferred to S. Maria degli Angeli, Rome, and replaced by a mosaic executed by Pietro Paolo Cristofari on the basis of a cartoon painted by Luigi Vanvitelli in 1730 (ARFSP, *Liste 1736,* vol. 4/77, Lista 5 April–31 July; *Liste 1730,* vol. 4/71, Lista 26 July).

References: Castelli e ponti di . . . Zabaglia, 1824, pp. xvi–xvii, 16–17, and pl. XIX; Busiri-Vici, 1901, pp. 29–31; Borea, 1965, pp. 187–88; Spear, 1982, 1:98–99.

4. Ecstasy of Saint Francis

Plate 125

The mosaic, based on a painting by Domenichino in S. Maria della Concezione, Rome, had been ordered by Pope Pius VI for his hometown of Cesena, but because of the disruptions caused by the wars at the end of the eighteenth century, it was never sent there. Domenico De Angelis painted the cartoon for at least some parts of the work, and the mosaic was executed from 1795 to 1801 by Domenico Cerasoli, Bartolomeo Tomberli, and Filippo Cocchi (ARFSP, *Liste 1798*, vol. 5/39, no. 81; *Liste 1799*, vol. 5/42, no. 111; *Liste 1801*, vol. 5/48, no. 186). Twenty-five years later, it was placed on the altar that had been dedicated to saints Martial and Valeria in the left transept, where it was unveiled on 24 April 1824 (ARFSP, *Studio del musaico*, Sezione II, Titolo I, no. 116). Originally on this altar in the Chapel of the Sacrament was a painting of Saint Maurice attributed to Carlo Pellegrini. It was replaced in the mid-1820s by the mosaic after Caravaggio's *Entombment of Christ*, which was in turn replaced by *Ecstasy of Saint Francis* in 1896, when the altar on which the latter was located was rededicated to saints Martial and Valeria.

References: Borea, 1965, p. 188; Spear, 1982, 1:281–82.

5. Saint Wenceslas of Bohemia

Plate 126

Angelo Caroselli was paid for his painting of Saint Wenceslas, which is now lost, from 1627 to 1632. The mosaic was executed by Pietro Paolo Cristofari in 1739–40 (ARFSP, *Liste 1740*, vol. 4/81, Lista 31 July). The ovals of saints Cyril and Methodius, to the sides of the altar, are twentieth-century works.

References: Incisa della Rocchetta, 1965, pp. 22–27; Moir, 1967, 1:132; 2:63–64.

6. Martyrdom of Saints Processus and Martinianus

Plate 127

The original altarpiece by Valentin de Boulogne, now in the Vatican Picture Gallery, was painted in 1629–30. Filippo Cocchi received the commission for the mosaic on 24 July 1709, but the initial payment for his work was recorded only in February 1710. On 30 September 1711, the Congregazione della Reverenda Fabbrica noted that he was still working on it, and that it would be finished in less than two years (ARFSP, *Decreta*, vol. 3/168, pp. 71v, 91v; *Registro delle liste*, vol. 396, p. 86). At different times from 1727 to 1737, Liborio Fattori, Giovan Battista Brughi, and Pietro Paolo Cristofari worked on the altarpiece. However, whether they were involved with completing or restoring the piece is unclear.

References: I caravaggeschi francesi, 1973, p. 123; *I mosaici minuiti romani*, 1981, p. 32, n. 25.

7. Martyrdom of Saint Erasmus

Plate 128

The original altarpiece by Nicolas Poussin of 1629 is now in the Vatican Picture Gallery. Pietro Paolo Cristofari was paid from 27 November 1737 to 16 August 1739 for executing the mosaic (ARFSP, *Liste 1739*, vol. 4/80, Lista 31 July).

References: Blunt, 1966, pp. 66–68.

8. Saint Michael the Archangel

Plate 129

It was for this altar that the first mosaic altarpiece in the new basilica was made. Giovanni Battista Calandra was paid from 31 May 1627 to 18 December 1629 for a mosaic of Saint Michael the Archangel that he executed after a cartoon by the Cavaliere d'Arpino, which was painted expressly for the mosaic (ARFSP, *Libro dei manuali*, vol. 246, p. 21). In March 1756 the Congregazione della Reverenda Fabbrica judged that since the Calandra mosaic was in bad condition and not worth restoring, it should be replaced by a new mosaic after Guido Reni's *Saint Michael* in S. Maria della Concezione, Rome (ARFSP, *Decreta*, vol. 3/170, pp. 25v, 29). The mosaic was executed by Bernardino Regoli and Giovanni Francesco Fiani, who were paid from April 1757 to April 1758 (ARFSP, *Liste 1757*, vol. 4/98; *Liste 1758*, vol. 4/99). In 1771 Liborio Fattori, Giovanni Battista Fiani, and Bartolomeo Tomberli restored Calandra's *Saint Michael* prior to Pope Clement XIV's presenting it to Cardinal Marefoschi, who had it installed in

the cathedral of Macerata. (ARFSP, *Decreta*, vol. 3/14, p. 185). The mosaic can still be seen there.

References: Gnudi, 1955, p. 81; Röttgen, 1973, p. 131.

9. Burial of Saint Petronilla Plate 130

The original painting of 1623 by Giovanni Francesco Barbieri ("Il Guercino") is now in the Capitoline Picture Gallery, Rome. In 1725–26 Sebastiano Conca was paid to do a cartoon after the picture for the mosaicists (ARFSP, *Liste 1725*, vol. 4/66, Lista 20 December; *Liste 1726*, vol. 4/67, Lista 10 December). Pietro Paolo Cristofari began the mosaic on the basis of Conca's cartoon, but at some point he rejected it in favor of the original picture. He was paid for the mosaic from July 1728 to April 1730 (ARFSP, *Liste 1728*, vol. 4/69, Lista 23 July; *Liste 1730*, vol. 4/71, Lista 26 July).

References: Grimaldi, 1968, pp. 54–56, 92; *Il Guercino*, 1968, pp. 112 ff; *Sebastiano Conca*, 1981, p. 27.

10. Last Communion of Saint Jerome Plate 131

The altarpiece is taken from the painting of 1614 by Domenichino, which is now in the Vatican Picture Gallery. The cartoon after the painting was made by Luigi Vanvitelli, who received final payment for the work on 23 May 1730 (ARFSP, *Liste 1730*, vol. 4/71, Lista 26 July). The mosaic was executed by Pietro Paolo Cristofari, the final payment to whom is dated 26 March 1733 (ARFSP, *Liste 1733*, vol. 4/74). Originally, the altar contained a painting of Saint Jerome by Girolamo Muziano, possibly finished by Paul Brill, which is now in S. Maria degli Angeli, Rome.

References: Procacci, 1954, p. 262, n. 65; Borea, 1965, pp. 148–49; Spear, 1982, 1:175–78.

11. Mass of Saint Basil Plate 132

The painting (*Fig. 19*) that served as the cartoon for this altarpiece was commissioned from Pierre Subleyras on 13 September 1743.

He was paid for the picture, which is now in S. Maria degli Angeli, Rome, from 23 December 1743 to 29 December 1747 (ARFSP, *Liste 1743*, vol. 4/84; *Liste 1747*, vol. 4/88). The mosaic was made from 1748 to 1751 by Guglielmo Paleat, Giuseppe Ottaviani, Enrico Enuò, and Nicolo Onofri; Onofri, however, withdrew from the project in mid-1750 because of illness (ARFSP, *Liste 1748*, vol. 4/89, Lista 30 December; *Liste 1750*, vol. 4/91, Lista 3 August; *Liste 1751*, vol. 4/92, Lista 14 August). Originally, the altar contained a picture of Saint Basil by Girolamo Muziano, finished by Cesare Nebbia, which is now lost. In 1723–24 Luigi Vanvitelli painted a cartoon after the Muziano for the use of the mosaicists, but the mosaic was never made.

References: Dimier, 1930, 2:66–67, 76–77; Procacci, 1954, p. 262.

12. Navicella Plate 133

Giovanni Lanfranco received final payment for the picture for this altar in 1631. A cartoon of it was made by Niccolò Ricciolini in 1719–20, and the mosaic was executed by Pietro Paolo Cristofari, who was paid for his work from 20 December 1721 through 25 September 1726 (ARFSP, *Liste 1721*, vol. 4/62, p. 415; *Liste 1726*, vol. 4/67). Sindone and Martinetti note that this was the first work executed by the "Scuola del Cavaliere Pietro Paolo Cristofari" and that the painting by Lanfranco was preserved "nel Portico superiore della Basilica," where a section of it can still be found (*Fig. 28*). Originally, the altar held Bernardo Castello's *Christ Walking on the Water*, which is known today only from an engraving by Jacques Callot.

References: Sindone and Martinetti, 1750, p. 148; Waterhouse, 1937, p. 77; Salerno, 1958, p. 58; *Italian Drawings . . . Albertina*, 1971, no. 76; Chappell and Kirwin, 1974, pp. 130–31, 145–46.

13. Raising of Tabitha Plate 134

The cartoon was painted by Placido Costanzi, who received payment for it on 31 July 1740 (ARFSP, *Liste 1740*, vol. 4/81). The

picture was to replace the altarpiece by Giovanni Baglione, painted in about 1604 to 1606 but in complete ruin by the mid-eighteenth century. The Costanzi cartoon was neglected for several years. In March 1756 the Congregazione della Reverenda Fabbrica finally decided to execute the mosaic, and in 1758 Costanzi was paid 450 *scudi* for repainting his picture (ARFSP, *Decreta*, vol. 3/170, pp. 25, 29; *Liste 1758,* vol. 4/99, Lista 4 April). The picture is signed and dated 1757. The mosaic was executed by Giuseppe Ottaviani, Guglielmo Paleat, Bernardino Regoli, and Giovanni Francesco Fiani from 1758 to 1760 (ARFSP, *Liste 1758,* vol. 4/99, Lista 20 December; *Liste 1760,* vol. 4/101, Lista 22 December). Costanzi's picture, along with a copy of Baglione's painting, is now in S. Maria degli Angeli, Rome.

References: Chattard, 1762, p. 76; Chappell and Kirwin, 1974, pp. 130–31, 144–45; Clark, 1981, p. 60.

14. Saint Peter Healing the Cripple at the Porta Spetiosa
Plate 135

The history of the altarpiece goes back to a commission given to Tommaso Laureti in 1599. After Laureti's death in 1602, the commission passed to Ludovico Cigoli, who finished the picture by the end of 1606. It soon deteriorated, however, and it is known today only from engravings by Jacques Callot and Nicholas Dorigny. In 1719 Giovanni Domenico Campiglia painted a cartoon of the Cigoli, which must have been intended for a mosaic; the mosaic was never executed (ARFSP, *Liste 1719,* vol. 4/60, Lista 20 September). The altarpiece in place was made from a painting by Francesco Mancini, who received payments for it from 1744 to 1748 (ARFSP, *Liste 1744,* vol. 4/85, p. 33v; *Liste 1748,* vol. 4/89, Lista 31 July). The mosaic was executed from 1751 to 1758 by Alessandro Cocchi, Enrico Enuò, Guglielmo Paleat, and Giuseppe Ottaviani (ARFSP, *Liste 1751,* vol 4/92, Lista 14 August; *Liste 1758,* vol. 4/99, Lista 4 April). At the beginning of the nineteenth century, Mancini's picture was in the Palazzo del Quirinale, Rome; in the late 1920s it was exhibited at the Museo Petriano.

References: Cascioli, [1925], p. 21; Sestieri, 1977, pp. 71–72.

15. Christ of the Sacred Heart Appearing to Saint Margaret Mary Alacoque
Plate 136

Originally, the altar held Francesco Vanni's painting *Fall of Simon Magus,* which underwent a number of restorations and is now dismantled and in storage. A new picture on the same subject to replace Vanni's was commissioned from Pompeo Batoni, who received payments for it from 1746 to 1755 (ARFSP, *Liste 1746,* vol. 4/87, Lista 13 April; *Liste 1755,* vol. 4/96, Lista 19 April). A mosaic after Batoni's picture was begun, but after only one payment to Guglielmo Paleat, Giuseppe Ottaviani, Giovanni Francesco Fiani, and Alessandro Cocchi, the project apparently was abandoned and the Batoni cartoon sent to S. Maria degli Angeli, Rome (ARFSP, *Liste 1755,* vol. 4/96, Lista 23 December). The Vanni painting remained on the altar until the 1920s, when it was finally replaced by the present mosaic, which had been commissioned to celebrate the canonization of Saint Margaret Mary Alacoque in 1920.

The painting for this work was created by Carlo Muccioli in 1919–20. The mosaic was executed from 1920 to 1925 by Ludovico Lucietto, Evandro Monticelli, Carlo Simonetti, Luigi Chiaserotti, Lorenzo Cassio, and Romolo Sellini. In 1955 Muccioli's picture was sold to the Seminario Serafico dei Minori Cappuccini in Todi (Perugia) (ARFSP, *Studio del musaico,* Sezione II, Titolo I, no. 276).

References: Chattard, 1762, pp. 95–96; Galassi Paluzzi, 1963, pp. 125–27; Chappell and Kirwin, 1974, pp. 130–31, 136–37; Clark, 1981, pp. 108–9.

16. Death of Sapphira
Plate 137

The mosaic altarpiece was made by Pietro Adami from 1725 to 1727 (ARFSP, *Liste 1725,* vol. 4/66, Lista 7 April; *Liste 1728,* vol. 4/69, Lista 22 March). It is the only mosaic on the pier altars based on a picture from the original Petrine cycle painted around 1600. Christofano Roncalli was paid for the painting, now in S. Maria degli Angeli, Rome, from 1599 to 1604. Originally, the painting was located on the east side of the pier, where the mosaic

of Raphael's *Transfiguration* is now placed. The mosaic of *Death of Sapphira* also was first located there, but in 1768 it was moved to its present location on the south side of the pier and the *Transfiguration* put in its place. The altar on the south side of the pier has held in turn the following works: *The Crucifixion of Saint Peter* by Domenico Passignano; from 1759 a copy by Stefano Pozzi of Raphael's *Transfiguration*, while it was being worked in mosaic; after 1768, the mosaic of Roncalli's *Death of Sapphira*.

References: Chattard, 1762, p. 101; Incisa della Rocchetta, 1932, pp. 255–70; Chappell and Kirwin, 1974, pp. 130–31, 132–36.

17. Transfiguration Plate 138

The idea for a mosaic copy after Raphael's *Transfiguration* goes back to 1744, when the Congregazione della Reverenda Fabbrica asked permission to copy the painting, then in the church of S. Pietro in Montorio (ARFSP, *Decreta*, vol. 3/170, p. 4v). It was not executed in mosaic until several years later, from 1759 to 1767, by Giovanni Francesco Fiani, Guglielmo Paleat, Alessandro Cocchi, Bernardino Regoli, Pietro Polverelli, and Vincenzo Castellini (ARFSP, *Liste 1767*, vol. 4/108, Lista 27 July). The cartoon had been painted by Stefano Pozzi, who received payments from the Fabbrica from 21 December 1756 to 15 August 1759 (ARFSP, *Liste 1756*, vol. 4/97; *Liste 1759*, vol. 4/100). The final recognition and acceptance of the mosaic was made in June 1768 by Salvatore Monosilo, who noted that it had only recently been placed in the basilica (ARFSP, *Liste 1768*, vol. 4/109, pp. 155, 172). The altar on which it was set had originally contained *Death of Sapphira* by Christofano Roncalli, first as a painting, and then as a mosaic. The painting by Raphael is presently in the Vatican Picture Gallery. Pozzi's copy was exhibited at the Museo Petriano in the 1920s.

References: Cascioli, [1925], p. 21; Dussler, 1971, pp. 52–55.

18. Christ Carrying the Cross, and Saint Veronica Plate 139
19. Saint Andrew Adoring the Cross of His Martyrdom Plate 140

20. Martyrdom of Saint Longinus Plate 141
21. Saint Helen and the Miracle of the True Cross Plate 142

In 1633 the Congregazione della Reverenda Fabbrica decided to decorate the altars in the Grotto under the four piers of the crossing with pictures. Andrea Sacchi was commissioned to paint them, and they date from 1633 to 1650. The pictures are now kept in the Chapter House near the sacristy. In the summer of 1682, the Congregazione noted that the pictures were being ruined by humidity, and Fabio Cristofari was commissioned to clean them and make mosaics after them (ARFSP, *Entrata e uscita*, vol. 382, f. 19). The first payment for his work on the mosaics was made on 18 November 1682 (ARFSP, *Liste 1682*, vol. 4/23); payments continued to be made to him until his death on 27 January 1689. On 27 July of that year his heirs were paid for all his work in the Presentation Chapel and on the four altarpieces for the Grotto altars (ARFSP, *Liste 1689*, vol. 4/30). The minutes of a meeting of the Congregazione della Reverenda Fabbrica held on 30 September 1711 confirm that the mosaics were all executed by him (ARFSP, *Decreta*, vol. 3/168, p. 91v passim). In March 1714 Pietro Paolo and Filippo Cristofari, Fabio's sons, managed to get a final payment for the four pictures done for the Grotto altars (ARFSP, *Uscita*, vol. 403, p. 200v).

References: Harris, 1977, pp. 71–74.

22. Incredulity of Saint Thomas Plate 143

The first picture for this altar was painted by Domenico Passignano. The mosaic, begun in the early fall of 1806, however, is based on a new painting by Vincenzo Camuccini (*Fig. 25*), who received a final payment for it in August of that year (ARFSP, *Entrata e uscita*, vol. 473, pp. 462–63, 473, 474). New contracts for the completion of the mosaic were made in 1811 and 1822 (ARFSP, *Studio del mosäi al Vaticano*, vol. 29/1, nos. 120, 248). The piece was only finally put in place on 16 December 1822 (ARFSP, *Diario dei Cerimonieri*, busta 41, f. 274). Through the years the following mosaicists worked on the picture: Bartolomeo Tomberli, Vincenzo Castellini, Antonio Castellini, Raffaele Castellini, Raf-

faele Cocchi, Domenico Pennacchini, Vincenzo Cocchi, and Michele Volpini (ARFSP, *Protocollo 1822*, vol. 6/11, no. 434). The painting by Camuccini, for which two small *modelli* are known, was exhibited at the Museo Petriano in the late 1920s. Prior to that it had been preserved in the Vatican Mosaic Studio.

References: Memorie enciclopediche romane sulle belle arti, 1806, 1:36–40; Falconieri, 1875, pp. 75–76; Cascioli, [1925], p. 51; Hiesinger, 1978, pp. 303–15; *Vincenzo Camuccini . . .* , 1978, p. 78, nos. 165, 166.

23. Saint Joseph Patron of the Universal Church Plate 144

Originally on this altar was a painting of 1630 by Agostino Ciampelli representing saints Simon and Jude. In February 1814 it was replaced by the mosaic after Guido Reni's *Crucifixion of Saint Peter*, which previously had been in the sacristy (ARFSP, *Atti e conti*, pacco 95, p. 666). The dedication of the altar to saints Simon and Jude was then memorialized by two mosaic ovals representing the saints on the walls on the sides of the altar, for which Vincenzo Camuccini received a final payment on 9 April 1822 (ARFSP, *Protocollo 1822*, vol. 6/9, no. 94). The paintings by Camuccini were exhibited at the Museo Petriano in the late 1920s. *Crucifixion of Saint Peter* was in turn replaced by *Saint Joseph*, which had been commissioned by Pope John XXIII. The painting by Achille Funi was presented to the mosaic studio in 1961. The mosaic by Virgilio Cassio, Odoardo Anselmi, Silvio Secchi, Fabrizio Parsi, and Giulio Purificati was placed on the altar in 1963.

References: Cascioli, [1925], pp. 50, 51; *Vincenzo Camuccini . . .* , 1978, p. 81, no. 169.

24. Crucifixion of Saint Peter Plate 145

This altar at first contained a painting of saints Martial and Valeria by Giacomo (Giovan Antonio) Galli, called "Lo Spadarino." In April 1824 it was replaced by the mosaic after Domenichino's *Ecstasy of Saint Francis*, which is now in the Chapel of the Sacrament,

and the picture by "Lo Spadarino" was given to the church of S. Caterina della Rota in Rome. It is now in the the Chapter House in Saint Peter's. At the end of the nineteenth century, the altar was rededicated to the saints Martial and Valeria on the insistence of and through the persistence of the then Bishop of Limoges. A mosaic altarpiece was executed from May 1893 to December 1895 by Giovanni Ubizi, Pietro Bornia, Ettore Vanutelli, Federico Campanili, Augusto Moglia, Licinio Campanili, and Innocenzo Pallini on the basis of a cartoon painted for them by Cesare Vallati (ARFSP, *Studio del mosaico*, Sezione II, Titolo I, no. 116). The mosaic representing saints Marital and Valeria remained on the altar until 1963, when it was replaced by the mosaic after Guido Reni's *Crucifixion of Saint Peter*, the piece presently on the altar. The earlier mosaic is now on display at the Vatican Mosaic Studio.

The mosaic of *Crucifixion of Saint Peter* was executed by Bartolomeo Tomberli, Domenico Cerasoli, and Lorenzo Roccheggiani, who received payments for their work from 21 August 1779 to 10 April 1784 (ARFSP, *Liste 1784*, vol. 4/120, p. 144v). The piece was placed in the sacristy in May 1784; in 1814 it was moved to the altar of saints Simon and Jude in the center of the left transept (ARFSR, *Atti e conti*, pacco 95, p. 666). It was displaced from that site to the right altar in 1963 by the mosaic *Saint Joseph Patron of the Universal Church*. The painting by Gudo Reni is in the Vatican Picture Gallery.

References: Gnudi, 1955, pp. 55–56; Moir, 1967, 2:72.

25. Entombment of Christ Plate 146

The mosaic is based on Caravaggio's painting now preserved in the Vatican Picture Gallery. The earliest payments for the mosaic that have been recovered are those made to Domenico Cerasoli, Filippo Cocchi, and Antonio Castellini in 1806 for work in progress (ARFSP, *Riparti delle liste*, vol. 465, p. 547). In 1821 the piece was restored by Domenico Cerasoli, Raffaele Cocchi, Raffaele Castellini, and Nicolo Roccheggiani (ARFSP, *Entrata e uscita*, vol. 510, p. 77). Two years later, in August 1823, records show that the architect Giuseppe Valadier suggested the mosaic would go well on the main altar of the sacristy, and that it could easily be adapted to that place (ARFSP, *Protocollo 1823*, vol. 6/13, no. 287). Pistolesi

records, however, that it was in place on the side altar in the Chapel of the Sacrament in 1829, where it remained until 1896. It then was moved to the sacristy, having been displaced by the mosaic after Domenichino's *Ecstasy of Saint Francis*.

References: Pistolesi, 1829, 1:102–4; Friedlander, 1955, pp. 186–89; Marini, 1974, pp. 398–99.

26. Saint Gregory and the Miracle of the Corporal
Plate 147

Andrea Sacchi's picture for the altar in the Clementine Chapel dates from 1625 to 1627. On 12 January 1770 the Congregazione della Reverenda Fabbrica decided to have it made in mosaic (ARFSP, *Decreta*, 3/170, p. 80v). It was executed by Alessandro Cocchi, Filippo Cocchi, and Vincenzo Castellini, who received final payment for their work on 25 April 1772 (ARFSP, *Liste 1772*, vol. 4/113, p. 191v). The painting by Sacchi is now in the Chapter House beside the sacristy.

References: Harris, 1977, p. 52.

27. Immaculate Conception
Plate 148

Pietro Bianchi received his first payment for the picture that served as the cartoon for this mosaic in 1734 (ARFSP, *Liste 1734*, vol. 4/75, Lista 24 April). However, the Fabbrica did not receive the picture until somewhat later. In 1738 Bianchi was paid another 200 *scudi* for the painting, with the condition that he finish it within one year, but apparently it was only barely finished at the time of his death in 1740 (ARFSP, *Liste 1738*, vol. 4/79, Lista 31 March). The final payment for the painting was made to Bianchi's heirs in the summer of 1741 (ARFSR, *Liste 1741*, vol. 4/82, Lista 31 July). The mosaic was executed by Nicolo Onofri, Enrico Enuò, Giuseppe Ottaviani, and Guglielmo Paleat from 1744 to 1747 (ARFSP, *Liste 1744*, vol. 4/85, p. 6v; *Liste 1745*, vol. 4/86, Lista 31 July; *Liste 1747*, vol. 4/88, Lista 24 December). The painting by Bianchi is now in S. Maria degli Angeli, Rome.

References: Clark, 1981, p. 60.

28. Presentation of the Virgin
Plate 149

Giovanni Francesco Romanelli was paid from 27 March 1639 to 13 November 1642 for the painting that replaced one by Domenico Passignano, which was originally on this altar (ARFSP, *Liste dei manuali*, vol. 292, p. 18). A cartoon of Romanelli's painting was done by Luigi Vanvitelli in 1725, and the mosaic was executed by Pietro Paolo Cristofari from 1726 to 1728 (ARFSP, *Liste 1726*, vol. 4/67, Lista 25 September, 17 December; *Liste 1729*, vol. 4/70, Lista 23 July). Romanelli's painting is now in S. Maria degli Angeli, Rome.

References: Faldi, 1970, pp. 68, 302; Kerber, 1973, pp. 133, 162–63, n. 7.

29. Saint Peter Baptizing the Centurion Cornelius
Plate 150

The cartoon, painted by Andrea Procaccini from 1710 to 1711, is now in the church of S. Francesco in Urbino. The mosaic was begun by Giovan Battista Brughi in 1726, but it was left incomplete at the time of his death in 1731 (ARFSP, *Giornale*, vol. 412, p. 478). In the summer of 1733 Pietro Paolo Cristofari resumed work on the mosaic, and final payment was made to him three years later, in July 1736 (ARFSP, *Liste 1733*, vol. 4/74, f. 5; *Saldaconti degli artisti*, vol. 424, f. 77; *Liste 1736*, vol. 4/77, f. 7).

References: DiFederico, 1968, pp. 194–97.

30. Baptism of Christ
Plate 151

Carlo Maratti painted the picture from which the mosaic was made from the winter of 1696 to the summer of 1698. It is now in S. Maria degli Angeli in Rome. The mosaic was begun by Giovan Battista Brughi in the summer of 1730, but he died in early 1731, leaving it incomplete (ARFSP, *Liste 1730*, vol. 4/71, f. 5). It was finished by Pietro Paolo Cristofari, to whom payments were made from July 1732 to March 1734 (ARFSP, *Liste 1732*, vol. 4/72, f. 2; *Liste 1734*, vol. 4/74, f. 2).

References: DiFederico, 1968, pp. 194–97.

31. Baptism of Saints Processus and Martinianus

Plate 152

The picture that served as the cartoon was painted by Giuseppe Passeri from 1709 to 1711. The mosaic was made by Giovan Battista Brughi, who was paid from the summer of 1726 to 3 April 1730 (ARFSP, *Liste 1726*, vol. 4/67, f. 4; *Liste 1730*, vol. 4/71, f. 1). The mosaic was then reworked by Pietro Paolo Cristofari from July 1736 to December 1737, right after he had finished the mosaic *Saint Peter Baptizing the Centurion Cornelius* for the same chapel. Final payment to Pietro Paolo was made on 24 April 1738 (ARFSP, *Liste 1738*, vol. 4/78). The painting by Passeri is presently in the church of S. Francesco in Urbino.

References: DiFederico, 1968, pp. 194–97.

Plates

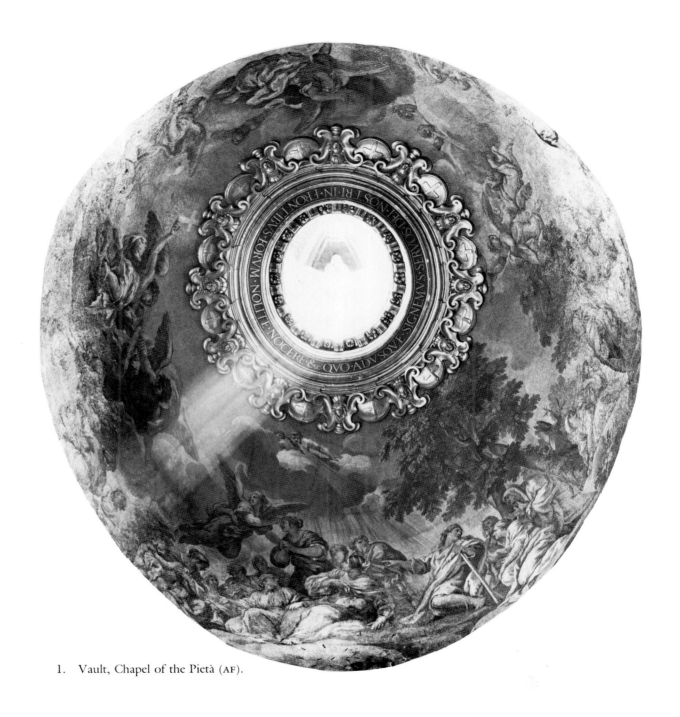

1. Vault, Chapel of the Pietà (AF).

2. Vault, Chapel of the Pietà (AF).

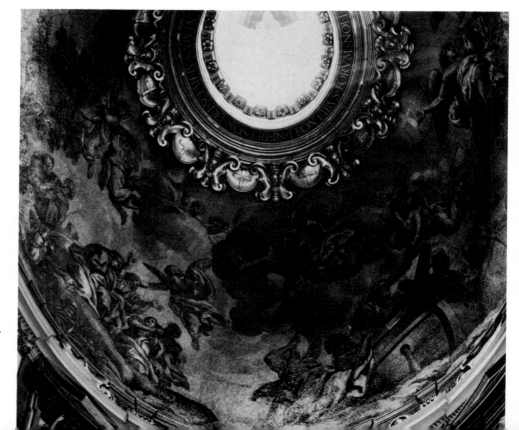

3. Vault, Chapel of the Pietà (AF).

I

II

I. *Transfiguration* (detail).

II. *Christ of the Sacred Heart Appearing to Saint Mary Margaret Alacoque* (detail).

III. *Saint Peter Healing the Cripple at the Porta Spetiosa* (detail).

IV. *Death of Sapphira* (detail).

III

IV

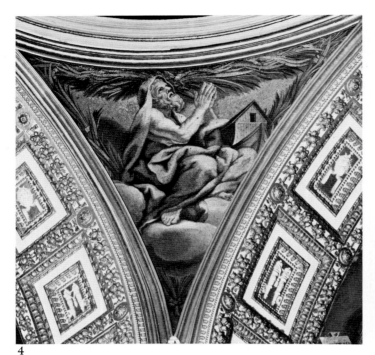

4

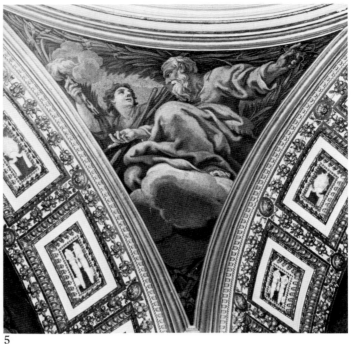

5

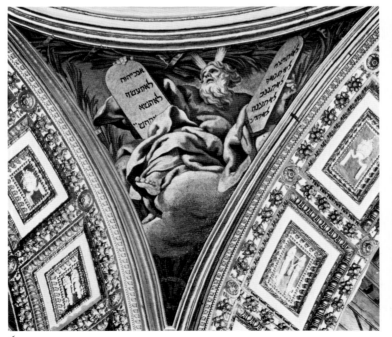

6

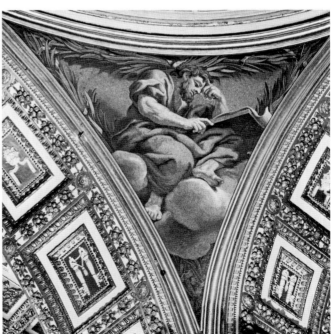

7

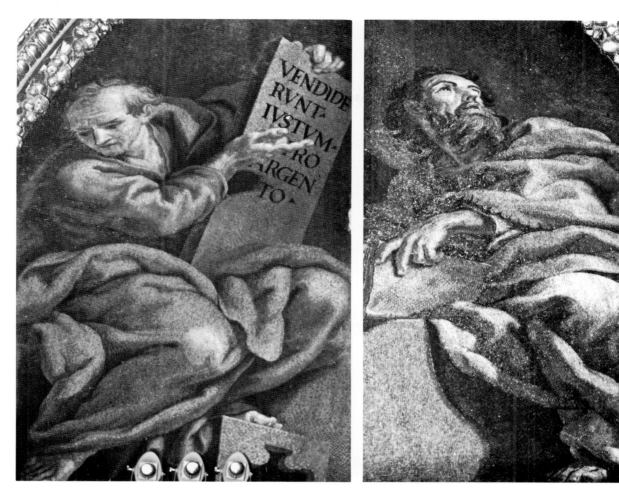

8. *The Prophet Amos,* Lunette, Chapel of the Pietà (AF).

9. *The Prophet Zechariah,* Lunette, Chapel of the Pietà (AF).

OPPOSITE:

4. *Noah and the Ark,* Pendentive, Chapel of the Pietà (AF).

5. *Abraham and the Sacrifice of Isaac,* Pendentive, Chapel of the Pietà (AF).

6. *Moses with the Tablets of the Law,* Pendentive, Chapel of the Pietà (AF).

7. *The Prophet Jeremiah,* pendentive, Chapel of the Pietà (AF).

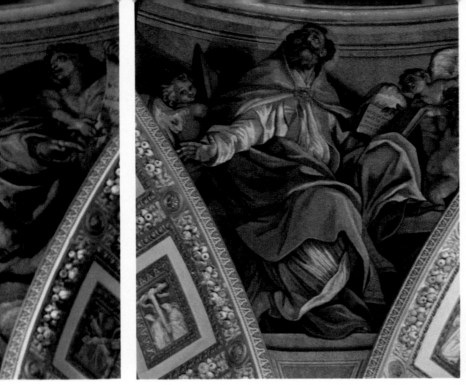

VI

V. *Saint Cyril of Alexandria,* Pendentive, Chapel of the Madonna della Colonna.

VI. *Saint Bonaventure,* Pendentive, Chapel of the Madonna della Colonna.

VII. Vault, Baptismal Chapel.

VIII. *Death of Sapphira.*

V

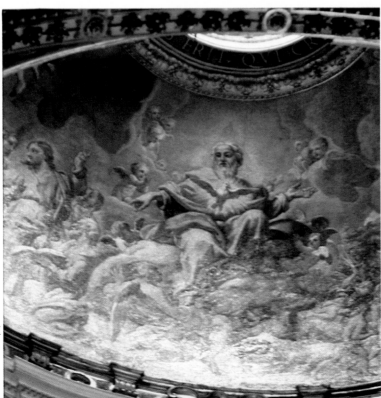

VII

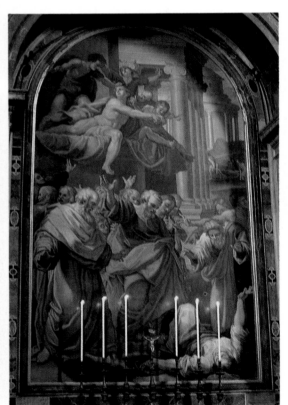

VIII

X

IX. *Mass of Saint Basil* (detail).

X. *Navicella* (detail).

XI. *Saint Thomas Aquinas,* Pendentive, Chapel of the
Madonna della Colonna.

XII. Vault, Presentation Chapel.

XII

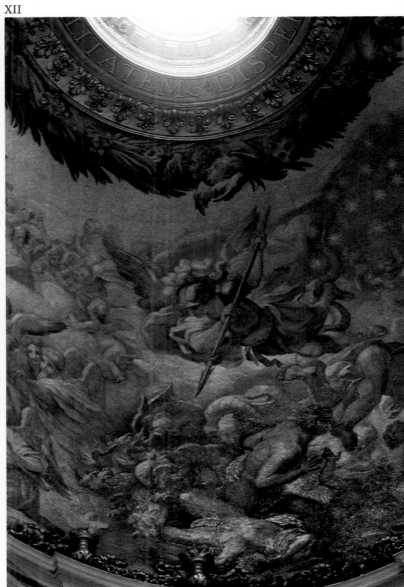

IX

XI

10. *The Phrygian Sibyl,* Lunette, Chapel of the Pietà (AF).

11. *The Cumaean Sibyl,* Lunette, Chapel of the Pietà (AF).

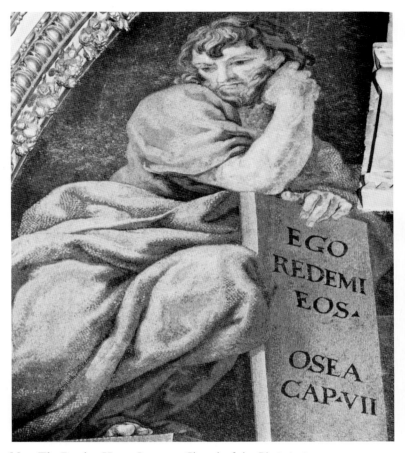

12. *The Prophet Hosea,* Lunette, Chapel of the Pietà (AF).

13. *The Prophet Isaiah,* Lunette, Chapel of the Pietà (AF).

XIII.

XIII. *Aaron Filling a Vase with Manna,* Pendentive, Chapel of the Sacrament.

XIV. *Abraham and the Sacrifice of Isaac,* Pendentive, Chapel of the Pietà.

XV. *Saint Peter,* Porta Santa.

XVI. *Saint Basil the Great,* Pendentive, Gregorian Chapel.

X

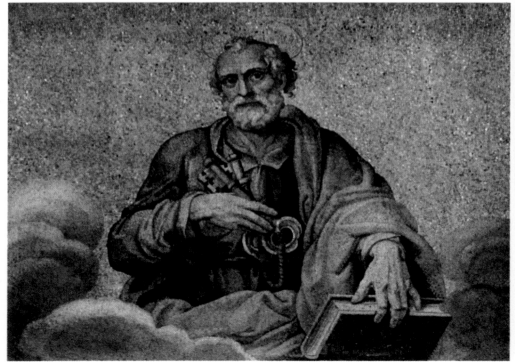

XV

XVI

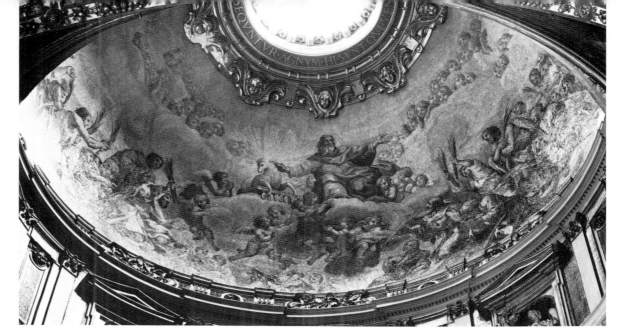

14. Vault, Chapel of Saint Sebastian (AF).

15. Vault, Chapel of Saint Sebastian (AF).

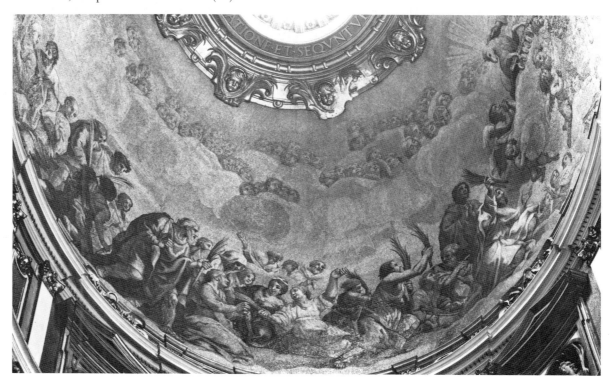

16

17

18

19

16. *Abel Offering a Lamb as a Sacrifice,* Pendentive, Chapel of Saint Sebastian (AF).

17. *The Prophet Isaiah,* Pendentive, Chapel of Saint Sebastian (AF).

18. *Zechariah, Son of Jehoiada, Stoned in the Atrium of the Temple,* Pendentive, Chapel of Saint Sebastian (AF).

19. *The Prophet Jeremiah* (or Ezekiel), Pendentive, Chapel of Saint Sebastian (AF).

20. *Martyrdom of Two Hebrew Women Thrown from the Walls of the City for Having Circumcised Their Sons,* Lunette, Chapel of Saint Sebastian (AF).

21. *Eleazar Refusing to Eat Forbidden Meat,* Lunette, Chapel of Saint Sebastian (AF).

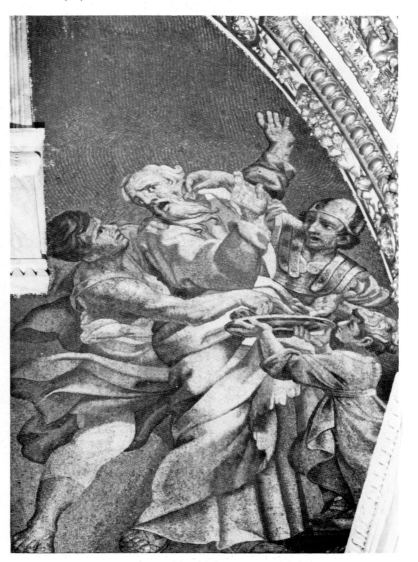

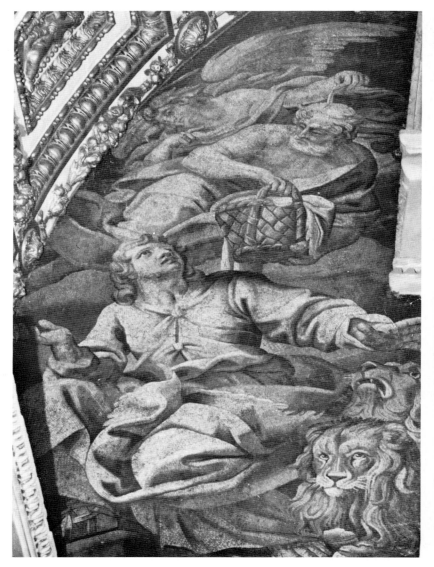

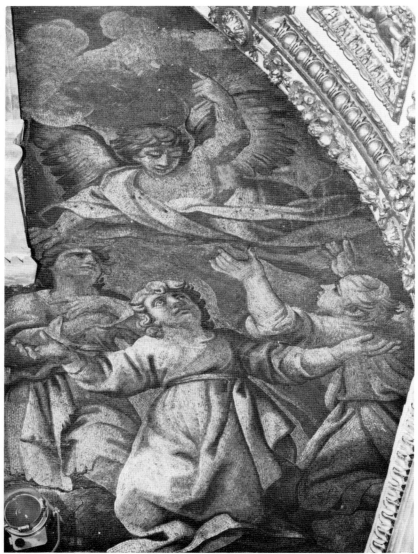

22. *Daniel in the Lions' Den*, Lunette, Chapel of Saint Sebastian (AF).

23. *Shadrach, Meshach, and Abed-nego in the Fiery Furnace*, Lunette, Chapel of Saint Sebastian (AF).

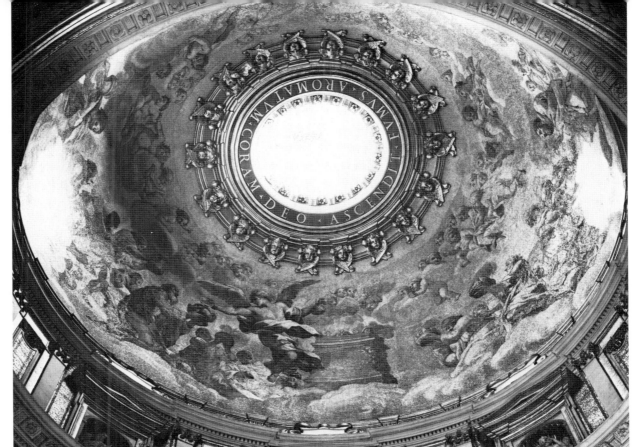

24. Vault, Chapel of the Sacrament (AF).

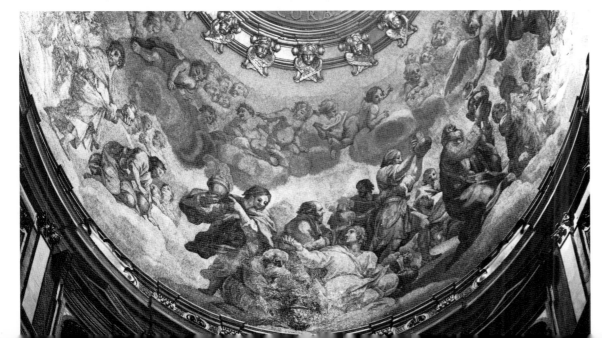

25. Vault, Chapel of the Sacrament (AF).

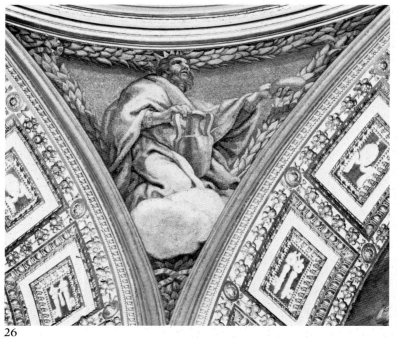

26

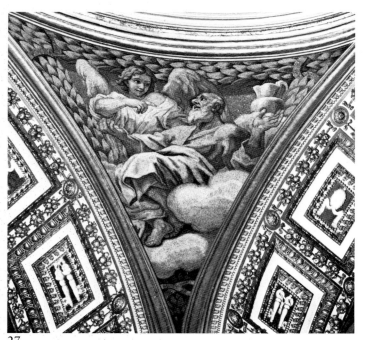

27

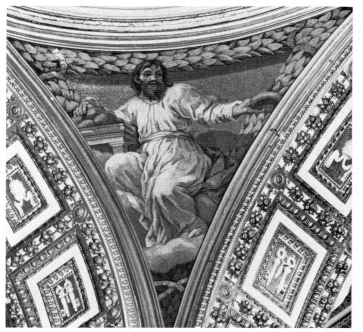

28

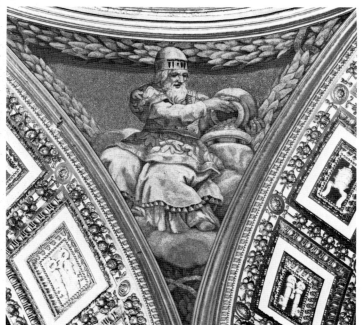

29

30. *Uzzah Struck Dead While Attempting to Steady the Ark of the Covenant,* Lunette, Chapel of the Sacrament (AF).

31. *An Angel About to Touch Isaiah's Lips with a Live Coal,* Lunette, Chapel of the Sacrament (AF).

32. *High Priest Offering to God the Fruits of the First Grain Harvest*, Lunette, Chapel of the Sacrament (AF).

33. *Return from Canaan with the Large Bunch of Grapes*, Lunette, Chapel of the Sacrament (AF).

34. *Jonathan Tasting the Honey,* Lunette, Chapel of the Sacrament (AF).

35. *The Idol Dagon Destroyed by the Presence of the Ark,* Lunette, Chapel of the Sacrament (AF).

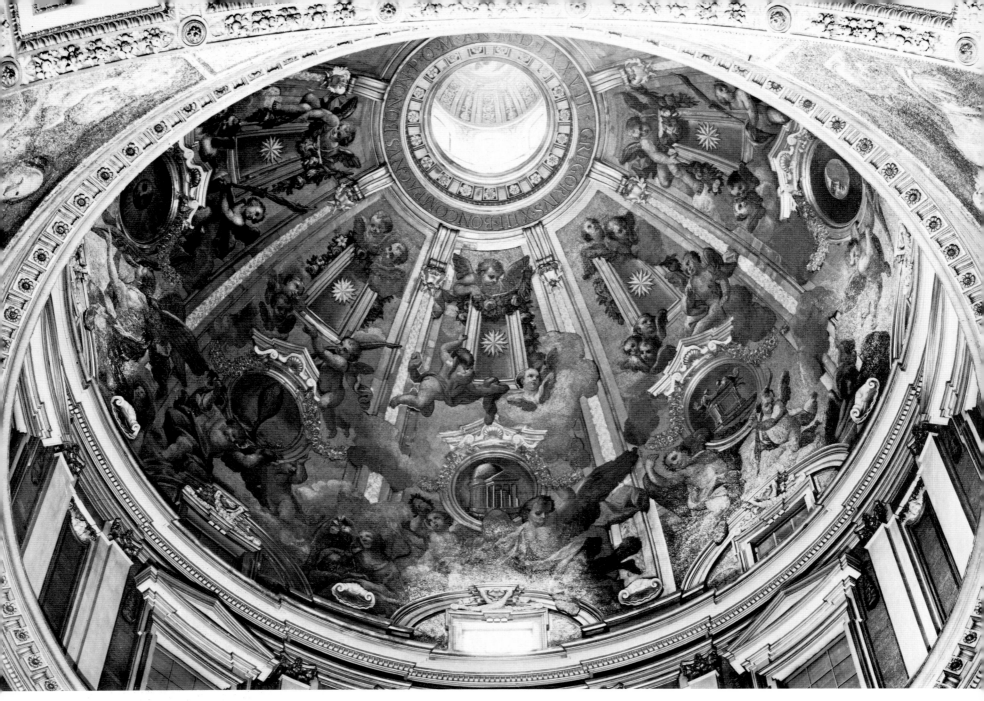

36. Vault, Gregorian Chapel (AF).

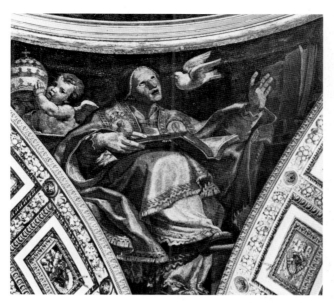

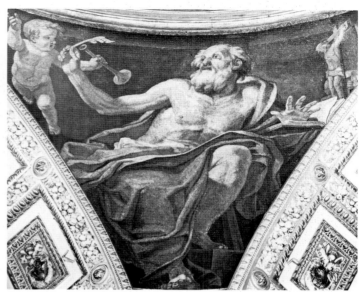

37. *Pope Gregory the Great,* Pendentive, Gregorian Chapel (AF).

38. *Saint Jerome,* Pendentive, Gregorian Chapel (AF).

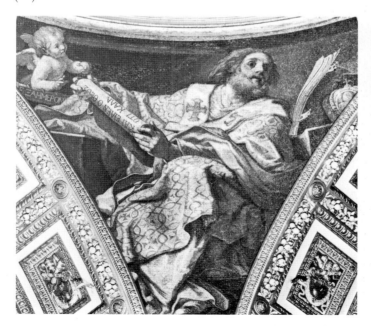

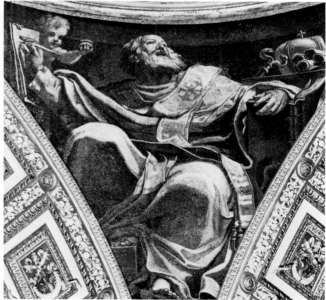

39. *Saint Gregory Nazianzus,* Pendentive, Gregorian Chapel (AF).

40. *Saint Basil the Great,* Pendentive, Gregorian Chapel (AF).

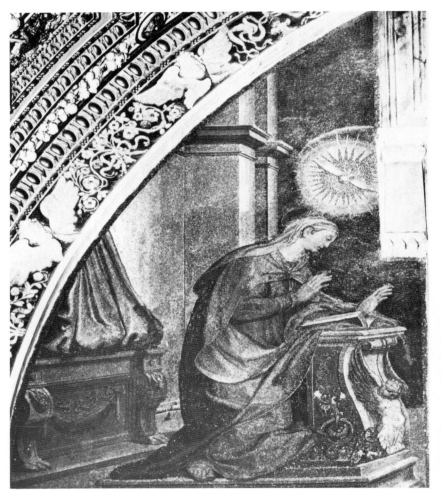

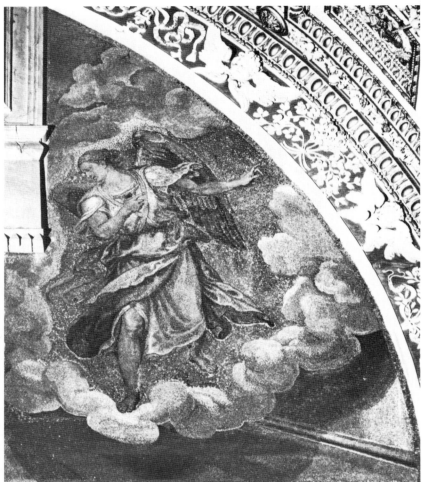

41. *The Annunciation, Virgin Mary,* Lunette, Gregorian Chapel (Hertziana).

42. *The Annunciation, Angel,* Lunette, Gregorian Chapel (Hertziana).

43. *The Prophet Ezekiel*, Lunette, Gregorian Chapel (AF).

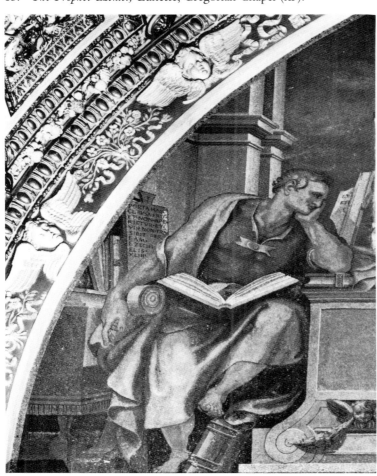

44. *The Prophet Isaiah*, Lunette, Gregorian Chapel (AF).

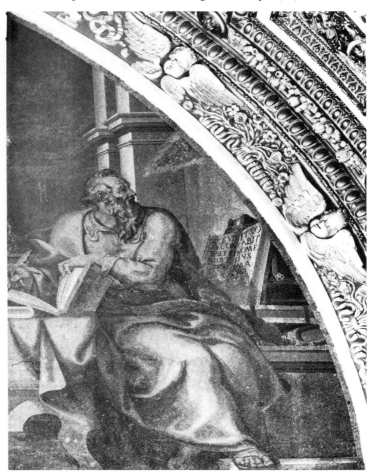

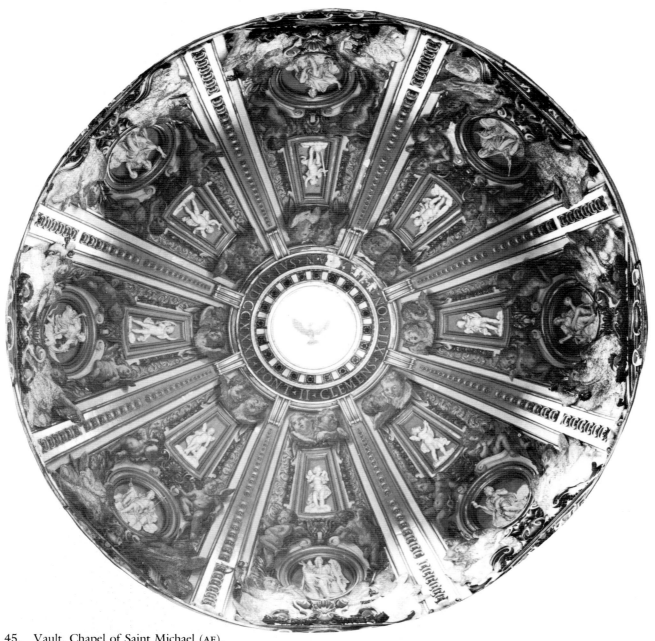

45. Vault, Chapel of Saint Michael (AF).

46. *Pope Leo the Great*, Pendentive, Chapel of Saint Michael (AF).

47. *Saint Bernard of Clairvaux*, Pendentive, Chapel of Saint Michael (AF).

48. *Saint Denys the Areopagite*, Pendentive, Chapel of Saint Michael (AF).

49. *Saint Gregory Thaumaturgus*, Pendentive, Chapel of Saint Michael (AF).

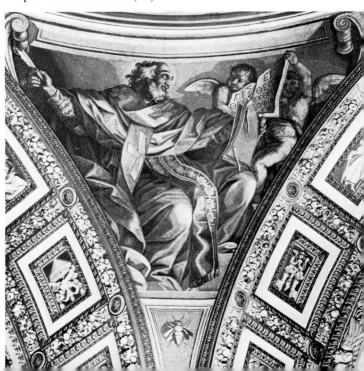

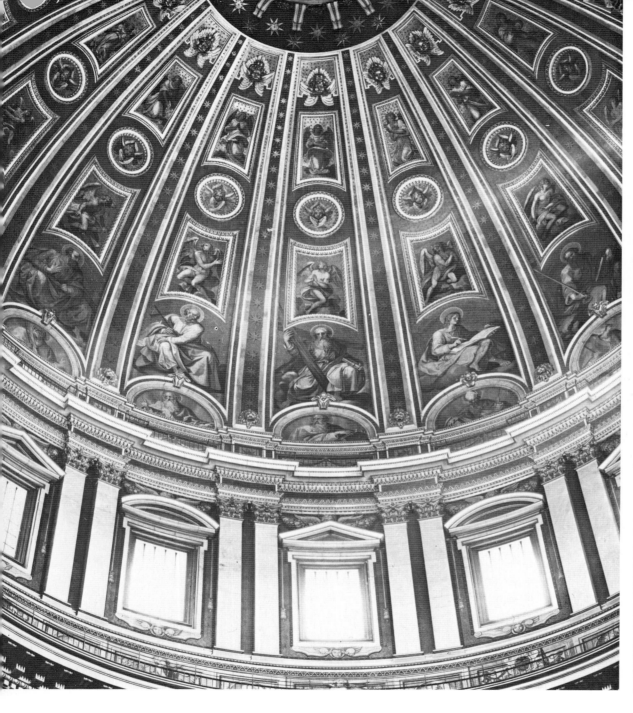

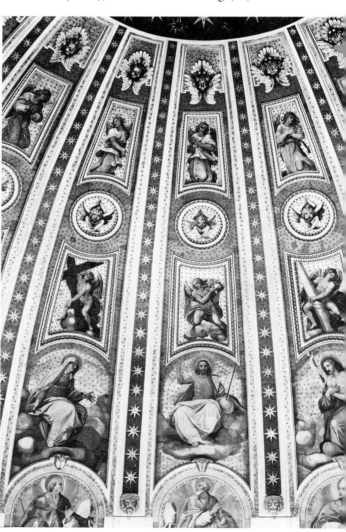

50. Vault, Dome of the Crossing (AF).

51. Vault (detail), Dome of the Crossing (AF).

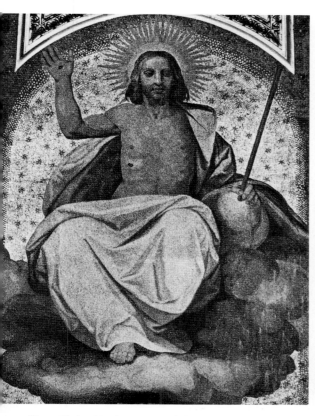

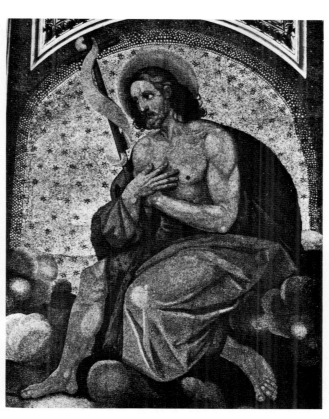

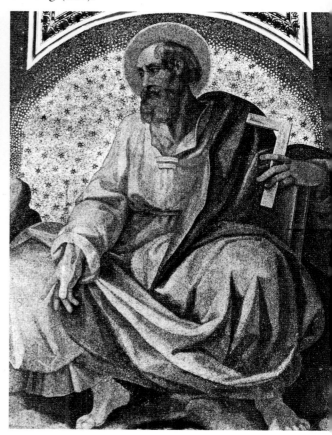

54. *Saint Thomas,* Vault, Dome of the Crossing (GFN).

52. *Christ,* Vault, Dome of the Crossing (GFN).

53. *Saint John the Baptist,* Vault, Dome of the Crossing (GFN).

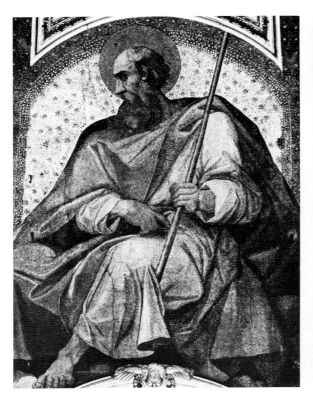

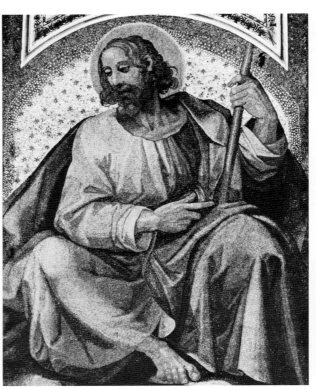

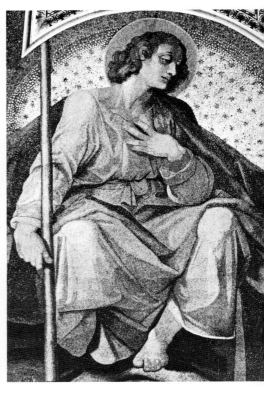

55. *Saint Thaddaeus,* Vault, Dome of the Crossing (GFN).

56. *Saint James the Less,* Vault, Dome of the Crossing (GFN).

57. *Saint Matthias,* Vault, Dome of the Crossing (GFN).

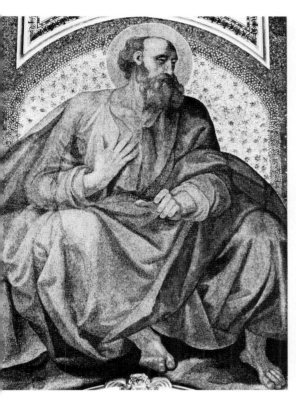 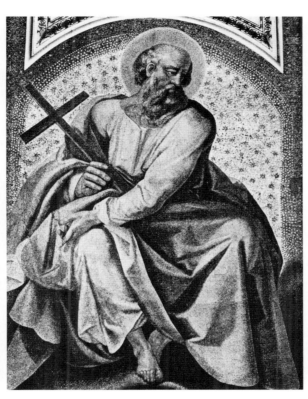 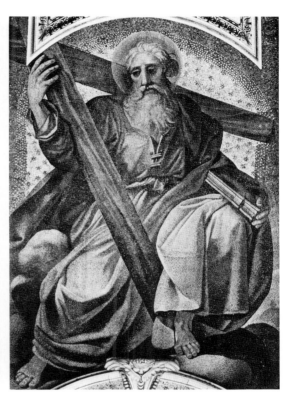

58. *Saint Matthew,* Vault, Dome of the Crossing (GFN).

59. *Saint Philip,* Vault, Dome of the Crossing (GFN).

60. *Saint Andrew,* Vault, Dome of the Crossing (GFN).

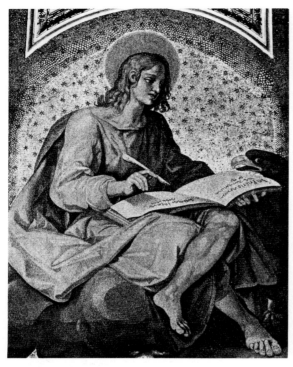

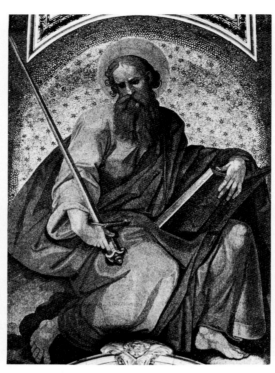

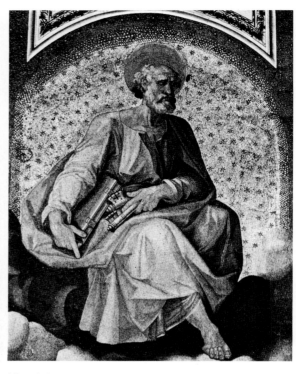

61. *Saint John the Evangelist,* Vault, Dome of the Crossing (GFN).

62. *Saint Paul,* Vault, Dome of the Crossing (GFN).

63. *Saint Peter,* Vault, Dome of the Crossing (GFN).

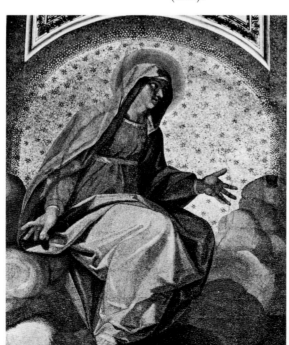

64. *Virgin Mary,* Vault, Dome of the Crossing (GFN).

65. Frieze (detail), Dome of the Crossing (Hertziana).

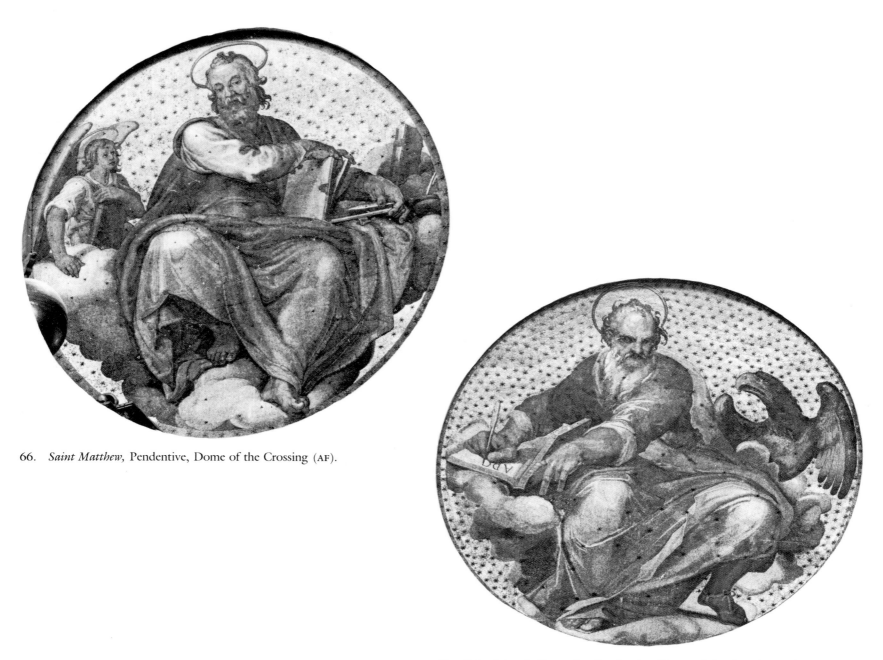

66. *Saint Matthew,* Pendentive, Dome of the Crossing (AF).

67. *Saint John the Evangelist,* Pendentive, Dome of the Crossing (AF).

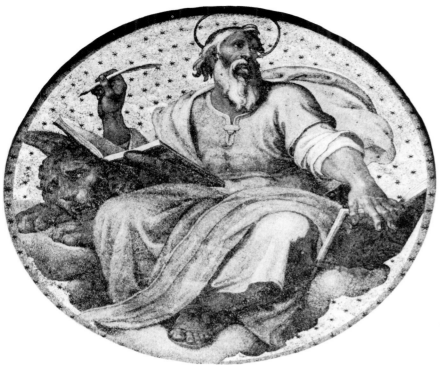

68. *Saint Mark,* Pendentive, Dome of the Crossing (AF).

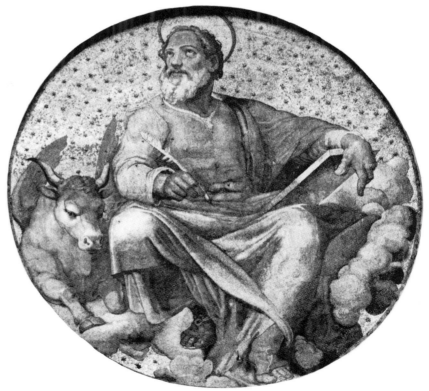

69. *Saint Luke,* Pendentive, Dome of the Crossing (AF).

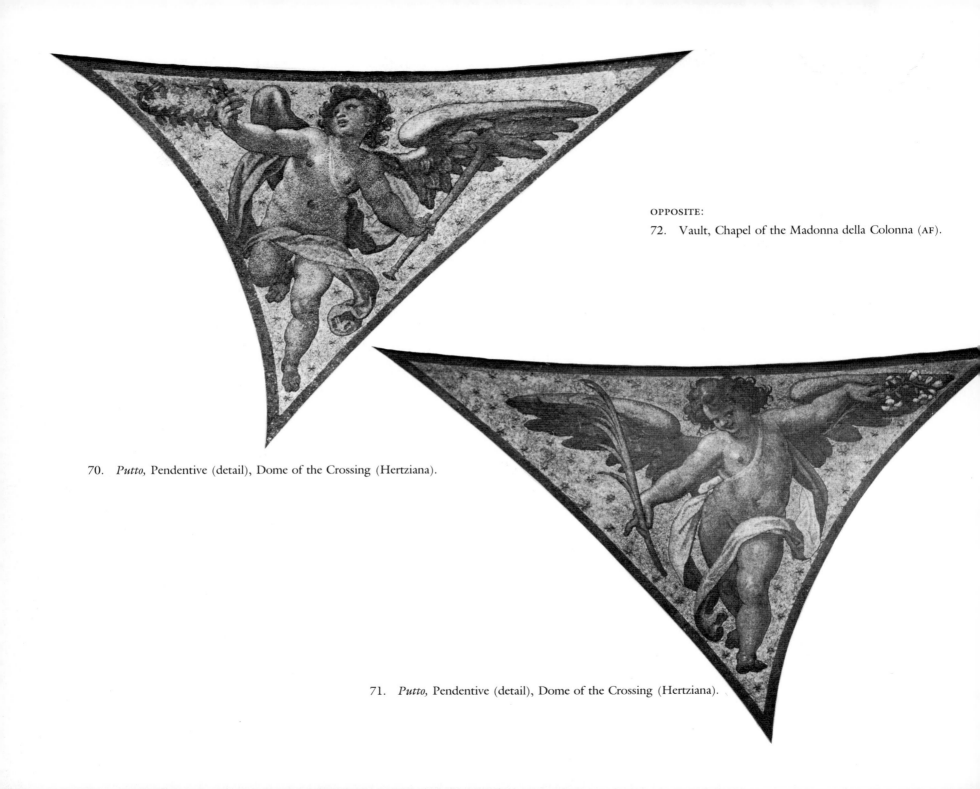

OPPOSITE:
72. Vault, Chapel of the Madonna della Colonna (AF).

70. *Putto*, Pendentive (detail), Dome of the Crossing (Hertziana).

71. *Putto*, Pendentive (detail), Dome of the Crossing (Hertziana).

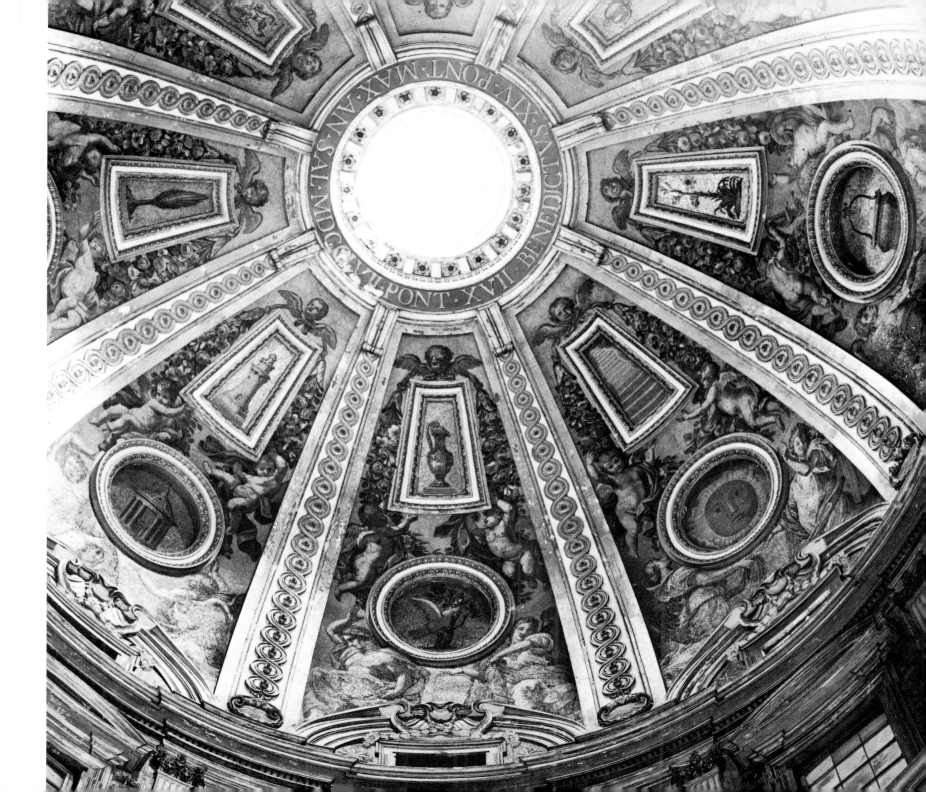

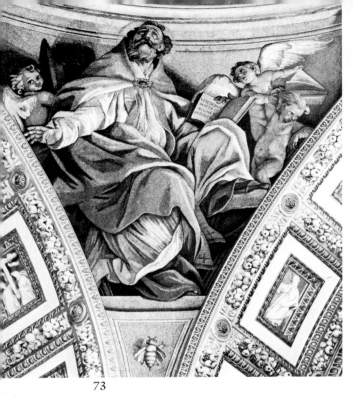

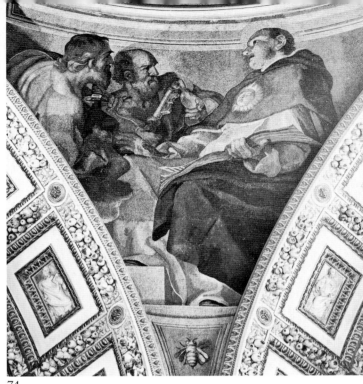

73

74

73. *Saint Bonaventure*, Pendentive, Chapel of the Madonna della Colonna (AF).

74. *Saint Thomas Aquinas*, Pendentive, Chapel of the Madonna della Colonna (AF).

75. *Saint Cyril of Alexandria*, Pendentive, Chapel of the Madonna della Colonna (AF).

76. *Saint John Damascene*, Pendentive, Chapel of the Madonna della Colonna (AF).

OPPOSITE:

77. Vault, Clementine Chapel (AF).

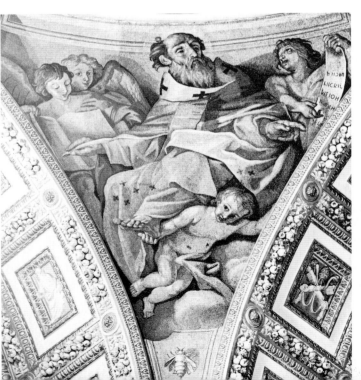

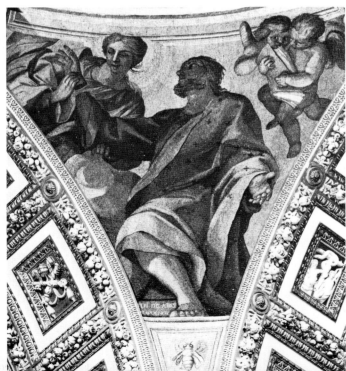

75

76

The inscription around the central oculus reads: CLEMENS · VIII · PONT · MAX · AN · SAL · M·D·CI · PONT · X ·

77

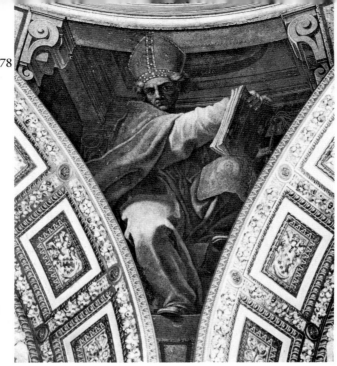

78

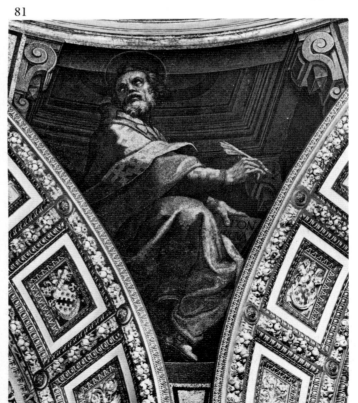

79

80

81

78. *Saint Ambrose,* Pendentive, Clementine Chapel (AF).

79. *Saint Augustine,* Pendentive, Clementine Chapel (AF).

80. *Saint John Chrysostom,* Pendentive, Clementine Chapel (AF).

81. *Saint Athanasius,* Pendentive, Clementine Chapel (AF).

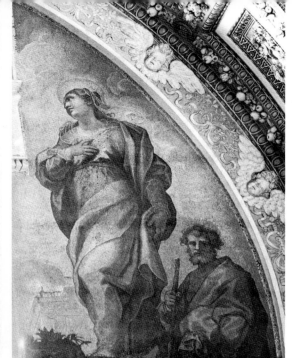

82. *The Visitation, Saint Elizabeth,* Lunette, Clementine Chapel (Hertziana).

83. *The Visitation, Virgin Mary,* Lunette, Clementine Chapel (Hertziana).

82

83

84

85

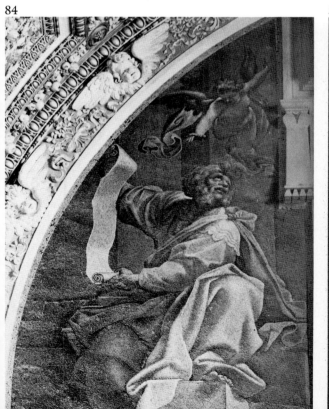

84. *Malachi Assisted by an Angel,* Lunette, Clementine Chapel (Hertziana).

85. *Daniel in the Lions' Den,* Lunette, Clementine Chapel (Hertziana).

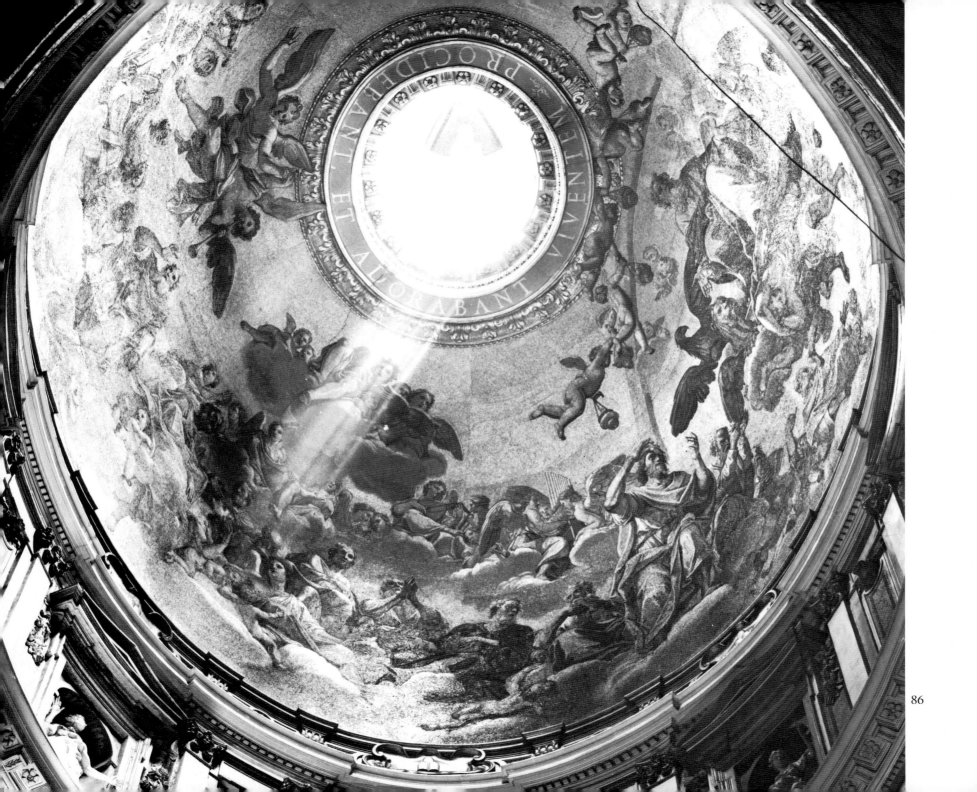

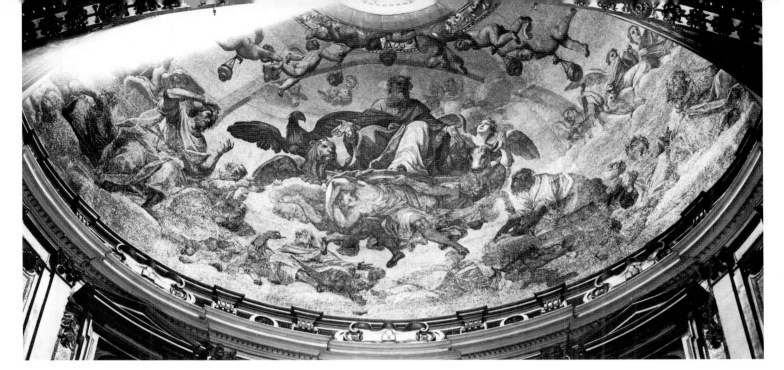

87. Vault, Chapel of the Choir (AF).

88. Vault, Chapel of the Choir (AF).

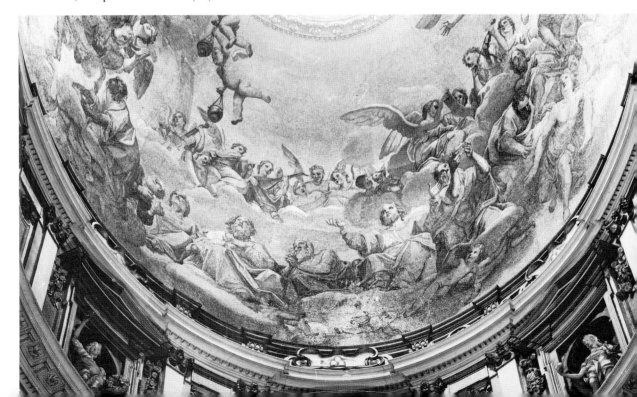

OPPOSITE:

86. Vault, Chapel of the Choir (AF).

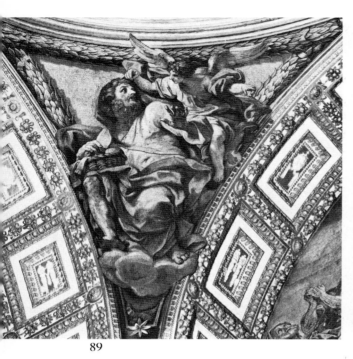

89

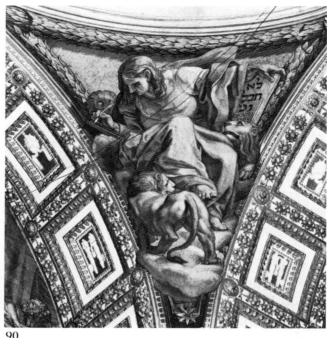

90

89. *Habakkuk and the Angel*, Pendentive, Chapel of the Choir (AF).

90. *Daniel in the Lions' Den*, Pendentive, Chapel of the Choir (AF).

91. *King David*, Pendentive, Chapel of the Choir (AF).

92. *Jonah and the Whale*, Pendentive, Chapel of the Choir (AF).

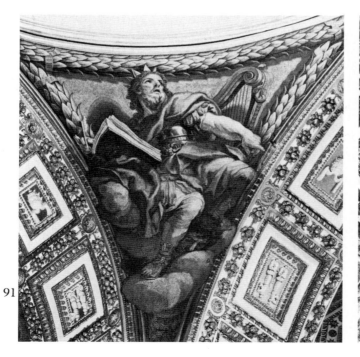

91

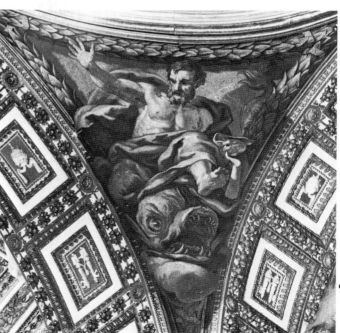

92

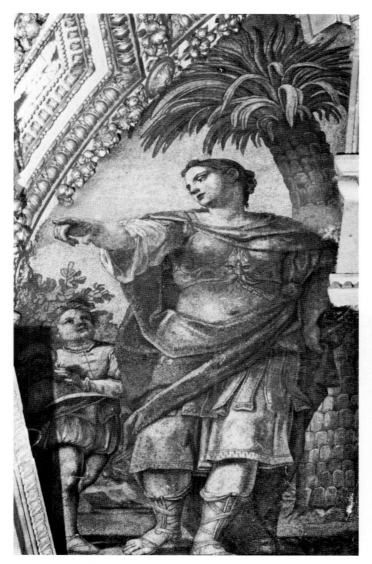

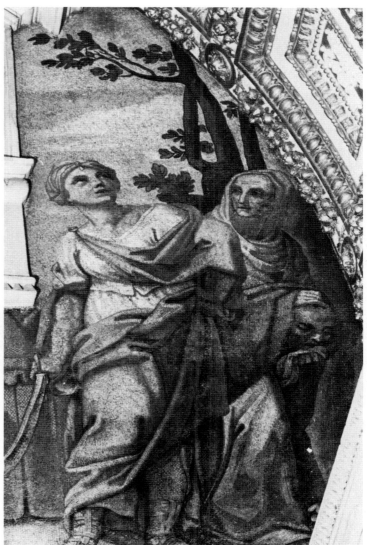

93. *Deborah Sending for Barak in Order to Make Him the Leader of the People of Israel,* Lunette, Chapel of the Choir (AF).

94. *Judith with the Head of Holofernes,* Lunette, Chapel of the Choir (AF).

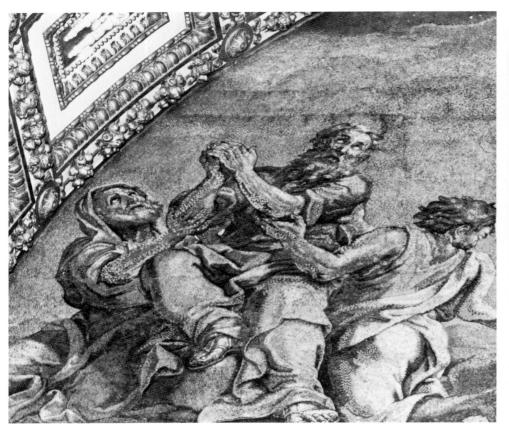

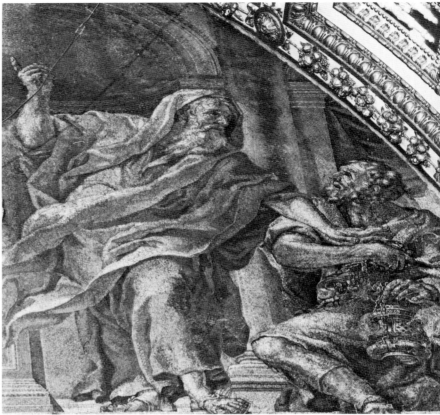

95. *Moses Praying to God Supported by Aaron and Hur,* Lunette, Chapel of the Choir (AF).

96. *Azariah Rebuking King Uzziah for Attempting to Burn Incense on the Altar in the Sanctuary,* Lunette, Chapel of the Choir (AF).

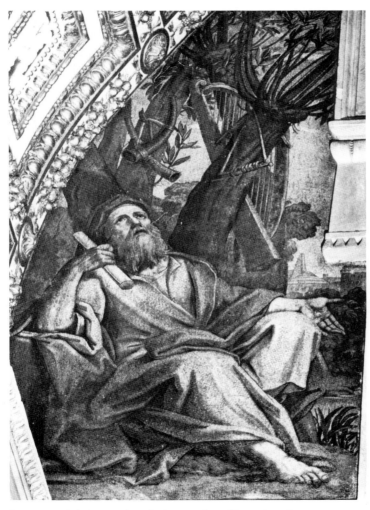

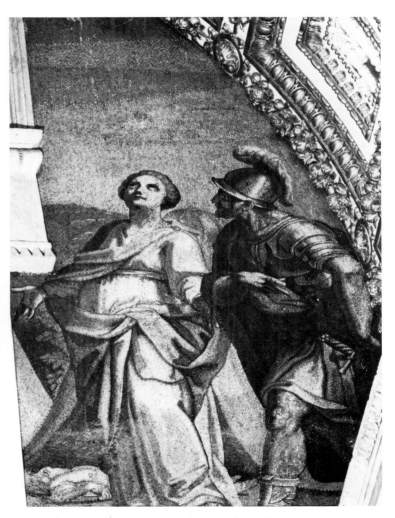

97. *Jeremiah Lamenting the Destruction of Jerusalem*, Lunette, Chapel of the Choir (AF).

98. *Deborah and Barak Giving Thanks to the Lord for their Victory*, Lunette, Chapel of the Choir (AF).

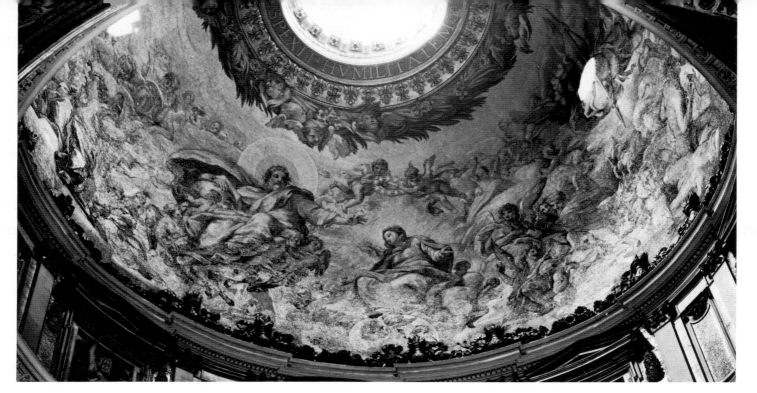

99. Vault, Presentation Chapel (AF).

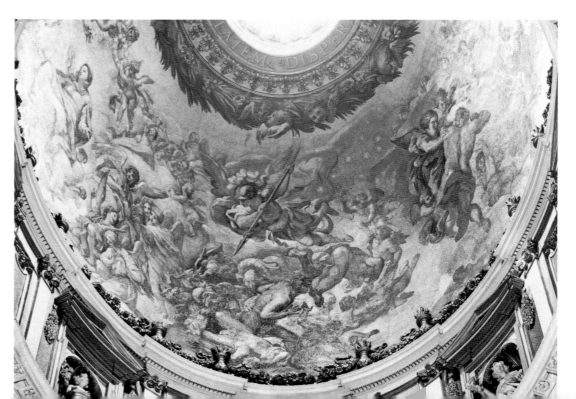

100. Vault, Presentation Chapel (AF).

101

102

101. *Aaron with the Censer,* Pendentive, Presentation Chapel (**AF**).

102. *Noah with the Ark and the Dove,* Pendentive, Presentation Chapel (**AF**).

103. *Gideon with the Fleece,* Pendentive, Presentation Chapel (**AF**).

104. *Balaam with the Star of Jacob,* Pendentive, Presentation Chapel (**AF**).

103

104

105. *Moses Removing His Sandals as He Approaches the Burning Bush,* Lunette, Presentation Chapel (AF).

106. *Miriam Singing and Dancing in Thanksgiving for the Safe Passage through the Red Sea,* Lunette, Presentation Chapel (AF).

107. *Joshua Stopping the Sun*, Lunette, Presentation Chapel (AF).

108. *Isaiah with the Cloud*, Lunette, Presentation Chapel (AF).

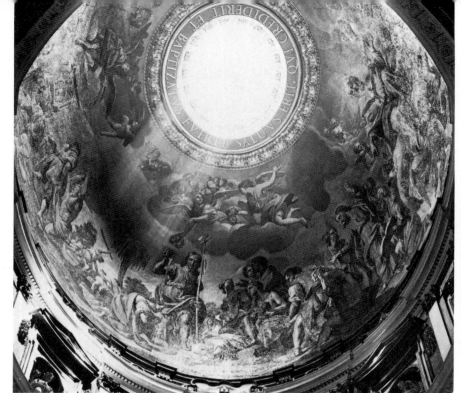

111. *Christ at the Right Hand of God*, Vault (detail),
Baptismal Chapel (Rigamonti).

109. Vault, Baptismal Chapel (AF).

110. Vault, Baptismal Chapel (AF).

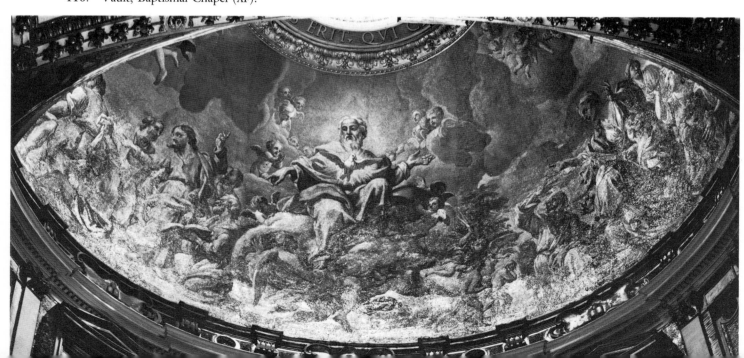

112. *Europe,* Pendentive, Baptismal Chapel (Rigamonti).

113. *Asia,* Pendentive, Baptismal Chapel (Rigamonti).

114. *Africa,* Pendentive, Baptismal Chapel (Rigamonti).

115. *America,* Pendentive, Baptismal Chapel (Rigamonti).

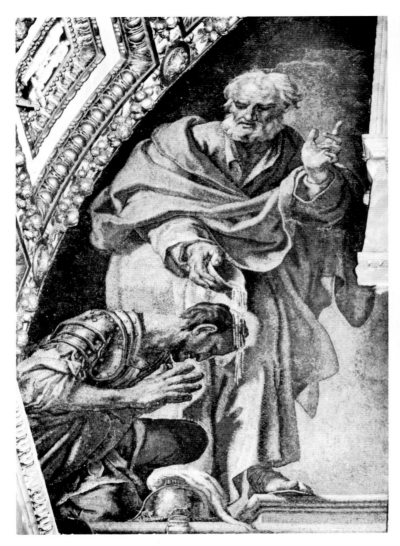

116. *Saint Peter Baptizing the Centurion Cornelius*, Lunette, Baptismal Chapel (AF).

117. *Saint Philip Baptizing the Eunuch of Queen Candace*, Lunette, Baptismal Chapel (AF).

118. *Christ Baptizing Saint Peter,* Lunette, Baptismal Chapel (AF).

119. *Saint Sylvester Baptising Constantine,* Lunette, Baptismal Chapel (AF).

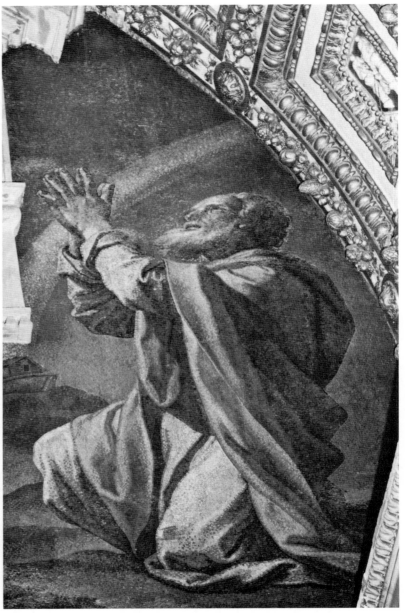

120. *Moses Striking Water from the Rocks,* Lunette, Baptismal Chapel (AF).

121. *Noah Praying before the Rainbow of the Covenant,* Lunette, Baptismal Chapel (AF).

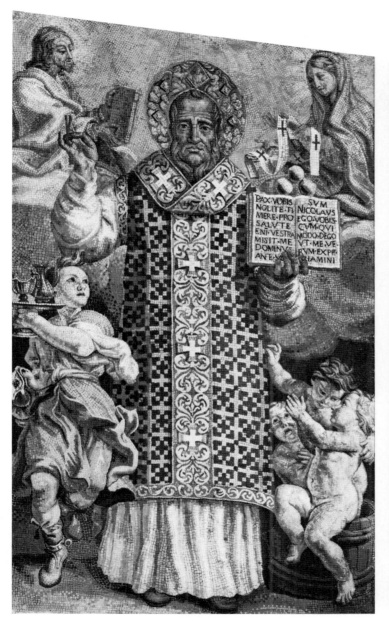

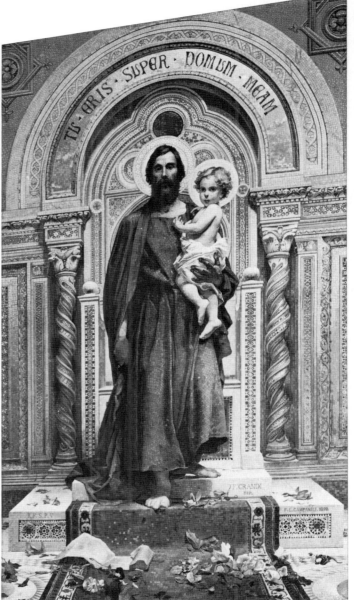

122. *Saint Nicholas of Bari* (AF).

123. *Saint Joseph and the Child Jesus* (AF).

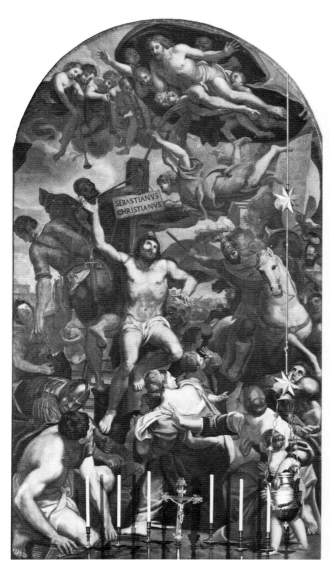

124. *Martyrdom of Saint Sebastian* (AF).

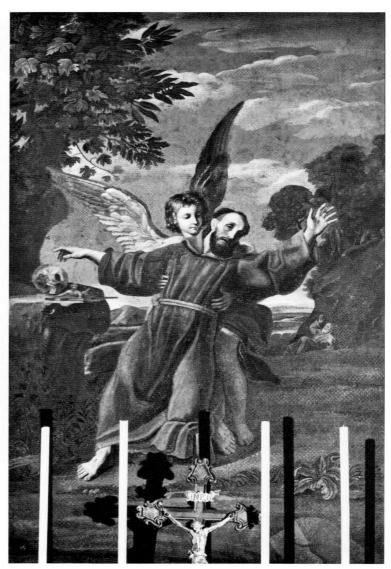

125. *Ecstasy of Saint Francis* (AF).

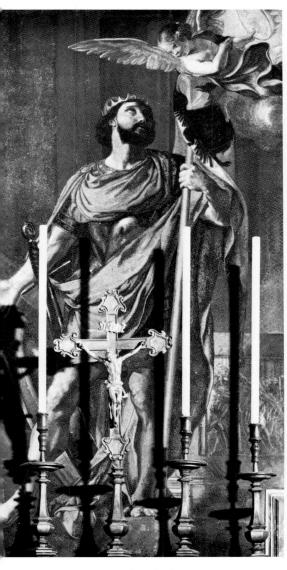

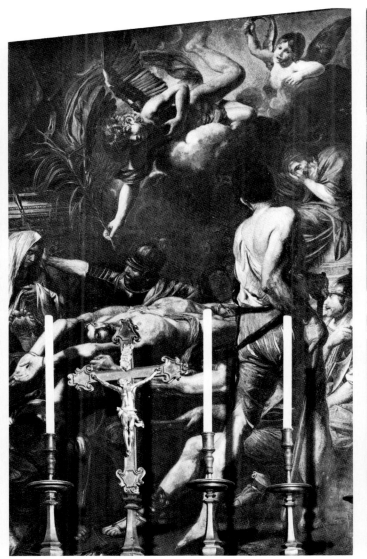

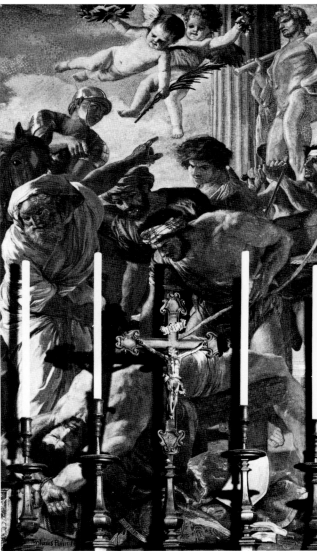

126. *Saint Wenceslas of Bohemia* (AF).

127. *Martyrdom of Saints Processus and Martinianus* (AF).

128. *Martyrdom of Saint Erasmus* (AF).

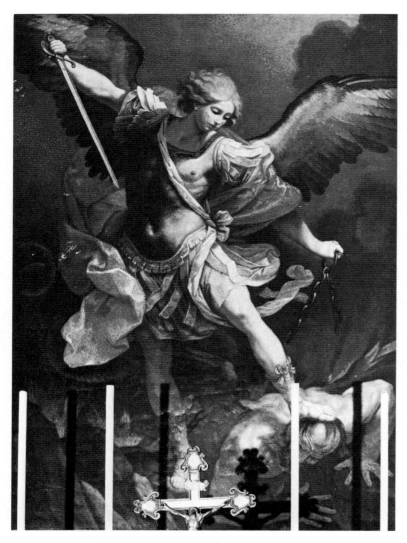

129. *Saint Michael the Archangel* (AF).

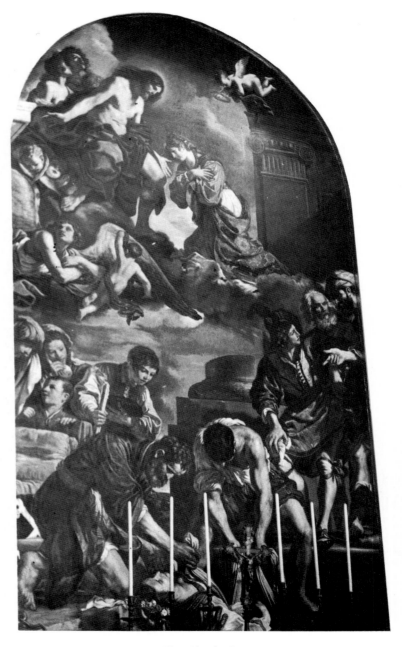

130. *Burial of Saint Petronilla* (Giordani).

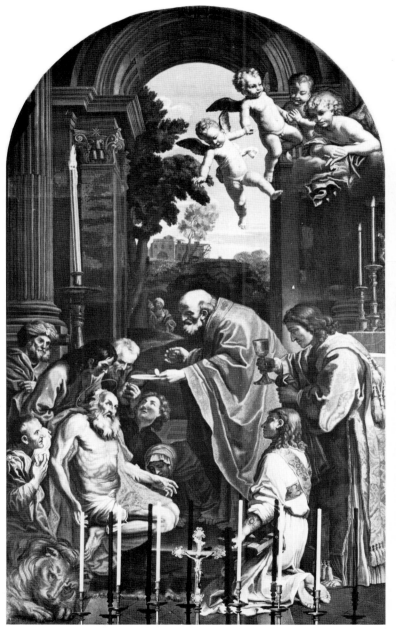

131. *Last Communion of Saint Jerome* (AF).

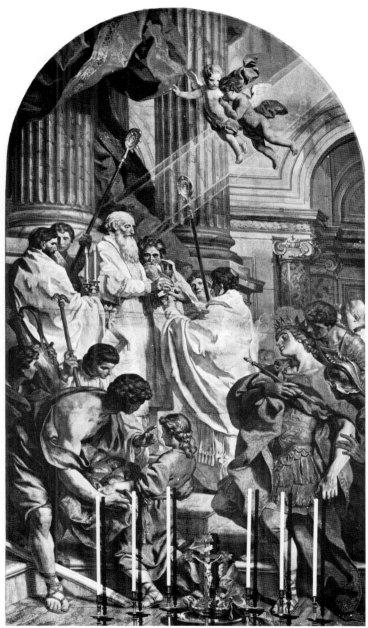

132. *Mass of Saint Basil* (AF).

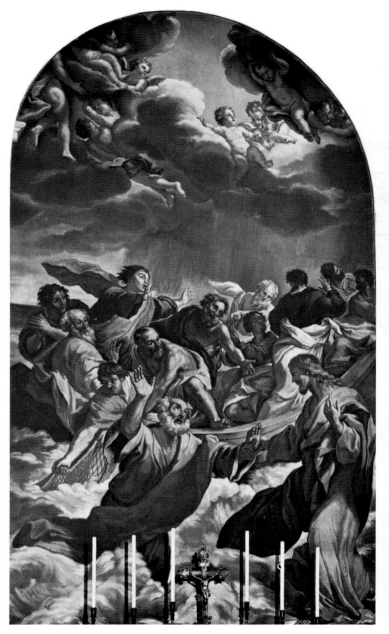

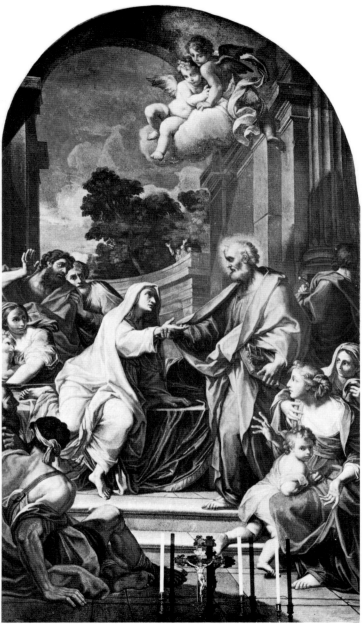

133. *Navicella* (AF).

134. *Raising of Tabitha* (AF).

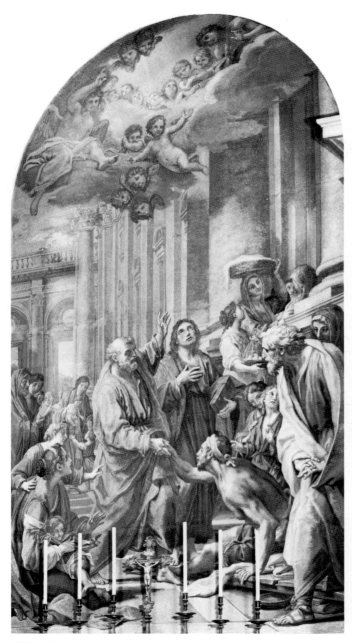

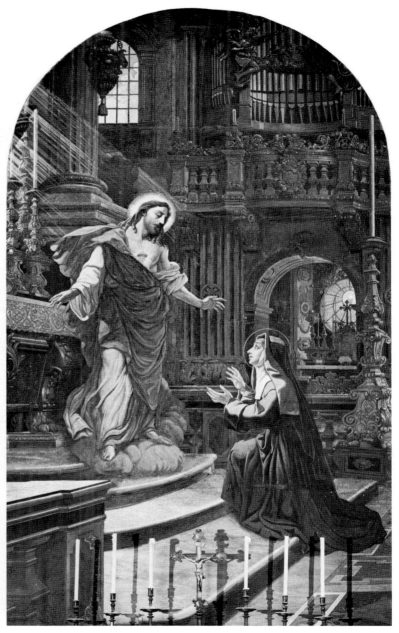

135. *Saint Peter Healing the Cripple at the Porta Spetiosa* (AF).

136. *Christ of the Sacred Heart Appearing to Saint Margaret Mary Alacoque* (AF).

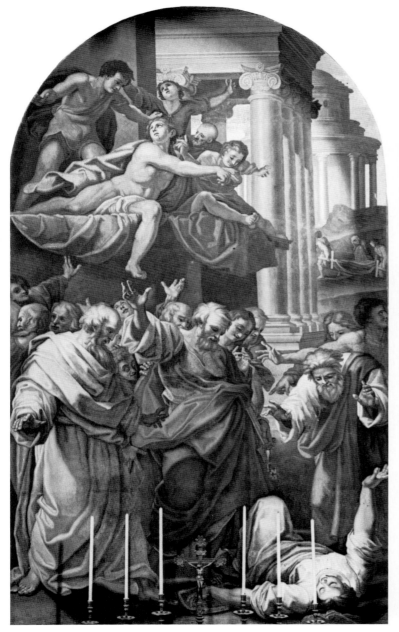

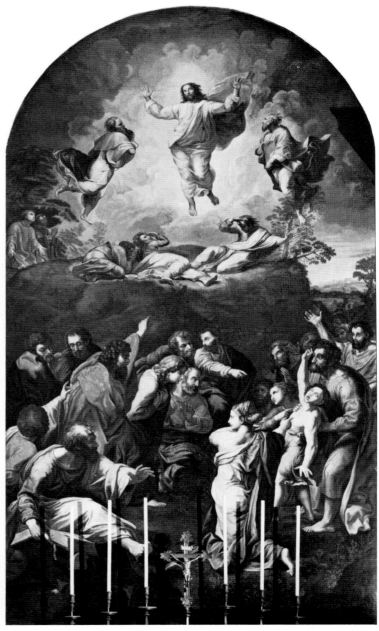

137. *Death of Sapphira* (Giordani).

138. *Transfiguration* (AF).

139. *Christ Carrying the Cross, and Saint Veronica* (AF).

140. *Saint Andrew Adoring the Cross of His Martyrdom* (AF).

141. *Martyrdom of Saint Longinus* (AF).

142. *Saint Helen and the Miracle of the True Cross* (AF).

139

140

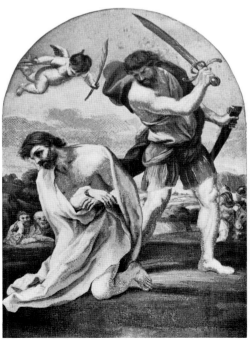

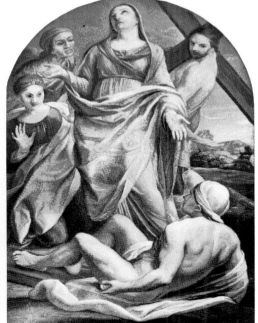

141

142

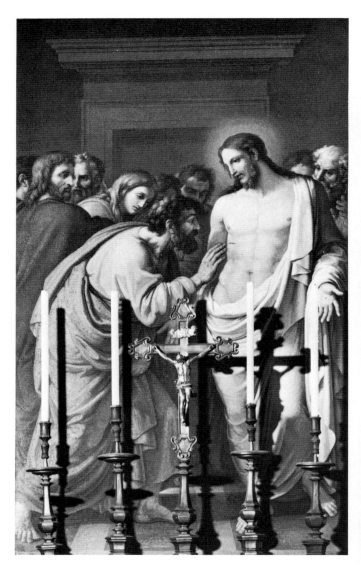

143. *Incredulity of Saint Thomas* (AF).

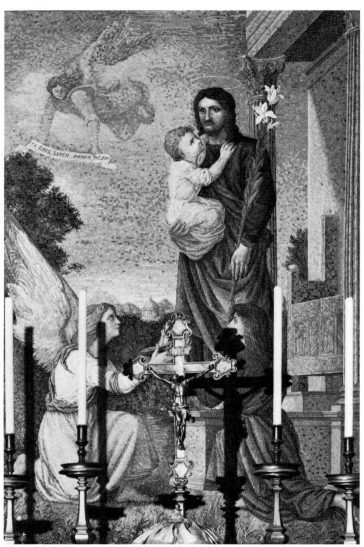

144. *Saint Joseph Patron of the Universal Church* (AF).

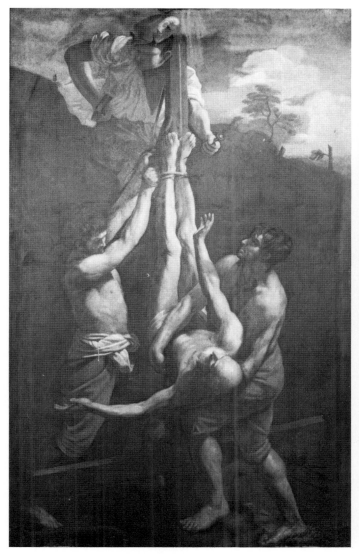

145. *Crucifixion of Saint Peter* (Archivio Fotografico Vaticano).

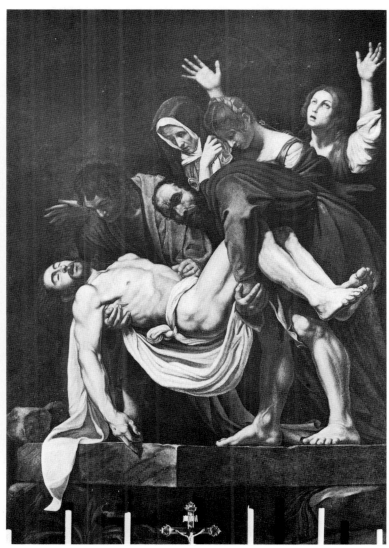

146. *Entombment of Christ* (AF).

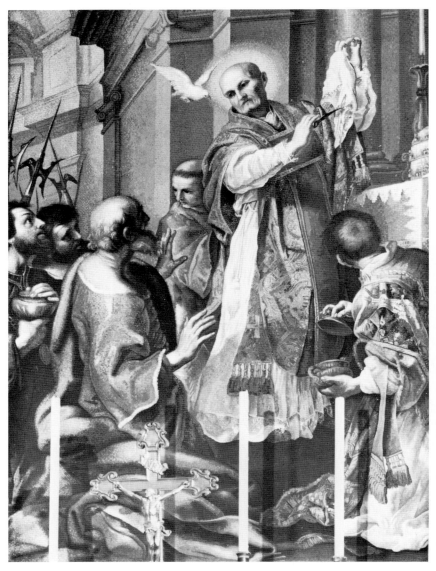

147. *Saint Gregory and the Miracle of the Corporal* (AF).

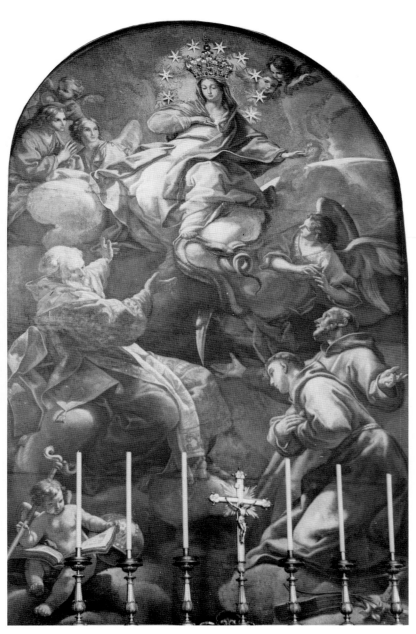

148. *Immaculate Conception* (Giordani).

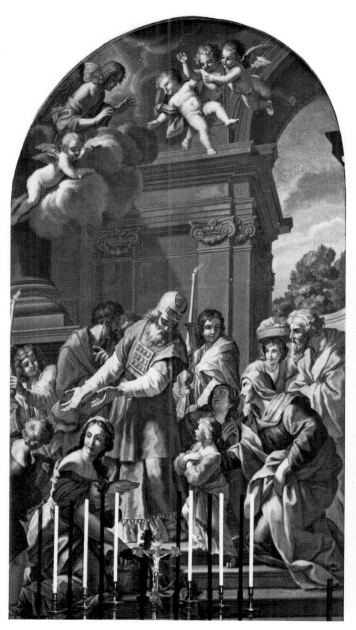

149. *Presentation of the Virgin* (AF).

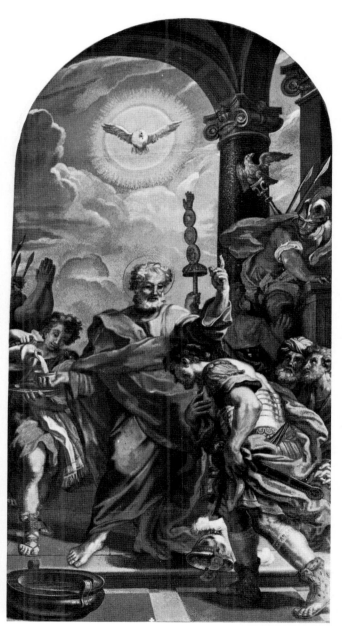

150. *Saint Peter Baptizing the Centurion Cornelius* (AF).

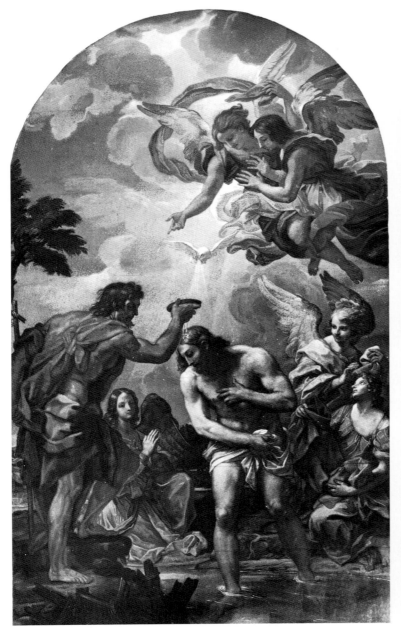

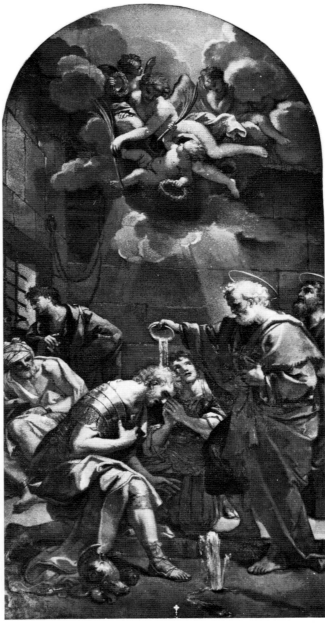

151. *Baptism of Christ* (AF).

152. *Baptism of Saints Processus and Martinianus* (AF).

Chronologies

Chronology of the Mosaics in the New Basilica of Saint Peter

1578–1580	Gregorian Chapel; vault, lunettes, and pendentives
1598–1600	Dome of the Crossing; pendentives
1601–1602	Clementine Chapel; vault, lunettes, and pendentives
1603–1612	Dome of the Crossing; vault
1627–1629	*Saint Michael the Archangel*, after the Cavaliere d'Arpino (Chapel of Saint Michael)
1629–1635	Chapel of the Madonna della Colonna; pendentives
1631–1647	Chapel of Saint Michael; pendentives
1643–1647	Chapel of the Madonna della Colonna; lunettes
1647–1648	Chapel of Saint Michael; pendentives
	Chapel of the Madonna della Colonna; lunettes
1652–1662	Chapel of the Sacrament; vault, pendentives, and lunettes
1652–1663	Chapel of Saint Sebastian; vault, pendentives, and lunettes
1669–1681	Chapel of the Pietà; vault, pendentives, and lunettes
1675	*Saint Peter* (Chapel of the Pietà, Porta Santa)
1675	Giotto's *Navicella* (Atrium)
c. 1681–1703	Chapel of the Choir; pendentives
1682–1689	*Christ Carrying the Cross, and Saint Veronica*
	Saint Andrew Adoring the Cross of His Martyrdom
	Martyrdom of Saint Longinus
	Saint Helen and the Miracle of the True Cross (Grotto altars)
1683–1689	Presentation Chapel; pendentives and lunettes
before 1689	*Saint Nicholas of Bari* (Chapel of the Crucifixion)
1704–1725	Presentation Chapel; vault
1709–after 1711	*Martyrdom of Saints Processus and Martinianus* (Right transept, center altar)
1711–1723	Chapel of the Choir; vault and lunettes
1711–1726	Baptismal Chapel; frieze and pendentives

1719–1729 Chapel of Saint Michael; lunettes and vault
1721–1726 *Navicella* (Chapel of Saint Michael)
1725–1727 *Death of Sapphira* (Clementine Chapel)
1726–1728 *Presentation of the Virgin* (Presentation Chapel)
1726–1730 *Baptism of Saints Processus and Martinianus* (Baptismal Chapel)
1726–1731 *Saint Peter Baptizing the Centurion Cornelius* (Baptismal Chapel)
1728–1730 *Burial of Saint Petronilla* (Chapel of Saint Michael)
1730–1731 *Baptism of Christ* (Baptismal Chapel)
1730–1733 *Last Communion of Saint Jerome* (Gregorian Chapel)
1730–1736 *Martyrdom of Saint Sebastian* (Chapel of Saint Sebastian)
1732–1734 *Baptism of Christ* (Baptismal Chapel)
1732–1746 Baptismal Chapel; lunettes and vault
1733–1736 *Saint Peter Baptizing the Centurion Cornelius* (Baptismal Chapel)
1736–1737 *Baptism of Saints Processus and Martinianus* (Baptismal Chapel)
1737–1739 *Martyrdom of Saint Erasmus* (Right transept, left altar)
1739–1740 *Saint Wenceslas of Bohemia* (Right transept, right altar)
1742–1757 Chapel of the Madonna della Colonna; vault
1744–1747 *Immaculate Conception* (Chapel of the Choir)
1748–1751 *Mass of Saint Basil* (Gregorian Chapel)
1751–1758 *Saint Peter Healing the Cripple at the Porta Spetiosa* (Chapel of the Madonna della Colonna)
1756–1758 *Saint Michael the Archangel*, after Reni (Chapel of Saint Michael)
1758–1760 *Raising of Tabitha* (Chapel of Saint Michael)
1759–1767 *Transfiguration* (Clementine Chapel)
1768–1779 Gregorian Chapel (renovation); pendentives, vault, and lunettes

1770–1772 *Saint Gregory and the Miracle of the Corporal* (Clementine Chapel)
1779–1784 *Crucifixion of Saint Peter* (Left transept, left altar)
1795–1801 *Ecstasy of Saint Francis* (Chapel of the Sacrament, right altar)
1805–1822 *Incredulity of Saint Thomas* (Left transept, right altar)
c. 1806–1821 *Entombment of Christ* (Sacristy)
1888–1893 *Saint Joseph and the Child Jesus* (Chapel of the Crucifixion)
1920–1925 *Christ of the Sacred Heart Appearing to Saint Margaret Mary Alacoque* (Chapel of the Madonna della Colonna)
1961–1963 *Saint Joseph Patron of the Universal Church* (Left transept, center altar)

Supervisors and Directors of the Vatican Mosaic Studio

1578–1580 Girolamo Muziano; supervised decorations in the Gregorian Chapel
1603–1612 Cavaliere d'Arpino; supervised decorations in the dome of the crossing
1605–1608 Andrea Aretino, supervisor of mosaics
1608–1613 Pietro Paolo Bernascone, supervisor of mosaics
1619–1621 Marcello Provenzale; in charge of mosaic supplies (*Munizioniere*)
1629–1644 Giovanni Battista Calandra, supervisor of mosaics
1644–1656 Guido Ubaldo Abbatini, principal mosaicist
1656–1689 Fabio Cristofari, principal mosaicist
1656–1727 Pietro da Cortona, Ciro Ferri, Carlo Maratti, and Giuseppe Chiari; acting supervisors on individual projects
1689–1720 Giuseppe Conti, principal mosaicist

DIRECTORS

1727–1743	Pietro Paolo Cristofari
1743–1755	Pier Leone Ghezzi
1755–1776	Salvatore Monosilio
1776–1795	Giovanni Battista Ponfreni
1795–1803	Domenico De Angelis
1803–1844	Vincenzo Camuccini
1844–1857	Filippo Agricola
1857	Luigi Durantini
1857–1871	Tommaso Minardi
1871–1884	Nicola Consoni
1884–1891	Francesco Grandi
1891–1922	Salvatore Nobili
1922–1931	Carlo Muccioli
1931–1948	Biagio Biagetti
1948–1951	Francesco Bencivega
1951–1955	Pietro Gaudenzi
1955–1968	vacant
1968—	Ferruccio Ferruzzi, artistic director
	Virgilio Cassio, technical director

Principal Artists of the Vatican Mosaic Studio

1580–1598	Girolamo Muziano
	Cesare Nebbia
	Paolo Rossetti
	Giovanni de' Vecchi
1598–1612	Andrea Aretino
	Giacomo Bresciano
	Cristoforo Casalano
	Giovanni Ercolano
	Orazio Gentileschi
	Lodovico Martinelli
	Cesare Nebbia
	Rosato Parasole

	Donato Parigi
	Marcello Provenzale
	Cesare Rossetti
	Paolo Rossetti
	Ranuccio Semprevivo
	Vincenzo Stella
	Cesare Torelli
	Giovanni de' Vecchi
	Francesco Zucchi
1629–1700	Guido Ubaldo Abbatini
	Giovanni Battista Calandra
	Bartolomeo Colombo
	Giuseppe Conti
	Fabio Cristofari
	Orazio Manenti
	Matteo Piccioni
1705–1725	Giovan Battista Brughi
	Prospero Clori
	Filippo Cocchi
	Giuseppe Conti
	Liborio Fattori
	Domenico Gossoni
	Matthia Moretti
	Giuseppe Ottaviani
	Leopoldo del Pozzo
	Matthia de' Rossi
1735–1740	Pietro Cardoni
	Prospero Clori
	Alessandro Cocchi
	Pietro Paolo Cristofari, director
	Enrico Enuò
	Liborio Fattori
	Giovanni Francesco Fiani
	Domenico Gossoni
	Silverio de Lelii
	Nicolo Onofri

	Giuseppe Ottaviani	1816	Vincenzo Camuccini, director
	Bernardino Regoli		Antonio Castellini
			Raffaele Castellini
1750–1760	Alessandro Cocchi		Guglielmo Chibel
	Enrico Enuò		Filippo Cocchi
	Liborio Fattori		Raffaele Cocchi
	Giovanni Francesco Fiani		Vincenzo Cocchi
	Pier Leone Ghezzi, director, 1743–55		Nicola DeVecchis
	Domenico Gossoni		Domenico Pennachini
	Salvatore Monosilio, director, 1755–76		Nicolo Roccheggiani
	Matthia Moretti		Bartolomeo Tomberli
	Nicolo Onofri		Michel Volpini
	Giuseppe Ottaviani		Gherardo Volpone
	Guglielmo Paleat		
	Pietro Polverelli	1885–1895	Pietro Bornia
	Bernardino Regoli		Federico Campanili
	Andrea Volpini		Licinio Campanili
			Francesco Grandi, director, 1884–91
1770–1775	Filippo Carlini		Augusto Moglia
	Antonio Castellini		Salvatore Nobili, director, 1891–1922
	Vincenzo Castellini		Innocenzo Pallini
	Domenico Cerasoli		Giovanni Ubizi
	Alessandro Cocchi		Ettore Vanutelli
	Filippo Cocchi		
	Vincenzo Cocchi	1920–1925	Lorenzo Cassio
	Liborio Fattori		Luigi Chiaserotti
	Giovanni Battista Fiani		Ludovico Lucietto
	Giovanni Francesco Fiani		Evandro Monticelli
	Salvatore Monosilio, director		Carlo Muccioli, director
	Guglielmo Paleat		Romolo Sellini
	Pietro Polverelli		Carlo Simonetti
	Bernardino Regoli		
	Giuseppe Regoli	1963	Odoardo Anselmi
	Lorenzo Roccheggiani		Virgilio Cassio, technical director
	Bartolomeo Tomberli		Fabrizio Parsi
	Andrea Volpini		Giulio Purificati
			Silvio Secchi

Bibliography

Ackerman, James S. *The Architecture of Michelangelo*. Rev. ed. 2 vols. London, 1964, 1966.

Agazzi, Augusto. *Il mosaico in Italia*. Milan, 1926.

Allgemeines Lexikon der Bildenden Künstler. Ulrich Thieme and Felix Becker, eds. 36 vols. Leipzig, 1907–47.

Alphonso, Tiberio. *De Basilicae Vaticane*. D. Michele Cerrati, ed. Rome, 1914.

"Apocalypse, Book of." *New Catholic Encyclopedia*. Vol. 1. Washington, D.C., 1967.

Avonto, Luigi. "Giovanni Battista Calandra: mosaicista vercellese del XVII secolo." *Bollettino storico vercellese* 9 (1977): 99–102.

Baglione, Giovanni. *Le vite de' pittori, scultori, et architetti*. Rome, 1642. (Facsimile edition, Valerio Mariani, ed., Rome, 1935.)

Baruffaldi, Girolamo. *Vite de' pittori e scultori ferraresi*. Vol. 2. Ferrari, 1846.

Belting, Hans. "Das Fassadenmosaik des Atriums von Alt St. Peter in Rom." *Wallraf-Richartz Jahrbuch* 23 (1961): 37–54.

Bibliothèque de la Compagnie de Jésus. Carlos Sommervogel, ed. Vols. 1, 6. Brussels, 1890–Paris, 1909.

Blunt, Anthony. *The Paintings of Nicolas Poussin: A Critical Catalogue*. London, 1966.

Bonanni, Philippo. *Numismata Summorum Pontificum*. Rome, 1715.

Borea, Evelina. *Domenichino*. Milan, 1965.

Borghini, Raffaelo. *Il Riposo*. Florence, 1584.

Briganti, Giuliano. *Pietro da Cortona e della pittura barocca*. Florence, 1962.

Busiri-Vici, Andrea. *Il celebre studio del mosaico della Reverenda Fabbrica di S. Pietro*. Rome, 1901.

Canons and Decrees of the Council of Trent. Translated by H. J. Schroeder. 4th printing. Saint Louis, Mo. 1960.

Cascioli, Giuseppe. "La Navicella di Giotto a S. Pietro in Vaticano." *Bessarione* 33 (1916): 118–38.

———. *Guida illustrata al nuovo museo di San Pietro (Petriano)*. Rome, [1925].

Castelli e ponti di Maestro Niccola Zabaglia. Filippo Maria Renazzi, ed. 2d ed. Rome, 1824.

Chappell, Miles L., and W. Chandler Kirwin. "A Petrine Triumph: The Decorations of the Navi Piccole in San Pietro under Clement VIII." *Storia dell'arte* 21 (1974): 119–70.

Charles, R. H. *Studies in the Apocalypse*. Edinburgh, 1913.

Chattard, Giovanni Pietro. *Nuova descrizione del Vaticano*. Vol. 1. Rome, 1762.

Clark, Anthony Morris. *Studies in Roman Eighteenth-Century Painting*. Edgar Peters Bowron, ed. Washington, D.C., 1981.

"Covenant." *The New Bible Dictionary*. J. D. Douglas, ed. Grand Rapids, Mich., 1962.

De Rossi, G. B. *Musaici cristiani e saggi di pavimenti*. Rome, 1873–99.

DiFederico, Frank R. "Documentation for the Paintings and Mosaics of the Baptismal Chapel in Saint Peter's." *Art Bulletin* 50 (1968): 194–98.

———. "Documentation for Francesco Trevisani's Decorations for the Vestibule of the Baptismal Chapel in Saint Peter's. *Storia dell'arte* 6 (1970): 155–74.

———. "Alcuni modelli del Trevisani per San Pietro." *Arte Illustrata* 5 (1972): 321–24.

———. *Francesco Trevisani: Eighteenth-Century Painter in Rome*. Washington, D.C., 1977.

———. "The Mosaic Decorations for the Chapel of the Choir in Saint Peter's." *Storia dell'arte* 32 (1978): 71–81.

Dimier, Louis. "Subleyras." *Les Peintures français du XVIIIe siècle*. Paris, 1930. Vol. 2, pp. 49–92.

"Doctor of the Church." *New Catholic Encyclopedia*. Vol. 4. Washington, D.C., 1967.

Dussler, Luitpold. *Raphael*. Translated by Sebastian Cruft. London, 1971.

Falconieri, Carlo. *Vita di Vincenzo Camuccini*. Rome, 1875.

Faldi, Italo. *Pittori viterbesi di cinque secoli*. Viterbo, 1970.

"Fathers of the Church." *New Catholic Encyclopedia*. Vol. 5. Washington, D.C., 1967.

Feuillet, André. *The Apocalypse*. Translated by Thomas E. Crane. Staten Island, N. Y., 1965.

Fontana, Carlo. *Templum Vaticanum*. Rome, 1694.

Francia, Ennio. *1506–1606: Storia della construzione del nuovo San Pietro*. Rome, 1977.

Friedlaender, Walter. *Caravaggio Studies*. Princeton, N.J., 1955.

Furietti, Josephi Alexandri. *De Musivis*. Rome, 1752.

Galassi Paluzzi, Carlo. *San Pietro in Vaticano*. 2 vols. Rome, 1963.

———. *La Basilica di S. Pietro*. Bologna, 1974.

Gerspach, Edouardo. *La Mosaïque*. Paris, [n.d.].

Giannatiempo, Maria. *Disegni di Pietro da Cortona e Ciro Ferri*. Rome, 1977.

Giannelli, Felice. "Studio del Musaico al Vaticano." *L'Album* 12 (1845): 41–47.

Gizzi, Gio. Battista. *Breve descrizione della Basilica Vaticana*. Rome, 1721.

Gnudi, Cesare. *Guido Reni*. Florence, 1955.

González-Palacios, Alvar. "Il quadro di pietra." *Bolaffiarte* 6 (October 1975): 42–43, 108.

———. "Giovanni Battista Calandra, un mosaicista alla corte dei Barberini." *Ricerche di storia dell'arte*, nos. 1–2 (1976): 211–40.

———. "Provenzale e Moretti: Indagine su due mosaici." *Antichità viva* 15 (1976): 26–33.

Grassi, Luigi. *Bernini pittore*. Rome, 1945.

Grimaldi, Giacomo. *Descrizione della basilica antica di S. Pietro in Vaticano*. Reto Naggl, ed. Città del Vaticano, 1972.

Grimaldi, Nefta Barbanti. *Il Guercino*. Bologna, 1968.

Harris, Ann Sutherland. *Andrea Sacchi*. Oxford, 1977.

Hautecoeur, Louis. "I musaicisti Sampietrini del settecento." *L'Arte* 13 (1910): 450–60.

Heimbürger Ravalli, Minna. *Architettura, scultura, e arti minori nel barocco*. Florence, 1977.

Heisinger, Ulrich. "The Paintings of Vincenzo Camuccini, 1771–1844." *Art Bulletin* 60 (1978): 297–320.

Hibbard, Howard. *Carlo Maderno*. University Park, Pa., 1971.

I caravaggeschi francesi. Arnauld Brejon de Lavergnée and Jean-Pierre Cuzin, eds. Rome, 1973.

Il Guercino. Denis Mahon, ed. Bologna, 1968.

I mosaici minuiti romani. Domenico Petochi, ed. Rome, 1981.

Incisa della Rocchetta, Giovanni. "Le vicende di tre quadri d'altare." *Roma* 10 (1932): 255–70.

———. "Il bozzetto del 'S. Venceslao' di Angelo Caroselli." *Bollettino dei musei comunali di Roma* 12 (1965): 22–27.

Italian Drawings in the Albertina. W. Koschatzky, K. Oberhüber, and E. Knab, eds. New York, 1971.

The Jerusalem Bible. New York, 1966.

Kerber, Bernard. "Giuseppe Bartolomeo Chiari." *Art Bulletin,* 50 (1968): 75–86.

———. "Kupferstiche nach Gianfrancesco Romanelli." *Giessener Beiträge zur Kunstgeschichte*. Geissen, 1973. Vol. 2, pp. 133–70.

Kirwin, William Chandler. *Christofano Roncalli (1551/2–1626), An Exponent of the Proto-Baroque: His Activity Through 1605*. Ph.D. diss., Stanford University, 1972.

Körte, Werner. "Die Navicella des Giotto." *Festschrift Wilhelm Pinder*. Leipzig, 1938.

Krautheimer, Richard. "A Christian Triumph in 1597." *Essays Presented to Rudolf Wittkower*. Douglas Fraser, Howard Hibbard, and Milton J. Lewine, eds. Vol. 2. London, 1967.

———. *Corpus Basilicarum Christianarum Romae*. Vol. 5. Città del Vaticano, 1977.

———. *Rome: Profile of a City 312–1308*. Princeton, N.J., 1980.

Die Künstlerbiographien von Giovanni Battista Passeri. Jacob Hess, ed. Leipzig, 1934.

Lavin, Irving. *Bernini and the Crossing of Saint Peter's*. New York, 1968.

Lazzari, Andrea. *Delle chiese di Urbino e delle pitture in esse esistenti*. Urbino, 1801.

Letarouilly, Paul. *Le Vatican*. London, 1963.

Lieure, J. *Jacques Callot*. Vol. 1. Paris, 1924.

L'Orange, H. P., and P. J. Nordhagen. *Mosaics*. Translated by Ann E. Keep. London, 1966.

Mack, Rosamond, E. *Girolamo Muziano*. Ph.D. diss., Harvard University, 1973.

Marini, Maurizio. *Io Michelangelo da Caravaggio*. Rome, 1974.

Matthiae, Guglielmo. *Mosaici medioevali delle chiese di Roma*. 2 vols. Rome, 1967.

Memorie enciclopediche romane sulle belle arti. Rome, 1806. Vol. 1, pp. 36–40.

Mezzetti, Amalia. "Contributi a Carlo Maratti." *Rivista del Instituto* 4 (1955): 252–354.

Mignanti, Filippo Maria. *Istoria della Sacrosanta Patriarcale Basilica Vaticana*. Vol. 2. Rome, 1867.

Moir, Alfred. *The Italian Followers of Caravaggio*. 2 vols. Cambridge, Mass., 1967.

Montagu, Jennifer. "Alessandro Algardi and the 'Borghese Table.' " *Antologia di Belle Arti* 4 (1977): 311–28.

"Mosaics." *Encyclopedia of World Art* 10 (London, 1965), cols. 324–58.

Muñoz, Antonio. "Musaici della vecchia basilica Vaticana nel Museo di Roma." *Bollettino dei musei comunali di Roma* 6 (1959): 8–13.

Musolino, Giovanni. *La Basilica di San Marco in Venezia*. Venice, 1955.

The New Oxford Annotated Bible. New York, 1973.

Nordhagen, Per Jonas. "The Mosaics of John VII." *Acta Institutum Norvegiae* 2 (1965): 121–66.

Oakshott, Walter. *The Mosaics of Rome*. London, 1967.

Orbann, Johannes. "Der Abbruch Alt-Sankt-Peters 1605–1615." *Jahrbuch der Preussichen Kunstsammlungen*, Supplement, 39 (1919): 1–139.

Pascoli, Lione. *Vite de' pittori, scultori, et architetti moderni*. 2 vols. Rome, 1730, 1736.

Pastor, Ludwig. *The History of the Popes*. Vol. 20. London, 1952.

Patella, Anna. *Pittori della scuola bolognese a Roma fra il '600 e il '700: Bonaventura Lamberti, e Domenico Maria Muratori*. Ph.D. diss., Università degli studi di Roma, 1971–72.

Pistolesi, Erasmo. *Il Vaticano*. Vol. 1. Rome, 1829.

Pollak, Oskar. "Italienische Künstlerbriefe aus der Barockzeit." *Jahrbuch der Preussischen Kunstsammlungen*, Supplement, 34 (1913): 1–77.

———. "Ausgewählte Akten zur Geschichte der römischen Peterskirche." *Jahrbuch der Preussischen Kunstsammlungen*, Supplement, 36 (1915): 21–117.

———. *Die Kunsttätigkeit unter Urban VIII*. Vol. 2. Vienna, 1931.

Procacci, Ugo. "Una 'Vita' inedite del Muziano." *Arte Veneta* 8 (1954): 242–64.

Pullapilly, Cyriac K. *Caesar Baronius*. Notre Dame, Ind. 1975.

Rastelli, Giovanni Bernardino. *Descrizione della pompa et del apparato fatto in Roma per la translatione del corpo di S. Gregorio Nazianzeno*. Perugia [n.d.].

Röttgen, Herwarth. *Il Cavaliere d'Arpino*. Rome, 1973.

Rudolph, Stella. "The 'Gran Sala' in the Cancelleria Apostolica: A Homage to the Artistic Patronage of Clement XI." *Burlington Magazine* 120 (1978): 593–601.

Saccardo, Pierre. *Les Mosaïque de Saint-Mark à Venise*. Venice, 1896.

Salerno, Luigi. "Per Sisto Badalocchi e la cronologia del Lanfranco." *Commentari* 9 (1958): 44–64.

Sebastiano Conca (1680–1764). Gaeta, 1981.

Sedlmayr, Hans. "Der Bilderkreis von Neu-St. Peter in Rom." *Epochen und Werke*. Vol. 2. Vienna, 1960.

Sergiacomo, Gaetan. *Guide complet de la Basilique de St.-Pierre à Rome*. Rome, 1912.

Serie distinta degli avvenimenti nella caduta della cupola della chiesa metropolitana d'Urbino. Urbino, 1789.

Sestieri, Giancarlo. "Profilo de Francesco Mancini." *Storia dell'arte* 29 (1977): 67–79.

Siebenhüner, Herbert. "Umrisse zur Geschichte der Ausstatung von St. Peter in Rom von Paul III bis Paul V (1547–1606)." *Festschrift für Hans Sedlmayr*. Munich, 1962.

Sindone, Raffaele, and Antonio Martinetti. *Della sacrosanta basilica di S. Pietro in Vaticano*. Rome, 1750.

Spear, Richard E. *Domenichino*. 2 vols. New Haven, Conn., 1982.

Strappati, Vincenzo. "Lo Studio Vaticano del Mosaico." *L'Illustrazione Vaticana*, no. 22, 30 November 1931.

Studio Vaticano del Mosaico. Milan, 1934.

Toscana, Bruno. "Il pittore del Cardinal Poli: Guidubaldo Abbatini." *Paragone*, no. 177 (1967), pp. 36–42.

Turcio, Genesio. *La Basilica di S. Pietro*. Florence, 1946.

Vasi, Mariano. *Descrizione della Basilica di S. Pietro*. Rome, 1794.

Venturi, Lionello. "La 'Navicella' di Giotto." *L'Arte* 25 (1922): 49–69.

Vincenzo Camuccini, 1771–1844. Gianna Piantoni De Angelis, ed. Rome, 1978.

Vinella, Lucia. *Nicola LaPiccola*. Ph.D. diss., Università degli Studi di Roma, 1971–72.

Waetzoldt, Stephan. *Die Kopien des 17. Jahrhunderts nach Mosaiken und Wandmalereien in Rom*. Vienna/Munich, 1964.

Waterhouse, Ellis. *Baroque Painting in Rome*. London, 1937.

Westin, Jean K., and Robert H. Westin. *Carlo Maratti and His Contemporaries*. University Park, Pa., 1975.

Wilpert, Joseph. *Die römischen Mosaiken und Malereien der kirchlichen Bauten von IV. bis XIII. Jahrhundert*. 4 vols. Freiburg, 1917.

Zanotti, Giampietro. *Storia dell'Accademia Clementina*. Vol. 1. Bologna, 1739.

Index